VAN GOGH

Publisher and Creative Director: Nick Wells
Development and Picture Research: Sara Robson
Project Editors: Sara Robson and Polly Willis
Designer: Mike Spender
Production: Chris Herbert and Claire Walker

Special thanks to: Chelsea Edwards, Geoffrey Meadon and Gemma Walters

FLAME TREE PUBLISHING
Crabtree Hall, Crabtree Lane
Fulham, London, SW6 6TY
United Kingdom

www.flametreepublishing.com

First published 2007

09 11 10 08

3 5 7 9 10 8 6 4 2

Flame Tree is part of The Foundry Creative Media Company Limited

ISBN-10: 1 84451 711 X
ISBN-13: 978 1 84451 711 4

Every effort has been made to contact copyright holders. We apologize in advance for any omissions
and would be pleased to insert the appropriate acknowledgement in subsequent editions of this publication.

While every endeavour has been made to ensure the accuracy of the reproductions of the images in this book,
we would be grateful to receive any comments or suggestions for inclusion in future reprints.

Printed in China

VAN GOGH

Author: Tamsin Pickeral Foreword: Michael Robinson

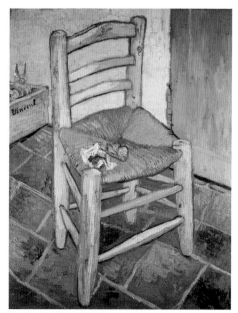

Vincent Van Gogh, *Van Gogh's Chair*

**FLAME TREE
PUBLISHING**

Vincent Van Gogh, *Field with Poppies*

Contents

Vincent Van Gogh, *Two Cut Sunflowers; Dr Paul Gachet; The Asylum Garden at Arles*

Vincent Van Gogh, *The Night Café, Arles; Landscape with Chariot; Old Man in Sorrow (On the Threshold of Eternity)*

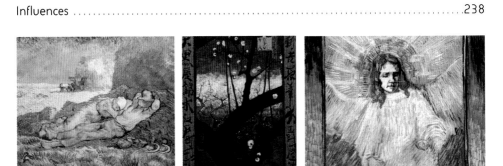

Vincent Van Gogh, *View of The Hague; Terrace of the Café; Olive Trees*

Vincent Van Gogh, *Noon: Rest from Work* (after Millet); *Flowering Plum Tree* (after Hiroshige); *The Angel* (after Rembrandt)

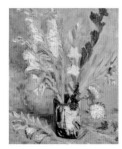 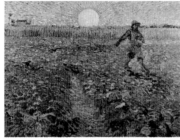 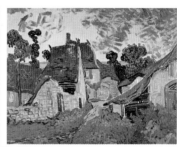

Vincent Van Gogh, *Vase with Gladioli; Sower at Sunset; Village Street in Auvers*

How To Use This Book

The reader is encouraged to use this book in a variety of ways, each of which caters for a range of interests, knowledge and uses.

- The book is organized into five sections: **Life**, **Society**, **Places**, **Influences** and **Styles & Techniques**.
- **Life** provides a snapshot of how Van Gogh's work developed during the course of his career, and discusses how different people and events in his life affected his work.
- **Society** shows how Van Gogh's work reflected the times in which he lived, and how events in the wider world of the time were a source of inspiration to him.
- **Places** looks at the work Van Gogh created in the different places he lived and travelled, and how these places affected his painting.
- **Influences** reveals who and what influenced Van Gogh, and touches on his inspiration to future generations of artists.
- **Styles & Techniques** delves into the different techniques Van Gogh used to produce his pieces, and the varying styles he experimented with throughout his career.

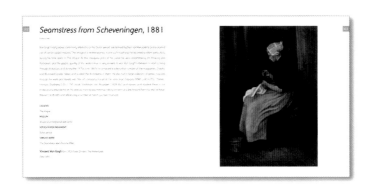



9

1. Title of work (NB: all works are by Van Gogh unless another artist's name is given at the foot of the page

2. Date of work (if known)

3. Information about the work and the context within which it was created

9. Picture credit

8. Place in which the work was created (if known)

7. Medium in which the work was created (if known)

6. Series, period or movement to which the work belongs (if known)

5. Similar work to the one pictured

4. Artist's name, date of birth and death, and place of birth features at the beginning of each chapter

Foreword

Vincent Van Gogh is arguably the most famous artist in the Western world. The record auction prices achieved for his paintings, fuelled by the desire to own a part of this troubled soul, are now legendary.

The legend-making book *Lust for Life* written in 1935 by Irving Stone largely informs our knowledge of Van Gogh. This and its adaptation for film in 1956 with Kirk Douglas in the starring role, portray the artist as a manic-depressive seeking recognition for his avant-garde approach to painting. His irascible behaviour around his fellow artist Paul Gauguin and constant rejection by an art-buying public led inevitably to a stay in an asylum and an eventual painful suicide. *Lust for Life* is largely based on the extensive correspondence between Vincent and his art dealer brother Theo, in which the artist demonstrates an overt angst and disillusionment with institutional hierarchies that form the basis for our understanding of his life and its mythology. The book and the film raise issues about the human condition and seek our empathy with the artist. But to what extent was Van Gogh complicit in the myth-making project?

Van Gogh had been mythologized before 1935. As early as 1910, the art critic and historian Julius Meier-Graefe wrote a book on the artist, which actually focused on his moral struggle in an idealized way. But Van Gogh actually presented himself as someone who was misunderstood, someone who was dominated by an intense drive and enthusiasm.

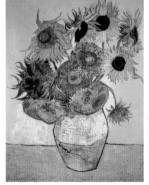

Vincent Van Gogh, *Sunflowers*

Let us firstly consider his *Self Portrait with Bandaged Ear* from 1889 and ask why he (or any artist for that matter) would want to paint himself with a bandaged ear. It could not be indifference since he was obviously too passionate. It therefore had to be a self-promoting advertisement for a tormented soul that would almost certainly fail to be acknowledged in the artist's own lifetime, but for posterity.

A further example of this self-promotion can be seen in a number of his later works most notably *Sunflowers* from 1888. In this painting his signature 'Vincent'

appears, not only in an enlarged format, but also in the centre of the work rather than the conventional bottom corner. He was, by any and all standards, an unconventional artist, and significantly he was very aware of this and aspired to become a part of the avant-garde after his arrival in Paris in 1886.

Van Gogh was verbally articulate and wrote hundreds of letters, mainly to his brother Theo; more importantly they were kept for posterity. He wrote about himself and his painting, and his letters appeared as a published tome as early as 1914. In his penultimate letter written a few days prior to his death, he is disparaging about his own work, 'I am risking my life for it and my reason has half foundered for it.' His last letter, which was actually found in his possession when he died read, 'As far as I'm concerned, I apply myself to my canvases with my entire mind. I am trying to do as well as certain painters whom I have greatly loved and admired.' These letters seem to suggest a self-fulfilling prophesy of his own death.

In the second half of the twentieth century the legend continued to be upheld. When two academics, Griselda Pollock and Fred Orton, wrote their essay on Van Gogh, the authors decided an appropriate title was *Rooted in the Earth: A Van Gogh Primer*. When the work was published the publishers changed the title to *Vincent Van Gogh: Artist of his Time*. As Pollock later argued, what artist is *not* of his time? What she was critical of is the way that history is written through carefully selecting and citing what she calls 'institutionally dominant art history'. It is not hard to see then that Van Gogh was and still is mythologized as the misunderstood artist genius, a profile that continues to be upheld by art history, despite efforts to deconstruct it.

Van Gogh's legacy still continues to inform us of the supposed troubled and tormented artist when we consider other artists of the twentieth century who have suffered for their art, such as Jackson Pollock. But his legacy extends beyond that to the artist as writer about his work, and the artist as celebrity. It would be hard to imagine Henri Matisse and Fernand Léger writing about their own work without this legacy, and even harder to imagine Yves Klein or Andy Warhol's infamy without the precedent set by the self-fulfilling prophesy of Van Gogh's life and early death.

Michael Robinson, *2007*

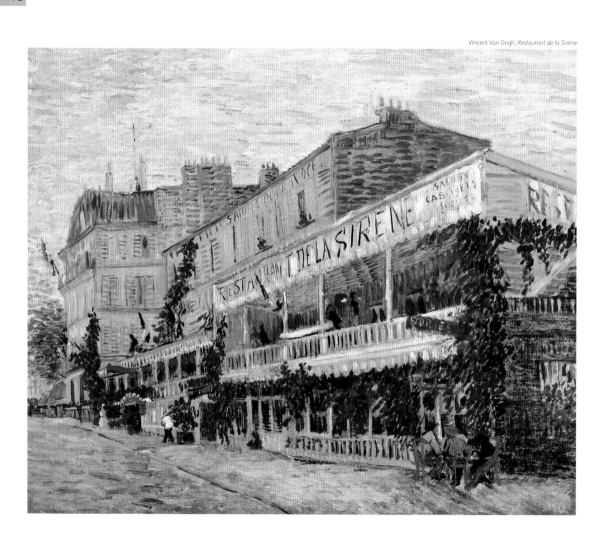

Introduction

In the summer of 1889 Jean-François Millet's painting, *Angelus*, was sold to America for the staggering sum of 580,000 francs. It was an event that rocked the art world and was a reflection of the unprecedented escalation in the art market during the nineteenth century. It is this aspect of art as being 'commercial' that is invariably overlooked in relation to the 'story' of the individual artist's life and their working methods. Vincent Van Gogh – the man, the legend, and the artist – has become all but lost in propagated myths and romantic visions. He is perceived as the 'mad artist', the man who painted in a frenzy, the tormented soul, the artist who cut off his ear, all partially true, but factors that have nonetheless suffocated the actuality of an intelligent and reasoned man. Van Gogh made a conscious decision to become an artist, having first tried different career avenues. It was an informed choice, and once made he set about creating his career in a thoroughly logical manner, and with a keen awareness and knowledge of the art market. As an artist Van Gogh strove to sell his work, and though unsuccessful, it is this aspect of his career that is often overshadowed by the perception that his paintings are mere visual manifestations of his troubled mind.

His early life was particularly significant in the light of his future career, and had an enormous impact on his subsequent artistic development. Van Gogh was a Dutchman, and though he spent most of his life as an artist in France, his art is often, mistakenly, described as French, when in essence the foundation for his art is undeniably Dutch. He was born and raised in a provincial area of the Netherlands into a middle-class family, the son of a Protestant pastor. The area was primarily agricultural with a large population of peasants and from an early age Van Gogh was aware of the disparity between his middle-class background and the poverty-stricken life of those around him. He later developed socialist ideals, but instead of propagating change through his art, he instead immortalized the peasant in nostalgic and heroic terms, similar to those of Jean-François Millet (1814–75) and Jules Breton (1827–1906). It is worth noting that Van Gogh considered Millet to be one of the greatest artists, and frequently referred to and copied Millet's works, especially when considering that it was a Millet that took the art world by storm in 1889. Though Van Gogh could not have predicted this unprecedented sale, which caused much controversy amidst his circle, did he perhaps recognize the direction in which Millet's paintings were going? And if this was the case then did Van Gogh, by echoing the work of Millet, consciously believe he was creating art that would be commercially successful?

The religious nature of his upbringing was another factor that was pertinent to Van Gogh throughout his life. For a brief period of time he embraced religion with an ardent enthusiasm, keen to become a missionary and live and work amongst the less fortunate. His over-zealous approach, which was typical of his passionate, all or nothing nature, put him at odds with his superiors, and frightened those he was supposed to be helping. He maintained spiritual beliefs throughout his life, though rarely painted subjects of a religious genre. His beliefs moved away from those of organized religion and became increasingly spiritual in nature, which was later reflected in symbolic elements of his work. Interestingly he criticized a number of religious paintings by his friends Paul Gauguin (1848–1903) and Émile Bernard (1868–1941) and wrote, 'Of course with me there is no question of doing anything from the Bible and I have written to Bernard as well as to Gauguin that I believed that our duty lay in thoughts and not in dreams, and I was therefore surprised to see that in their work they let themselves go in that direction ...'

An important period of Van Gogh's early life was spent working for the art dealers Goupil et Cie. He joined the company, in which his uncle was partner, in 1869 and worked for them until 1876, a span of around six years, which is considerable in view of the length of his subsequent art career that spanned only approximately 10 years. During his time with Goupil et Cie he experienced the commercial side of the art world, and the practicalities of it: the organization of exhibitions; the sales of prints and originals; and the prices that these works fetched. The job saw him travel from The Hague to London and Paris, all of which afforded him the opportunity to study a wide range of paintings, including the Old Masters and the works of the Barbizon and French Realists of which he was so fond. The experience of working in this environment for a comparatively long time in the course of his short life was one that undeniably affected his subsequent development as an artist, especially with relevance to exhibiting and promoting his own work as well as that of his friends and contemporaries.

There is one name that is virtually synonymous with Van Gogh, and that is Theo, his younger brother. Throughout his life Van Gogh corresponded with Theo, and other friends, on a regular basis and the surviving letters between the two shed much on the nature of their complicated relationship that was both personal and professional. Theo also worked for Goupil et Cie, (later called Boussod et Valadon) and in 1886 was made a director of their modern art branch at 19 boulevard Montmartre. Primarily he dealt in works by the Barbizon artists, but was allowed to show works by more avant-garde artists (the Impressionists and later Post-Impressionists) in a room on the second floor. Theo, as a dealer, was therefore an important figure for Van Gogh's contemporaries, and to some extent he also relied

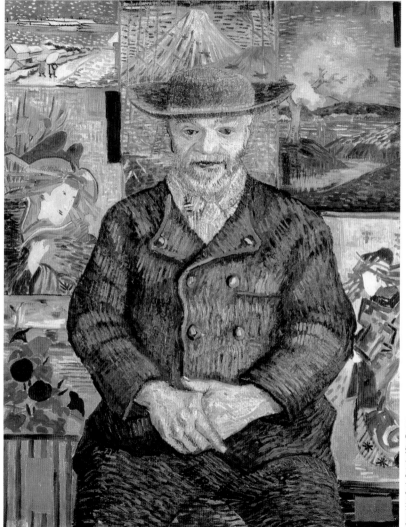

on Van Gogh to bring his artist friends into his commercial circle. Van Gogh, who remained unsuccessful commercially during his life (though not for lack of trying), relied on Theo financially, and Theo in turn acted as Van Gogh's primary dealer. Van Gogh was not passive, however, and during the two-year period in Paris when the two brothers lived together on rue Lepic, he actively promoted his own work by staging exhibitions at the cafés and restaurants in Montmartre and drew on his earlier experiences with Goupil et Cie. The professional nature of Theo and Van Gogh's relationship, which overlapped the personal one, led to tension and difficulties between the two men, but they nevertheless remained close until Van Gogh's death, and rather than Van Gogh being totally dependent (emotionally) on Theo, it transpires from their letters that the two brothers were somewhat reliant on each other.

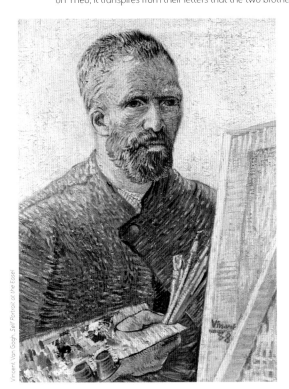

Vincent Van Gogh, *Self Portrait at the Easel*

Van Gogh relied heavily on his relationships, that of his brother, his mother, sisters and friends. He was a man who craved companionship of equal footing, but ironically in the same breath managed to alienate those that he drew around him. It was his dream to form an artists' community, to have a shared studio and foster a sense of brotherhood with his fellow artists along the lines of Japanese models, yet he was impossibly temperamental. His behaviour, which was symptomatic of his long struggle with mental illness (and an excessive fondness for absinthe), was alarming to many, disruptive and argumentative, with the consequence that people distanced themselves from him. He longed to be surrounded but by the same token he needed peace and quiet to work, and by his own admission Paris became too frantic, too busy and too loud for him to concentrate. One of the worst years of his life was spent in the asylum at Saint-Rémy during which period he had no contact with friends or social equals, and the sense of isolation, both mental and

physical became almost intolerable. Van Gogh was a man who felt more intensely than normal, whose emotions and passions ran at a higher level than others. His anger, his happiness, his kindness and compassion, his depression and even early on his religious zealousness was pitched at a supra-normal level. A parallel can be drawn between this sense of pure, undiluted (dangerous even) emotion and the intensely brilliant palette that he developed. His use of

Vincent Van Gogh, Autumn Landscape

colour as an expression of mood was something that evolved through his art, as did his varied use of brushwork. To separate the man from the art is in Van Gogh's case virtually impossible because his art was an expression of his self. However, despite this evident self-expression, it is also necessary to consider that he carefully chose his subjects, his format and composition, and that he developed his innovative style consciously. Van Gogh was well aware of contemporary painting and the works of his friends Gauguin and Bernard in particular, and he recognized that art was moving forward in a new direction. Even when his painting became a form of therapy following episodes of instability, his approach to his works was still grounded in reason, with a view to them being saleable, and he chose his subjects of landscapes, still lifes and portraits in this respect. Had he lived for a further 10 or 20 years even, he could possibly have finally gained the commercial success that he had craved, and which ironically has now become so extreme that his paintings – in the rare instances that they do appear on the art market – fetch prices beyond belief. Possibly what would have been more gratifying to the flame-haired Dutchman, though, was the knowledge that his art was to be of such enormous importance to a whole emerging generation of artists who took up his brush where he left off and painted their way towards a new expression of 'modern art'.

Vincent Van Gogh, *Wheat Field with Crows*

Van Gogh

Life

Man at Work, 1882

The tragically short artistic career of Vincent Van Gogh was, however, one of the most productive and documented of nineteenth-century European artists. He was born in 1853 in Groot-Zundert, Brabant, in the Netherlands, the son of a Protestant pastor within the strict Dutch Reform Church. The devout environs of his early family life were to have a profound influence on the sensitive and highly strung young man, who did not pursue a career as an artist until he was 27 years old. His late start and lack of formalized training is apparent in his early works, such as this, which reflect the artist's struggle to find his artistic expression and to produce convincing forms. It was several years before Van Gogh established his style, and during this period, and indeed throughout his career, he suffered from self-doubt and a lack of confidence in his work. However, even at the start of his career and in spite of his technical failings, his work was saturated with a particular energy and intense quality that would compound through his life.

CREATED

The Hague

MEDIUM

Oil on paper laid down on panel

SERIES/PERIOD/MOVEMENT

Early works, peasants and labourers

SIMILAR WORK

A Dutch Peasant by Friedrich Kallmorgen, 1888

Vincent Van Gogh *Born* 1853 Groot-Zundert, The Netherlands

Died 1890

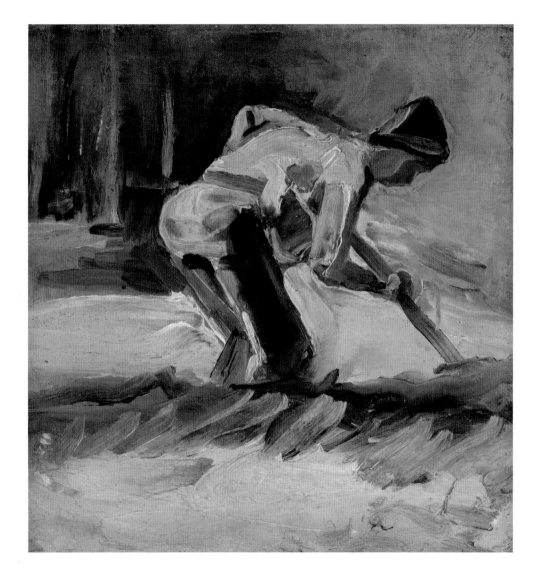

Farmstead After the Rain, 1883

© akg-images

After leaving school at the age of 16, in 1869 Van Gogh joined the firm Goupil et Cie, of which his uncle, also called Vincent, was a partner. Goupil et Cie specialized in reproductions of fine art and dealing in original art works, and had branches in London, Paris, Brussels, The Hague and New York. Initially Van Gogh settled well, and was sent by the company to their London office in 1869, travelling there via Paris. In London Van Gogh fell in love with his landlady's daughter, Ursula, who rejected his advances leaving him in a state of depression. Subsequently he was transferred between London and Paris twice by the company and was finally dismissed in 1876 due to his erratic behaviour. Though Van Gogh later berated Goupil et Cie and the mechanics of the art market, it was a period that exposed him to a wide range of art work and gave him an understanding of the art world. Despite his knowledge of other paintings his early work such as this was typically very 'Dutch' in tone, subject matter and atmosphere.

CREATED

The Hague

MEDIUM

Oil on canvas on wood

SERIES/PERIOD/MOVEMENT

Early works, Dutch period

SIMILAR WORK

The Windmill by Jacob Henricus Maris

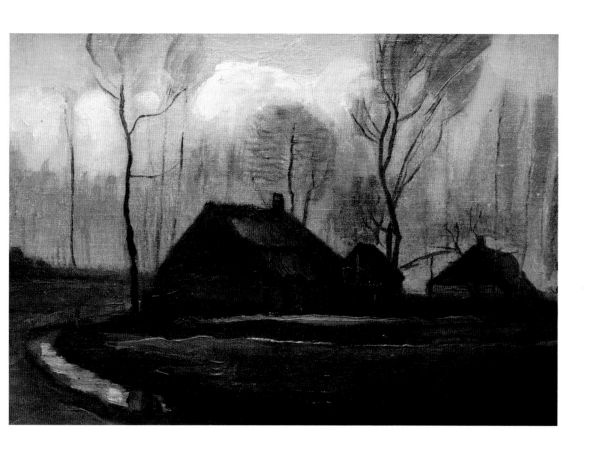

Peasant Woman Winding Bobbins, 1884

Following his dismissal from Goupil et Cie Van Gogh briefly turned to teaching, including Bible history in Isleworth, and became involved with parish work on the outskirts of London. Recognizing that he had a vocation, but unsure what it was Van Gogh continued his fraught, unstable existence and by 1877 had moved to Amsterdam and enrolled in theological college. After unsuccessful and frustrating studies, he returned in despair to his parents' home in Etten, before moving to the impoverished Belgian mining district of Borinage in 1878 to work as an evangelical missionary. His fanatical and over-zealous ministering frightened the locals and caused his dismissal from the missionary, and by 1880 he had turned towards art with a similar dedicated determination.

He strived to express the humility of working men and women, turning towards peasants, farmers labouring and weavers hard at work at their honest toil. He wrote to his younger brother Theo that he, 'should wish to express, not sentimental melancholy, but serious sorrow ... so far that people will say of my work, he feels deeply, he feels tenderly ...'

CREATED

Nuenen

MEDIUM

Gouache on paper laid down on board

SERIES/PERIOD/MOVEMENT

Early works, weavers and peasants

SIMILAR WORK

In the Fields by Camille Pissarro, 1890

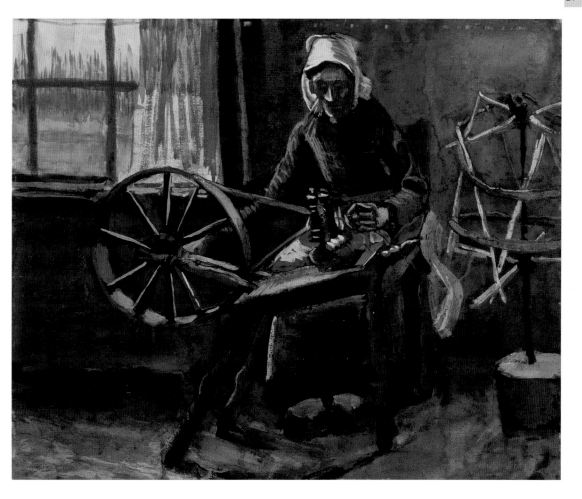

Peasant Woman, 1885

By the time of this painting Van Gogh was living in his parents' hometown of Nuenen, and had devoted himself to painting the local weavers and peasants. The preceding years had been full of turmoil, including an unrequited love for his widowed cousin Kee Vos and a relationship with a seamstress and prostitute called Clasina Maria Hoornik (Sien) in The Hague. Apart from the scandalous liaison that temporarily alienated Van Gogh from his family, his time spent in The Hague during 1882 was important for him artistically, and marked the real beginning of his future artistic development. He left The Hague and Sien in 1883 and spent three months in Drenthe, before arriving at his parents' house in Nuenen. During the summer of 1884 Van Gogh had an ultimately disastrous affair with Margot Begemann, whose family bitterly opposed the union. Margot unsuccessfully attempted suicide and the relationship floundered. The local opinion of Van Gogh was irreparably damaged, and the following year when *Peasant Woman* was painted, he was falsely accused of a local peasant's illegitimate pregnancy and subsequently found it difficult procuring models to pose for him.

CREATED

Nuenen

MEDIUM

Oil on canvas

SERIES/PERIOD/MOVEMENT

Early works, weavers and peasants

SIMILAR WORK

A Pensive Italian by Vincenzo Irolli

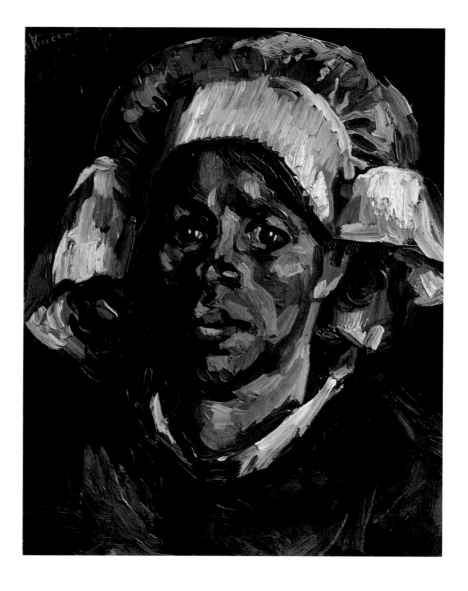

Still Life with Yellow Straw Hat, 1885

Van Gogh's father died in March 1885, and family relations between Van Gogh and his mother and sisters deteriorated. *Still Life with Yellow Straw Hat* was one of several still life paintings Van Gogh made in the last months of 1885. This painting was done in September, shortly after he had been unjustly accused of being responsible for a local peasant girl's illegitimate pregnancy. Van Gogh was having difficulties finding people to model for him, with the local churchmen going to great lengths to pay the peasants to stay away from the painter. Frustrated, Van Gogh turned to painting landscape scenes from around Nuenen and to still life subjects. His work was still defined by a dark and sombre tonality, although, as can be seen here, he was starting to incorporate lighter, warmer colours and was working towards a subtle graduation of dark to light across the canvas. These first years of his career, which itself spanned only a decade, were typically Dutch in character, and it was not until he moved to France at his brother's insistence that he truly began to explore the effects of brilliant colour.

CREATED

Nuenen

MEDIUM

Oil on canvas

SERIES/PERIOD/MOVEMENT

Still lifes

SIMILAR WORK

Flask, Glass and Fruit by Paul Cézanne, 1877

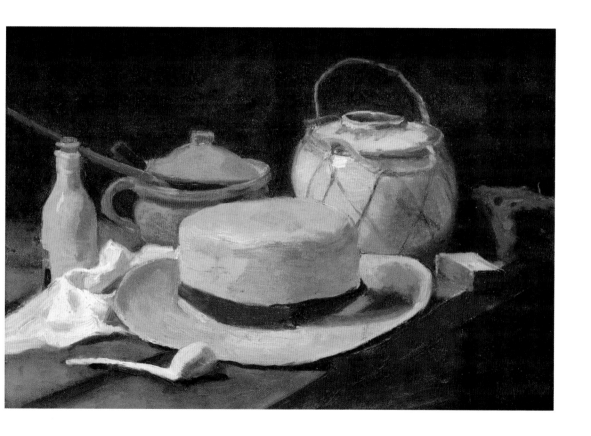

Backyards in Antwerp, 1885

In October 1885 Van Gogh made an important trip to Amsterdam where he toured the art galleries studying Rembrandt (1606–69), whose sombre tones and use of *chiaroscuro* he had already been influenced by, and seeing works by Aelbert Cuyp (1620–91), Jan van Goyen (1596–1656), Jean-Louis-Ernest Meissonier (1815–91), Peter Paul Rubens (1577–1640) and others. On his return, his brother Theo again tried to persuade him to move to Paris, but instead Van Gogh on 24 November 1885 took the train to Antwerp, and left his homeland for good. He rented a room at 194 Beeldekensstraat, and was immediately enthralled with the bustling city.

This painting was made shortly after his arrival, and shows the artist's strong individual voice starting to emerge. The departure from his home country marked a new direction for his visual language, with the dark tones and realist roots of his work being gradually superseded by a developing sense of pattern, colour and meaning. Here the bold composition, use of line and distinct perspective planes anticipate the more self-confident artistic expression that would later develop after his move to France.

CREATED

Antwerp

MEDIUM

Oil on canvas

SERIES/PERIOD/MOVEMENT

Early landscapes

SIMILAR WORK

Bridge at Asnières by Émile Bernard, 1887

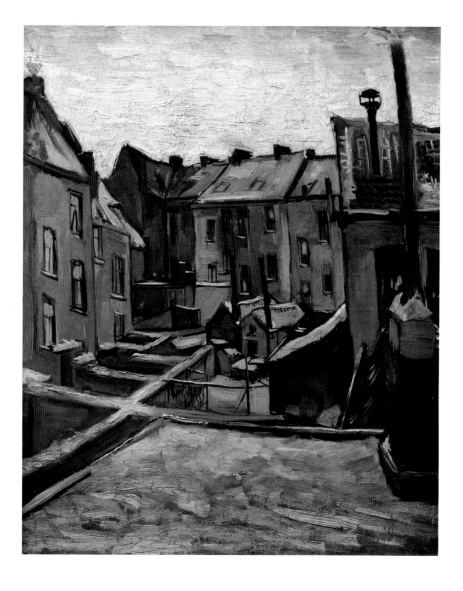

The Outskirts of Paris, 1886

Van Gogh saw Japanese prints for the first time while he was in Antwerp, and was instantly enamoured, drawn to their strong colour, pattern and aura of exoticism. He would admire Japanese art and its philosophy for the rest of his life. In January 1886 he started attending classes at the Municipal Academy, but his unconventional approach to his art and his unkempt manner put him at odds with the teachers. He was desperately short of money, barely eating and in extreme poor health – factors that led to his shambolic appearance and weak constitution. After many disputes with his teachers, Van Gogh finally left Antwerp in February and travelled to Paris, moving in with his brother Theo. Theo, an art dealer, who was younger that Van Gogh, had been – and continued to be – the one almost constant in the troubled artist's life.

This painting, done soon after his move to Paris, shows the artist's rapid absorption of contemporary French art, in particular that of the Impressionists, and his increasing experimentation with colour and composition.

CREATED

Paris

MEDIUM

Oil on cardboard

SERIES/PERIOD/MOVEMENT

Paris, early French works

SIMILAR WORK

Snow at Lower Norwood by Camille Pissarro, 1870

Boulevard de Clichy, 1887

© akg-images

Van Gogh and his brother Theo first lived in a small apartment in rue Laval (now rue Victor Massé) not far from boulevard de Clichy, which appears in this painting. This was a time of relative peace for the troubled artist, whose life was beset with increasingly violent bouts of angst. Shortly after his arrival in Paris he is thought to have studied with the artist Félix Cormon (1845–1924), where he would have come into contact with Louis Anquetin (1861–1932), Henri de Toulouse-Lautrec (1864–1901), John Russell (1858–1930) and the young Émile Bernard (1868–1941). Van Gogh would become friends with Russell and Bernard, whom he corresponded with regularly. He also met a number of his contemporaries, including Paul Gauguin (1848–1903), Camille Pissarro (1830–1903), Paul Signac (1863–1935) and Edgar Degas (1834–1917) through his brother Theo's connections and at Père Tanguy's shop that dealt in artists' materials.

Though Van Gogh retained and developed his particularly unique expression, this work shows the influence of the Impressionist paintings that he had suddenly become aware of, and especially the work of Claude Monet (1840–1926), Pissarro and Alfred Sisley (1839–99) whom he admired.

CREATED

Paris

MEDIUM

Oil on canvas

SERIES/PERIOD/MOVEMENT

Paris, early French works

SIMILAR WORK

The Boulevards Under Snow by Camille Pissarro, 1879

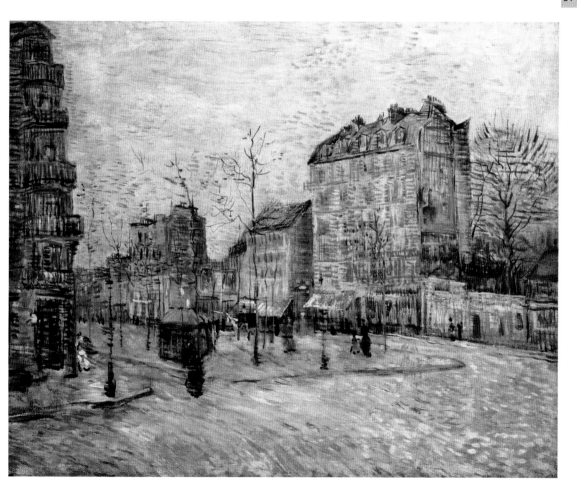

Two Cut Sunflowers, 1887

Van Gogh's continuing admiration for Japanese art became increasingly evident in his paintings, and in turn he admired the Impressionists for their absorption of Oriental influences. Drawing on his early experiences with the firm of art dealers Goupil et Cie, in March 1887 Van Gogh organized an exhibition of Japanese prints at the Café du Tambourin, and later turned to Japanese motifs for several of his paintings. By now his palette had become stridently coloured and almost unrecognizable from the sombre tones of his 'Dutch' period. In the summer of 1887 he began to paint vibrant sunflowers having first seen them blooming with brilliant yellow in the gardens around Montmartre. It was a motif that he would return to often and one that he is now perhaps most associated with. Almost a year after painting *Two Cut Sunflowers* Van Gogh wrote from Arles in the south of France to his friend Bernard, 'I am thinking of decorating my studio with half a dozen pictures of "Sunflowers", a decoration in which the raw or broken chrome yellows will blaze forth on various backgrounds ...'

CREATED

Paris

MEDIUM

Oil on canvas on Triplex

SERIES/PERIOD/MOVEMENT

Still lifes, flowers

SIMILAR WORK

Chrysanthemums by Paul Cézanne, c. 1896–98

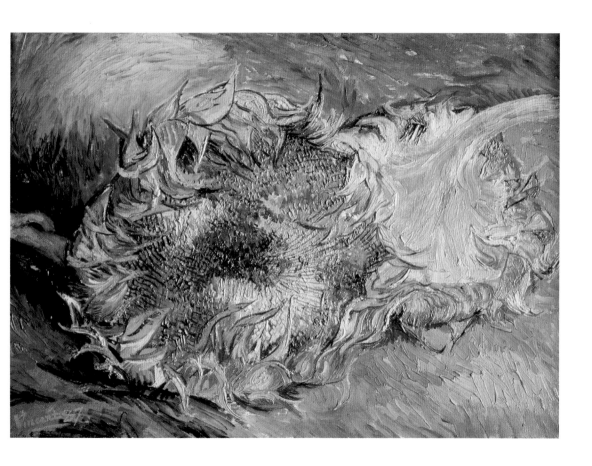

The Parisian Novels (The Yellow Books), 1887

Life in Paris had at first an iridescent effect on Van Gogh and his art. The frenzy of city life and the close contact with other artists whom he came to admire facilitated the emergence of his brilliant palette and tenacious sense of pattern and line. The dark quality of his Dutch work was gone, and though the artist continued to struggle with his mental anxieties, which compounded dramatically, his work became brighter, and incorporated increasingly symbolic elements. He was desperate to 'belong' to a group of artists, to feel a member and an associate, but ironically his difficult temperament invariably alienated him from the very people whose acceptance he craved. The Impressionists had broken up as a group the year he arrived in Paris, and even though he admired their techniques, he strove for greater form and line within his art.

He continued to paint numerous still-life pictures such as this, which has a delicate and Oriental feel, and reflects the influence of Japanese prints, of which he had quite a collection. Yellow and blue dominate; this was a combination that he was to favour throughout the rest of his career.

CREATED

Paris

MEDIUM

Oil on canvas

SERIES/PERIOD/MOVEMENT

Still lifes

SIMILAR WORK

Still Life with Pots and Fruit by Paul Cézanne, c. 1890–94

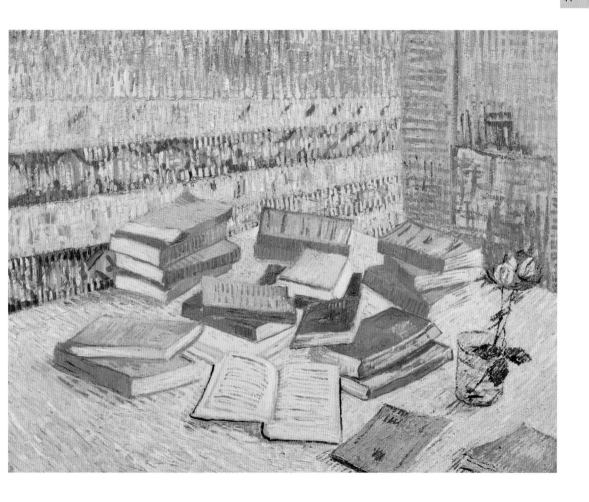

The Italian, 1887

While living in Paris Van Gogh sold few works and was supported financially by his younger brother Theo, with whom he also shared an apartment. The artist frequented the Café du Tambourin on the boulevard du Clichy, near his apartment, and sometimes exchanged still-life paintings for the odd meal. The proprietress of the café, Agostina Segatori, is thought to be the striking woman in this painting of *The Italian*. Van Gogh had also staged an exhibition of Japanese prints at the café in March 1887, some months before this painting was done, and it is thought through correspondence with Theo that he had embarked on a turbulent affair with Agostina. Relations with her were later cut, though the details surrounding the course of this remain unclear. At around the same time as this painting, Van Gogh had again drawn on his earlier experiences and staged the 'Impressionists of the Petit Boulevard' exhibition at the Grand Bouillon Restaurant du Chalet on the avenue de Clichy. Here he displayed a number of his own paintings and also the work of Anquetin, Toulouse-Lautrec, Pissarro, Gauguin, Georges Seurat (1859–91) and Bernard.

CREATED

Paris

MEDIUM

Oil on canvas

SERIES/PERIOD/MOVEMENT

Portraits

SIMILAR WORK

Portrait of my Sister, Madelaine by Émile Bernard, 1888

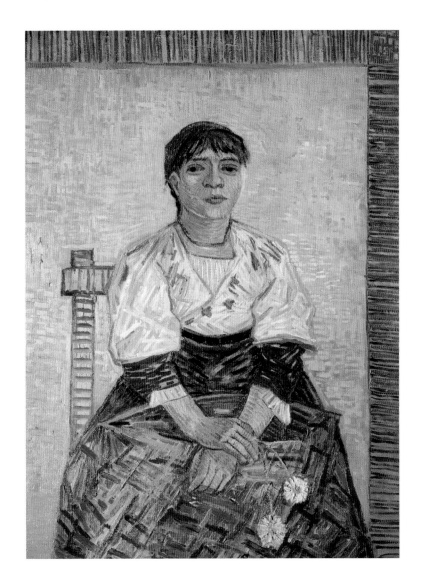

book

Self Portrait at the Easel, 1888

During his time in Paris Van Gogh painted 22 self portraits and continued to paint his portrait after his move to the south of France. The number of self portraits that he made has drawn comparisons with Rembrandt, but the difference being that Van Gogh's multiple self images were produced in the tiny time frame of just five years. Quite apart from the quantity, the expressiveness of these images and the disparity between different ones is of particular note. His physical image alters dramatically during the course of his depictions, which in part was reflective of his poor health. His altering images also convey the deeper metaphysical projections of the artist who was suffering with serious mental anxieties.

This painting was done shortly before he left Paris and during a particularly difficult time for Van Gogh. His relationship with his brother Theo was under considerable strain, caused in great part through Van Gogh's irascible nature. The brothers had shared accommodation for two years, on top of which Van Gogh was reliant on Theo's financial aid, a fact that undermined the artist's sense of self-worth and exasperated his already fragile balance of normality.

CREATED

Paris

MEDIUM

Oil on canvas

SERIES/PERIOD/MOVEMENT

Self Portraits

SIMILAR WORK

Self Portrait (Dedicated to Vincent Van Gogh) by Émile Bernard, 1888

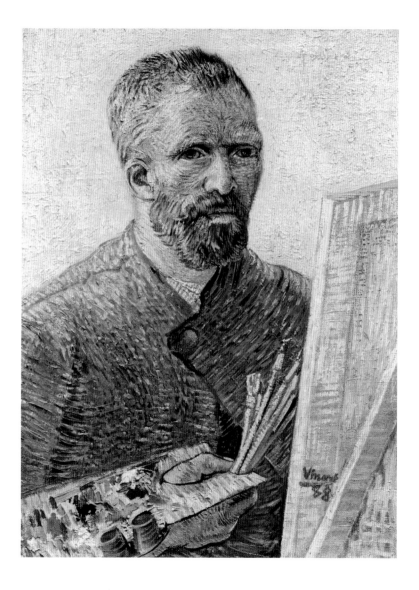

Pink Peach Trees, 1888

By early 1888 the situation between Van Gogh and his brother Theo had become desperate, and their living arrangement impossible. The Paris that had at first so attracted Van Gogh he now found stultifying and claustrophobic. In a letter to Theo he explained, 'It seems to me almost impossible to work in Paris unless one has some place of retreat where one can recuperate and get one's tranquillity and poise back'. On 20 February 1888 Van Gogh visited Seurat's studio with Theo for the first and last time, and afterwards boarded a train to Arles in the south of France. Armed with the preconceived idea that the south was an artistic Elysium full of warmth, peace and exotic colours, Van Gogh wrote to Gauguin, 'I always remember the emotions the trip from Paris to Arles evoked. How I kept watching to see if I had already reached Japan! Childish isn't it?' Ironically, when he did arrive in Arles it was cloaked in snow, but as the snow melted the trees burst into bloom, and his notions of the south were for a short time born out.

CREATED

Arles

MEDIUM

Oil on canvas

SERIES/PERIOD/MOVEMENT

Flowers and blossoms

SIMILAR WORK

Spring at Giverny by Claude Monet, 1903

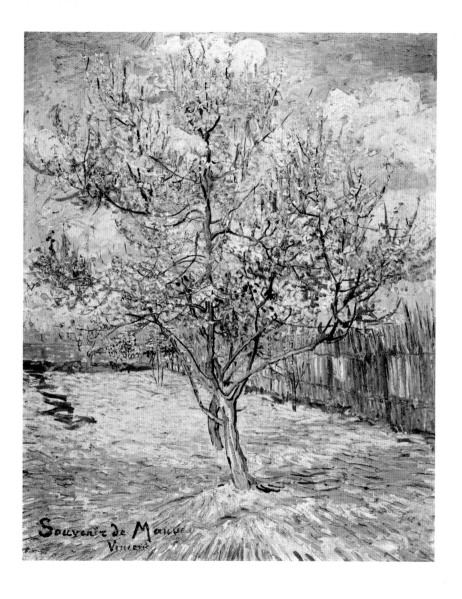

Souvenir de Mauve
Vincent

Haystacks in Provence, 1888

© akg-images

When Van Gogh arrived in Arles he first stayed at the Hotel-Restaurant Carrel on the rue Cavalerie, but by May had rented a small house at 2 place Lamartine, the 'Yellow House'. He was transfixed by the scenery as winter had unfolded into spring, and the colours of the countryside sharpened by the clear yellow light of southern France radiated with a purity of tone. Immediately Van Gogh began painting the local landscape with frenetic energy and during the course of these last two years of his life he produced an enormous number of canvases. His palette brightened again from his Parisian paintings, and he wrote to his sister explaining how nature in the south could not be painted with the same palette as that in the north. He seemed to develop a greater clarity of vision in Arles, drawing greatly on the precedent of the Japanese woodcut and refining his sense of line and form. His brushstrokes became more confident, and were applied with a rhythmic intensity that created a harmonious, almost musical quality to his paintings.

CREATED

Arles

MEDIUM

Oil on canvas

SERIES/PERIOD/MOVEMENT

Landscapes

SIMILAR WORK

Montagne Sainte-Victoire by Paul Cézanne, *c.* 1887–90

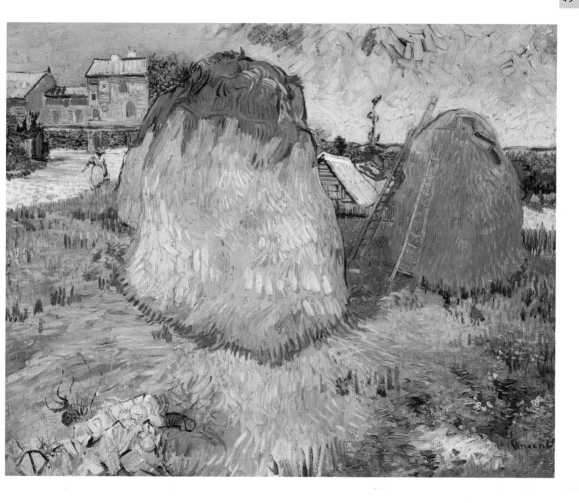

The Yellow House, 1888

© akg-images

Van Gogh lived and worked in the 'Yellow House', at first staying there with no furniture until he could scrape together enough money to buy some. His brother Theo, who sent him a small amount of money each month in return for his paintings (though he had little success in selling them), was still supporting him. Van Gogh's continued close relationship with his brother also kept him in touch with the art scene in Paris and with his fellow artists. He quickly became lonely in Arles, and before moving into the 'Yellow House' was hoping to persuade Gauguin or Bernard to join him and set up the studio together. He had met several local amateur artists in Arles, and in June 1888 met the artists Dodge McKnight (1860–1950) and Eugène Boch (1855–1941), with whom he was particularly taken, while they were spending some weeks in the area.

Increasingly, the colour that Van Gogh used came to be associated with symbolic meaning, so that here for example the fresh yellow house against a clear and deep blue sky expressed the artist's contentment at that particular moment.

CREATED

Arles

MEDIUM

Oil on canvas

SERIES/PERIOD/MOVEMENT

Mature works

SIMILAR WORK

The Village by Maurice de Vlaminck, c. 1904

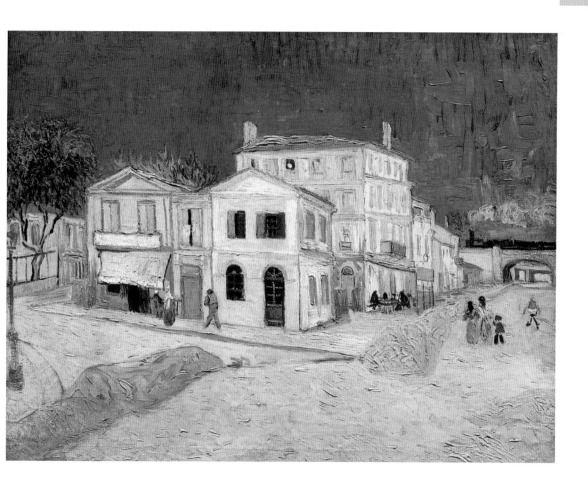

The Bedroom, 1888

© akg-images

On Van Gogh's arrival in Arles the first few paintings he undertook were done in a frenzy of enthusiasm with the rapid short brushstrokes of his Impressionist contemporaries, and a sheer delight in the beauty of the surrounding countryside. Within several months, however, his artistic vision became clearer and his style evolved again, becoming increasingly unique and ousting him from any conventional artistic label. His colours grew in intensity and took on a symbolic meaning. In October 1888 he painted his bedroom in the 'Yellow House', and wrote to Theo that 'It's just simply my bedroom, only here colour is to do everything and, giving by its simplification a grander style to things, it is here to be suggestive of rest or of sleep in general.' It offers an interesting insight into the artist whose own level of unrest and mental anxiety saw this painting as one 'to encourage sleep'. The broad flat areas of pure colour and the unusual perspective that angles the walls and pictures tilting inwards combined with the effect of being thrown forwards into the room create an atmosphere of charged excitement, quite at odds to the way the painter perceived the work in his overwrought mind.

CREATED

Arles

MEDIUM

Oil on canvas

SERIES/PERIOD/MOVEMENT

Mature works

SIMILAR WORK

The Rest by Henri Matisse, 1905

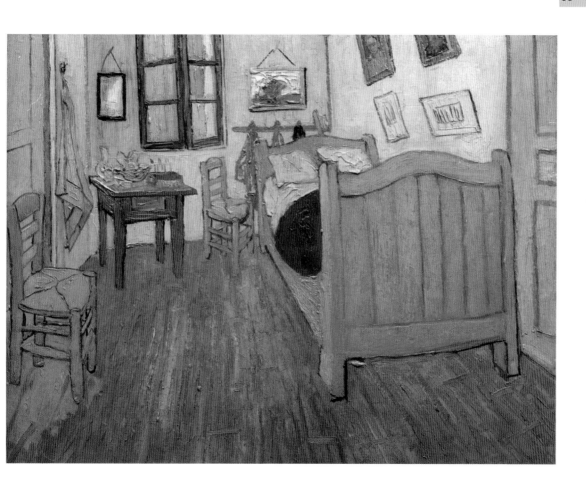

Memory of the Garden at Etten, 1888

On establishing himself in Arles it had been Van Gogh's dream to set up a community of artists, a joint studio where artists could work together, exchanging ideas and encouraging each other in their work and sales. He had pinned his hopes on Gauguin settling with him, and had immersed himself in the task of preparing his little 'Yellow House' in readiness for the artist. Finally, Gauguin arrived on 23 October 1888 to find Van Gogh in a state of near nervous exhaustion brought on by the excitement of his friend's arrival. *Memory of the Garden at Etten* was painted in November, a few weeks after Gauguin had moved in with Van Gogh and shows his influence, and also something of Pierre Puvis de Chavannes (1824–98), an artist that both Van Gogh and Gauguin greatly admired. Both artists painted the subject, working side-by-side, but it was an arrangement that would not last long. By mid-December Gauguin had written to Theo explaining that the two were simply incompatible and that he would soon be returning to Paris.

CREATED

Arles

MEDIUM

Oil on canvas

SERIES/PERIOD/MOVEMENT

Works at Arles

SIMILAR WORK

Garden at Arles by Paul Gauguin, 1888

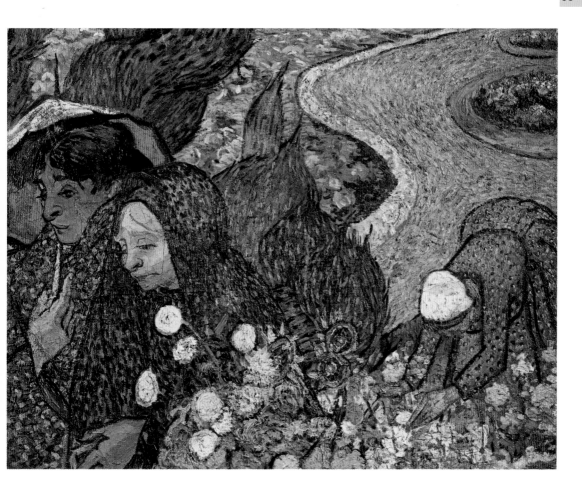

Self Portrait, 1888

Van Gogh, despite his own dreadful financial situation, had always promoted the work of his friends, and in particular that of Bernard and Gauguin. In the summer of 1888 his brother Theo had inherited a small sum of money, part of which went towards the continued support of Van Gogh. However, and at Van Gogh's insistence, another portion of the money was put towards a contract with Gauguin, whereby Theo paid him a monthly fee in return for 12 paintings a year. Gauguin's stay with Van Gogh was suggested by Theo to minimize the two painters' costs by them sharing their accommodation. Though Van Gogh had been anxious for Gauguin to join him, he was also concerned with the added responsibility now on Theo's shoulders, which was yet another indication of the complexity and polarity of Van Gogh's relationship with his brother.

Van Gogh painted this *Self Portrait* shortly before his relationship with Gauguin boiled over, and the melancholy resonance is quite evident. It is a haunting image, one of many such depictions of the artist, whose life was starting to unravel as he increasingly suffered from his mental anxieties.

CREATED

Arles

MEDIUM

Oil on canvas

SERIES/PERIOD/MOVEMENT

Self Portraits

SIMILAR WORK

Self Portrait by Paul Gauguin, 1896

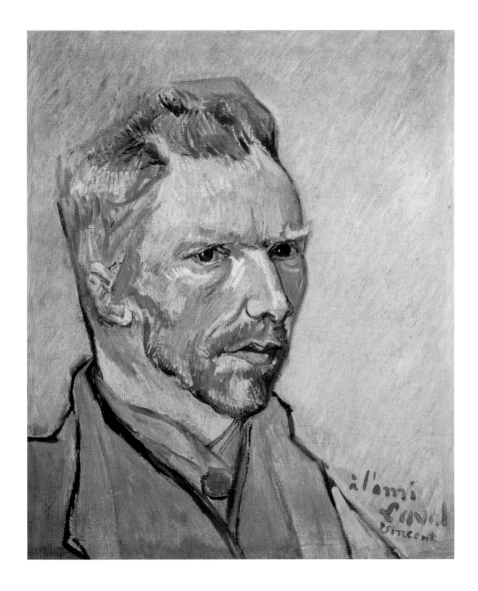

Van Gogh's Chair, 1888

Van Gogh painted this picture as a pendant to another painting he made at the same time of Gauguin's chair. The paintings were done in December 1888, when the relationship between Gauguin and Van Gogh had become strained, and though as yet nothing had been mentioned, Van Gogh was aware of the fact that his dream of sharing a studio was rapidly disintegrating. His simple chair sits empty, symbolic of its absent owner, and is an image that is infinitely sad. It is an extraordinary instance of propelling a most familiar object beyond the realm of still life so that it comes to represent the artist himself. He painted the picture on one of the coarse canvases that Gauguin had brought with him to Arles, and built the composition up through flat, broad areas of colour combined with complex pattern created through the complicated lines of the chair and tiles. By including his pipe and tobacco, and his name signed in the background, the object becomes instantly personalized and as such assumes a mantle of emotive expression unconnected to the everyday form of a chair.

CREATED

Arles

MEDIUM

Oil on canvas

SERIES/PERIOD/MOVEMENT

Works at Arles

SIMILAR WORK

Drapery on a Chair by Paul Cézanne, *c.* 1880–1900

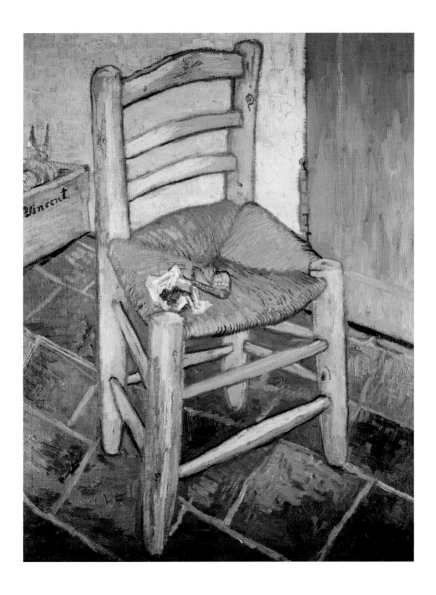

Gauguin's Chair, 1888

© akg-images

This was the accompanying picture to *Van Gogh's Chair*, and was painted at around the same time, in December 1888, just before Van Gogh's first serious episode of temporary insanity. Unlike Van Gogh's chair, which was simple and rush seated, Gauguin's chair was padded with arms, making it an altogether superior seat. It has retained a similar symbolic relevance and has again taken on the mantle of its absent owner, but in this painting the chair is less personal, there is less of Gauguin present, whereas there is no doubt from Van Gogh's simple rush chair who it belongs to. The artist approached the depiction of his friend's chair differently too, and the brushstrokes are more fragmented giving a sense of disorder through the short dabs of light paint that make up the patterned floor. The chair also looms slightly unerringly at the front of the canvas, breaking through the natural frame of the picture. Both this and *Van Gogh's Chair* were unfinished at the time of his first breakdown, he never returned to this painting, but did finish that of his chair in January 1889.

CREATED

Arles

MEDIUM

Oil on canvas

SERIES/PERIOD/MOVEMENT

Works at Arles

SIMILAR WORK

Still Life of the Artist's Accessories by Paul Cézanne, 1872

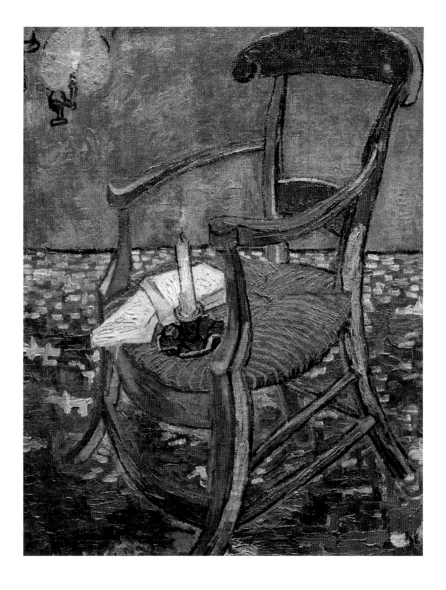

Still Life with Drawing Board, Pipe, Onions and Sealing Wax, 1889

© akg-images

In the days prior to 23 December 1888 Gauguin had told Van Gogh that he would be returning to Paris, and Van Gogh had grown increasingly agitated and tormented. That night, according to Gauguin, Van Gogh tried to attack him with a razor before fleeing to his room. Gauguin spent the night in a hotel and returned to the 'Yellow House' the next day to find the Police Commissioner waiting for him. Van Gogh had severed part of his ear, then attempted to stem the blood flow and had taken the ear to Rachel, a prostitute at a local brothel. Discovered barely conscious and lying in a pool of blood, the artist was transferred to the hospital. Gauguin summoned Theo urgently, and left a few days later.

Van Gogh wrote to Gauguin after his release from hospital, assuring him of their continued friendship and with a gentle admonishment for causing Theo to worry unnecessarily. He returned to the 'Yellow House' on 7 January 1889 and began painting again, working on several still life pictures, of which this is one.

CREATED

Arles

MEDIUM

Oil on canvas

SERIES/PERIOD/MOVEMENT

Still lifes

SIMILAR WORK

The Ham by Paul Gauguin, 1889

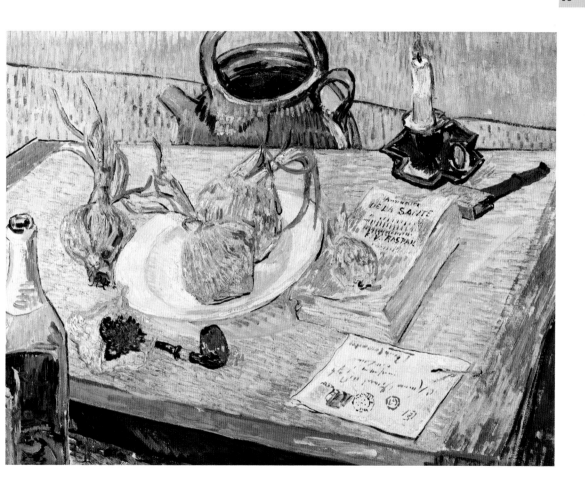

Self Portrait with Bandaged Ear, 1889

Van Gogh returned to his house at the beginning of January, and immediately wrote to Gauguin, sending a long and lucid letter apologizing for the 'incident' and assuring him of their continued friendship. Correspondence from Van Gogh to Theo and his friends indicates that he accepted his illness and wished to recover, though was perhaps unaware of the full extent of his mental condition, putting much of it down to poor physical health and fever. He was keen to start painting again and worked on this self portrait during the weeks following his return home. As with all the artist's self portraits, it is a frank statement of his self-perception at the time of painting, and here though the brushstrokes are controlled and considered the luminous green that envelops the background and the artist's bandaged face creates tension and an unworldly atmosphere. Behind the artist on the wall is a copy of a Japanese print, Utagawa Toyokuni's (c. 1765–1825) *Geishas in a Landscape*. The bright foreign landscape is in total contrast to the artist huddled in his winter clothes, and possibly alludes to the fragmentation of his dreams for an artists' colony in the south.

CREATED

Arles

MEDIUM

Oil on canvas

SERIES/PERIOD/MOVEMENT

Self Portraits

SIMILAR WORK

Self Portrait by Paul Gauguin, 1889

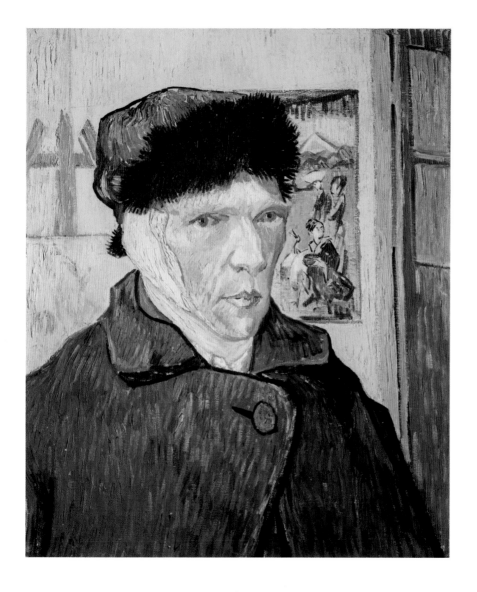

Portrait of Dr Felix Rey, 1889

While recovering at the hospital and before his return home in January, Van Gogh had become friendly with Pastor Salles and an intern, Dr Felix Rey. The two men would stay loyal to Van Gogh and help him in the troubled months that lay ahead. The artist's other true friend in the village of Arles was the postman Roulin, who kept in touch with Theo and advised him of Van Gogh's progress. Dr Rey visited Van Gogh at his home on the day he was discharged, and the artist decided to paint his portrait as soon as he was able to. Some weeks later he produced this painting, which the young doctor's mother reputedly hated so much that she used it to mend a hole in her henhouse. Van Gogh's treatment of his friend is typically direct, and with minimal line and a subdued palette he captured the nature of the doctor. It is his approach to painting the eyes, however, that lend the work its real feeling, and with a bare dab of paint Van Gogh created a look that is piercing, yet full of compassion.

CREATED

Arles

MEDIUM

Oil on canvas

SERIES/PERIOD/MOVEMENT

Portraits

SIMILAR WORK

Portrait of Paul Sérusier by Émile Bernard

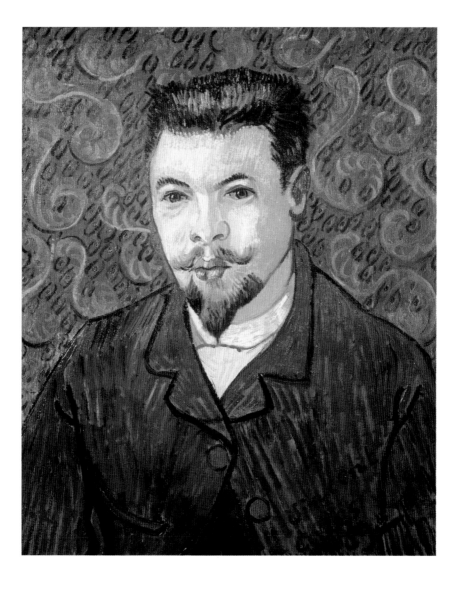

Augustine Roulin (La Berceuse), 1889

It came as a devastating blow to Van Gogh to learn that his dear friend Roulin the postman was about to leave Arles and move to Marseille. He learnt of the move shortly after his return home from the hospital in January, and it would seem to have certainly contributed in some way to the artist's subsequent breakdown a month later. Roulin had been Van Gogh's closest and most constant friend in Arles, and the artist had painted him, and members of his family time and again. This painting of Augustine Roulin had been started before Van Gogh's self-mutilation and on his return home he was eager to finish it before Roulin left. *La Berceuse*, the cradle rocker, was a symbolic subject for the artist, who was craving comfort and company. The maternal image of the wife and mother was to suggest consolation, and had been inspired both by the artist's own despair and by a novel about fishermen that Van Gogh and Gauguin had discussed before his departure. Moved by the thought of the loneliness and danger of the open sea Van Gogh created a painting that would be soothing and reassuring.

CREATED

Arles

MEDIUM

Oil on canvas

SERIES/PERIOD/MOVEMENT

Portraits

SIMILAR WORK

The Beautiful Angel (Madame Angele Satre, the Innkeeper at Pont-Aven) by Paul Gauguin, 1889

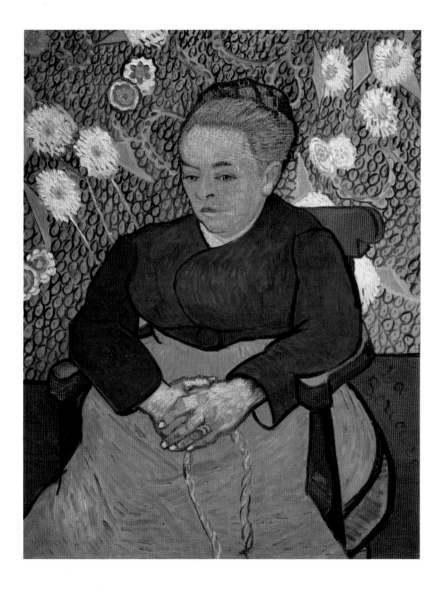

Dormitory at the Hospital in Arles, 1889

© akg-images

Unbearably lonely and unable to function, Van Gogh suffered another attack of mental anxiety and believed that people were trying to poison him. He returned to the hospital in early February and was discharged on 17 February. His release caused panic amongst the locals and a petition was put together requesting that the artist be returned to his family or to hospital. As a result the Police Commissioner escorted Van Gogh from the 'Yellow House', padlocked the door and took him back to the hospital. Later Van Gogh wrote to Theo of his regret at leaving his studio without putting up a fight. During this period Theo was planning on marrying Johanna Bonger, an event that undoubtedly compounded Van Gogh's feelings of desolation. At Theo's insistence, at the end of March Signac paid Van Gogh a visit and took him back to the 'Yellow House' where he broke down the door enabling Van Gogh to remove some of his belongings. He started this painting in April, by which time he was allowed to go for walks on his own, though he still lodged at the hospital.

CREATED

Arles

MEDIUM

Oil on canvas

SERIES/PERIOD/MOVEMENT

Hospital at Arles

SIMILAR WORK

Interior of the Concert Rouge by Henri Laurent Mouren

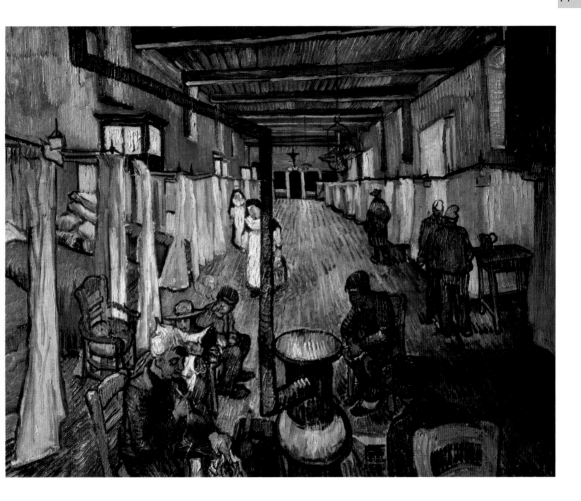

The Asylum Garden at Arles, 1889

By the end of March 1889 Van Gogh had reconciled himself to the fact that he was unable to live alone, and through correspondence with his sister Wilhelmina and Theo it is clear that he had a partial understanding of his condition. At the very least he was aware of his inabilities and tendencies towards self-harm, writing to his sister Wilhelmina, 'Everyday I am taking the remedy that the incomparable Dickens prescribes against suicide. It consists of a glass of wine, a piece of bread, some cheese, and a pipe of tobacco.'

He continued to paint through March and April, producing several pictures of the hospital and its garden. Here his palette has once again brightened, and the garden radiates with Oriental delicacy. The scene is one of enclosure, the garden surrounded by the walls of the hospital, but rather than seeming oppressive the walled oasis appears comforting. The high viewpoint looking down into the square suggests the artist painted the scene perhaps from his bedroom on the first floor, and the inclusion of the many small people along the balcony at the rear of the painting reiterates that this is a place where the artist is not alone.

CREATED

Arles

MEDIUM

Oil on canvas

SERIES/PERIOD/MOVEMENT

Hospital at Arles

SIMILAR WORK

Sunflowers by Johann Barthold Jongkind

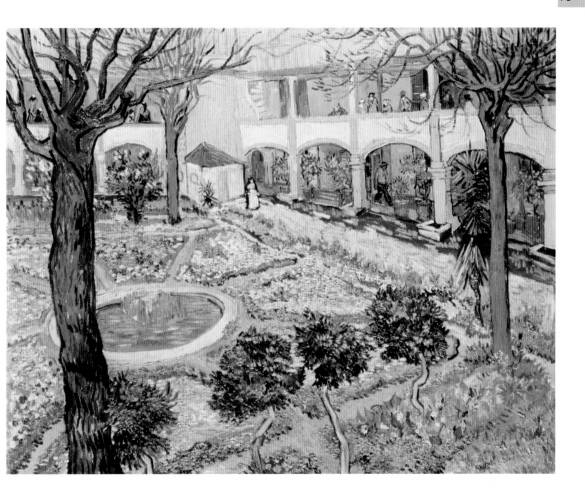

Portrait of the Postman Joseph Roulin, 1889

© Museum of Modern Art, New York, USA/The Bridgeman Art Library

Roulin the postman was some years older than Van Gogh and it would seem that the artist considered him something of a father figure, describing Roulin as having a particular fondness for the younger man. Roulin himself was a father, and his wife had given birth to a new baby daughter in the summer of 1888 prior to Van Gogh's first serious episode of mental illness. Certainly in Van Gogh's depictions of the postman there is an innate tenderness combined with a gravity and stateliness that relate to his position as an official state employee. Van Gogh described Roulin as being a reluctant subject and unable to relax, and the paintings he made of him capture his friend's unease. The head and shoulder composition here, which Van Gogh used frequently when painting Roulin, lend the work an almost iconic form. The simplicity of the figure itself is separate from the patterned background and yet also becomes part of it as the man's swirling beard repeats the foliage tendrils, and his cheeks take on the hue of the pink flowers behind.

CREATED

Arles

MEDIUM

Oil on canvas

SERIES/PERIOD/MOVEMENT

Portraits

SIMILAR WORK

Portrait of Père Tanguy by Émile Bernard, 1887

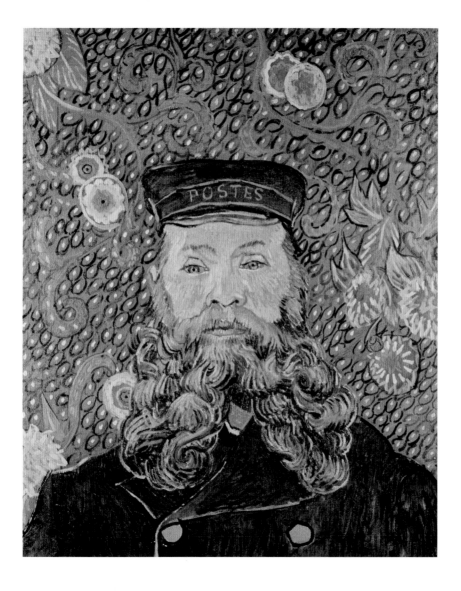

Irises, 1889

© akg-images

Van Gogh's friend Pastor Salles, who had rallied round the artist since his first breakdown, suggested that he have himself committed to the asylum in the nearby town of Saint-Rémy, a course of action that Van Gogh was in agreement with. One of the artist's greatest fears surrounding the move, however, was that he should be allowed to paint, so he could somehow contribute towards the 100 franc monthly rent that Theo would have to find. On 8 May accompanied by Pastor Salles, Van Gogh made the short trip to Saint-Rémy where he came under the care of the asylum's director, Dr Peyron. He was given a ground floor room and within the month was painting again, with *Irises*, being one of the first he finished. The vivid colours of the flowers had instantly captivated Van Gogh who depicted them as a densely packed profusion of colour nestling amongst a crowd of broad, green leaves atop a rich, earthy soil. The painting was exhibited at the 1889 Salon des Indépendants and sold for 300 francs to Octave Mirbeau (1848–1917) in 1892.

CREATED

Saint-Rémy

MEDIUM

Oil on canvas

SERIES/PERIOD/MOVEMENT

Flowers

SIMILAR WORK

The Poppy Field by Pál Szinyei Merse, 1896

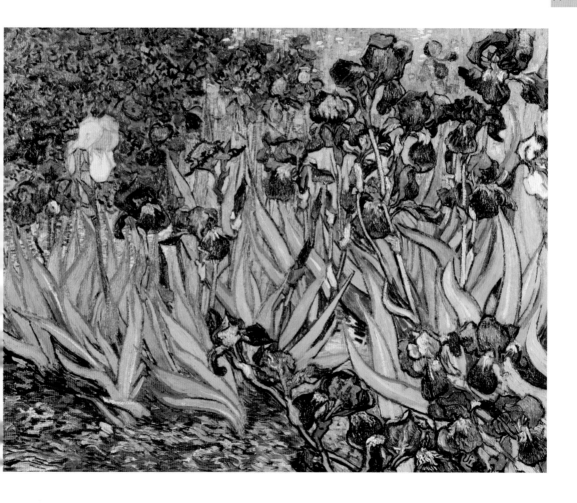

Green Wheat Field with Cypress Tree, 1889

© akg-images

Dr Peyron who ran the asylum in Saint-Rémy wrote in his notes on Van Gogh's arrival that he was suffering from acute mania, hallucinogenic episodes and epileptic fits at irregular intervals. Theories have since been put forward that he was schizophrenic, though this can not be proved, and it has been agreed that he may well have been epileptic, especially in light of the fact that there was a history of epilepsy in his family. Despite the doctor's diagnosis, it seems that Van Gogh received little to no actual treatment, and the artist later complained that nothing was done, that the food was poor and the patients ignored. He was allowed to paint in the hospital's garden, and by June was able to leave the hospital, accompanied by an attendant (Jean-François Poulet) to paint in the surrounding fields. He was particularly taken with the local cypress trees, which he painted several times. This picture reflects his increasingly free brushstrokes that create a rhythmic sense of languid horizontal movement that is counterbalanced through the strong vertical lines of the tree and wheat shafts in the foreground.

CREATED

Saint-Rémy

MEDIUM

Oil on canvas

SERIES/PERIOD/MOVEMENT

Landscapes

SIMILAR WORK

Olive Trees by Henri Matisse

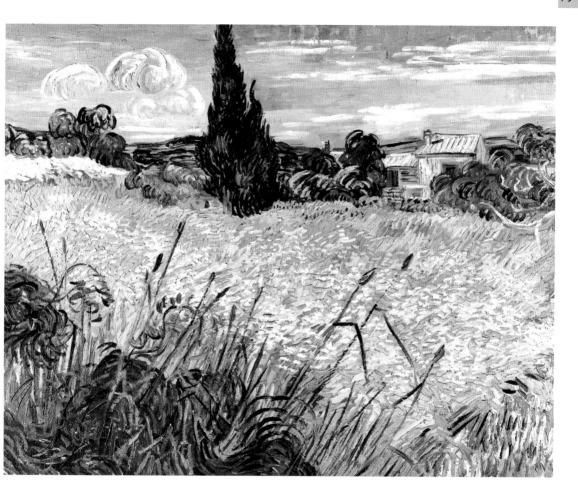

Starry Night, 1889

© akg-images

During Van Gogh's attacks he would become violent towards others, and also towards himself, trying to swallow his poisonous paints and commit other acts of self-harm. He was besieged with increasingly disturbing hallucinations and dreams often of a warped religious nature that might have been compounded by the austere religious atmosphere of the asylum. Once the attacks had passed he could recall little about them, and interestingly wrote to Theo that he had started to take some comfort from the fact that those around him also suffered the same strange effects during their own fits.

Starry Night has an almost visionary aspect, with the dominant cypress tree in the foreground appearing like a church steeple mirroring the smaller steeple behind. His brushstrokes had become even more fluid, creating a strong rolling effect through the star peppered sky. It is an image that is haunting, and full of unexplained but turbulent emotion. The intensity of the painting reflected Van Gogh's extraordinarily troubled mind, yet it is not a picture of despair, but rather suggests a rush of torrential feeling with no defined direction, much like the artist himself.

CREATED

Saint-Rémy

MEDIUM

Oil on canvas

SERIES/PERIOD/MOVEMENT

Landscapes

SIMILAR WORK

The Dream by Odilon Redon, 1904

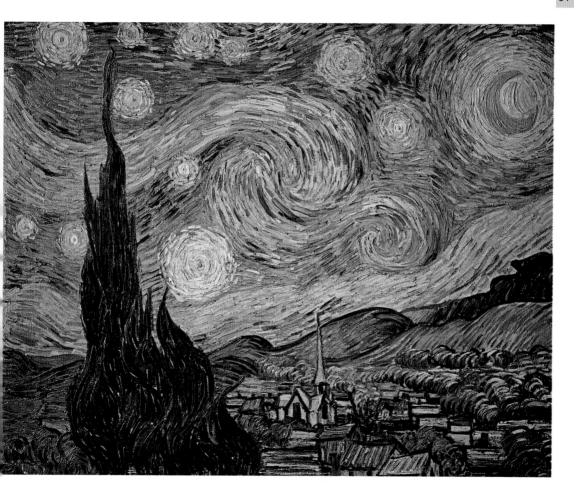

Portrait of Trabuc, 1889

© akg-images

In early July 1889, Van Gogh, accompanied by an attendant, was allowed to make a trip back to Arles to retrieve some canvases he had left there. At around the same time he heard from Theo that his wife Jo was expecting a baby, and shortly afterwards he suffered his first major attack since moving to Saint-Rémy. The episode left him profoundly depressed for some time, he began to fear the other patients and isolated himself, and he was unable to paint for almost six weeks. Though he kept in touch with the art scene through Theo, Van Gogh felt desperately removed from it and missed the company of fellow artists. He had little rapport with Dr Peyron or the attendants and guards at the hospital, and had no one with whom he could discuss his art.

This stiff painting of the head guard Trabuc lacks all the affection of his earlier portrait of Dr Rey from the hospital at Arles. Van Gogh was friendlier with Trabuc than the other guards at Saint-Rémy, and also painted a portrait of his wife.

CREATED

Saint-Rémy

MEDIUM

Oil on canvas

SERIES/PERIOD/MOVEMENT

Portraits

SIMILAR WORK

Self Portrait by Jan Toorop, 1915

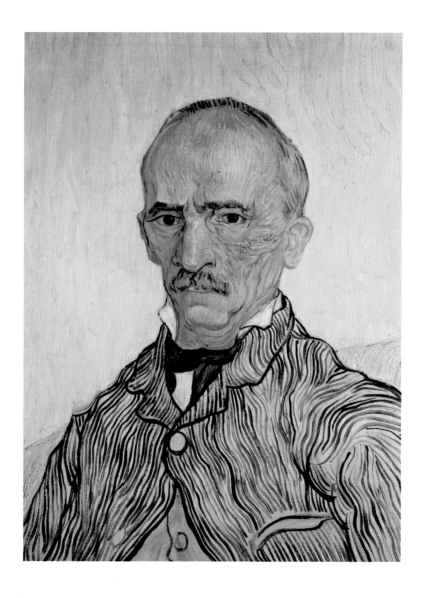

Portrait of Madame Trabuc, 1889

© akg-images

On Van Gogh's arrival at the Saint-Rémy asylum he concentrated on painting nature, flowers in the hospital garden and the trees and fields of the area immediately surrounding it. When he was able to resume painting following his severe breakdown in July 1889, he turned back to portraits and self portraits, painting amongst others a picture of the head guard at the hospital and the guard's wife, Madame Trabuc. The picture is austere with a conscious control of line and colour that is relieved only by the small, pale-pink posy pinned to her dress. The sallow quality of Madame Trabuc's skin is carried on into the background, a technique that he frequently employed in his portraits where the sitter and the background become essentially linked through either colour or pattern. Her hooded eyes and pursed mouth lends her a querulous air that makes one wonder how well she received the painting. Of all the employees at the hospital, however, Van Gogh was most friendly with Trabuc, though the guard later commented that he had never seen the artist laugh or smile during his year-long stay.

CREATED

Saint-Rémy

MEDIUM

Oil on canvas on wood

SERIES/PERIOD/MOVEMENT

Portraits

SIMILAR WORK

Arrangement in Grey, Portrait of the Painter by James Abbott McNeill Whistler, c. 1872

Self Portrait, 1889

By September 1889 Van Gogh was desperate to leave the Saint-Rémy asylum, and wrote to Theo explaining that he wanted to move back north to be near his old friends and the countryside. He was no more stable than when he had entered the asylum, and indeed could be considered to have deteriorated, his mental state swinging between bouts of insanity and lucidity. He had no clear idea where or how he could live in the north, though he felt he would like to stay with Pissarro with whom both Van Gogh and Theo were close. Though Pissarro was not against the idea, his wife was, and he suggested that Van Gogh went to see Dr Gachet, a friend of the Impressionist painters, who could minister to him in the town of Auvers-sur-Oise.

Van Gogh made several self portraits at this time, including this, which he believed showed him as 'calm' though 'vague'. There is of course little that is calm about this image, it is the face of a man beset with angst and overflowing with uncontrollable intense emotion.

CREATED

Saint-Rémy

MEDIUM

Oil on canvas

SERIES/PERIOD/MOVEMENT

Self Portraits

SIMILAR WORK

Self Portrait by Lorenzo Viani

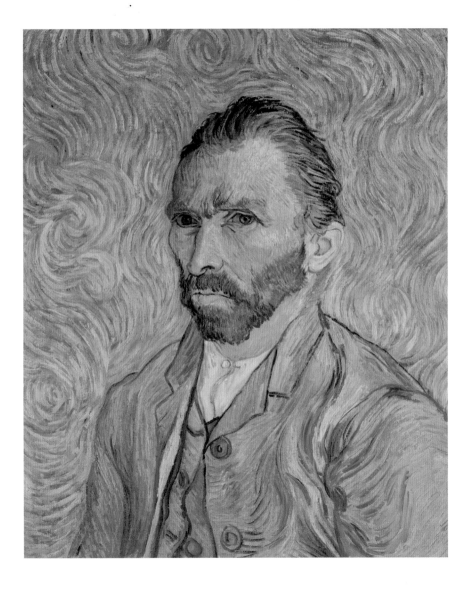

Branches of an Almond Tree in Blossom, 1890

© TopFoto

During the autumn of 1889 and into the beginning of 1890 Van Gogh made a series of studies after paintings by Jean-François Millet (1814–75), whom he greatly admired, and also copied works by Eugène Delacroix (1798–1863), Rembrandt and Honoré Daumier (1808–79) as well as starting to paint second versions of many of his own paintings. In part this activity was due to a lack of things for the artist to paint, the poor winter weather restricted his landscape painting and there were few models that he sought in the hospital. He suffered another attack in December, though recovered after a week, and then had another at the end of January 1890. On 31 January Jo, Van Gogh's sister-in-law, gave birth to a baby boy who was named Vincent after his uncle. After Van Gogh had recovered from his attack he painted *Branches of an Almond Tree in Blossom* to mark the birth of the new baby. The delicate palette and pattern of blossom against a clear blue sky signified the optimism Van Gogh felt surrounding the birth, and he later wrote to Theo that he had painted it with the greatest of patience and care.

CREATED

Saint-Rémy

MEDIUM

Oil on canvas

SERIES/PERIOD/MOVEMENT

Flowers and blossoms

SIMILAR WORK

Branch of a Flowering Apple Tree by Ando or Utagawa Hiroshige

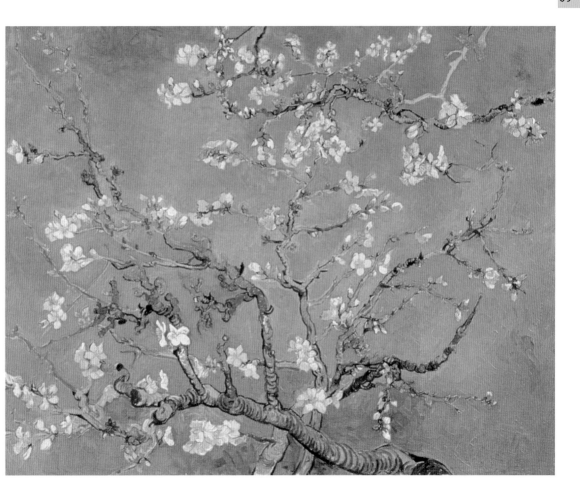

The Church in Auvers-sur-Oise, 1890

© akg-images

In February 1890 Van Gogh's *Red Vineyard* sold to the painter Anna Boch (1848–1936) for 400 francs – it was the first painting he had sold. At the end of the month he travelled, rather surprisingly, alone to Arles for two days, and suddenly suffered another serious attack, swallowing some of his poisonous paints and becoming dangerously ill. It seems the excitement of events, and a recent review of his work by the art critic Albert Aurier had triggered the episode. With the spring Van Gogh recovered and with the news of his imminent departure from Saint-Rémy he embarked on a series of colourful and positive paintings of flowers. He left the asylum on 16 May and travelled to Paris where he met Theo, Jo and the baby Vincent. Three days later he arrived in Auvers and rented a room in the Ravoux house not far from Dr Gachet who Theo had arranged to keep an eye on his brother. The church that Van Gogh painted soon after his arrival dominated the local scenery, just as it dominated his canvas, hunkering on a small rise above the town.

CREATED

Auvers-sur-Oise

MEDIUM

Oil on canvas

SERIES/PERIOD/MOVEMENT

Last works

SIMILAR WORK

La Chapelle Sainte-Anne by Henri Matisse, 1904

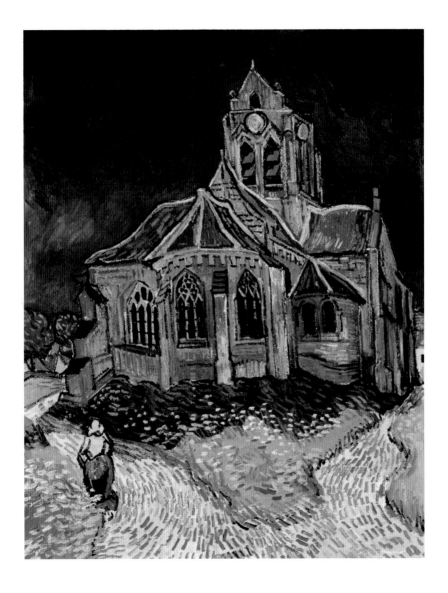

Dr Paul Gachet, 1890

After his arrival in Auvers Van Gogh embarked on another frenetic bout of painting, which would be his last. He painted rapidly, sometimes at a rate of one canvas a day, and the speed and intense sense of urgency with which he approached his works manifested itself as a latent emotional vibrancy that pervades these last paintings. He warmed to Dr Gachet (perhaps in the absence of other familiars), but it would appear that the doctor offered no real help to the disturbed young man. Van Gogh wrote that he liked Gachet, but rather amusingly, spoke of the doctor's own nervous problems and equated them in seriousness to his own. Van Gogh began work on this portrait of Gachet two weeks after meeting him, and on completion began another very similar version, encouraged by the doctor's enthusiasm for the paintings. There is a languid, worldly air to Gachet who appears somewhat melancholy in the painting. Van Gogh later wrote that the expression was 'sad ... yet clear and intelligent ...', and that he felt that was how some portraits ought to be.

CREATED

Auvers-sur-Oise

MEDIUM

Oil on canvas

SERIES/PERIOD/MOVEMENT

Portraits, last works

SIMILAR WORK

Boy with a Skull by Paul Cézanne, 1896–98

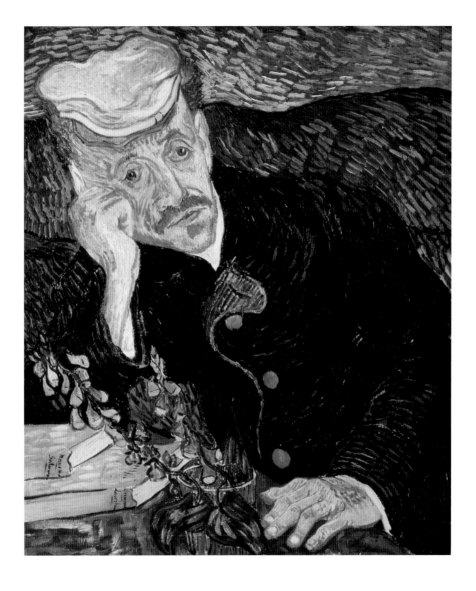

Madame Gachet in her Garden, 1890

© akg-images

Dr Gachet had had a long association with a number of painters, and had looked after Daumier in his last days. He was also a keen amateur artist, and this shared appreciation and knowledge of the arts finally gave Van Gogh a companion to whom he could talk and reason. Gachet was well known and popular around the town of Auvers, though it seems he was not able to persuade many of the locals to pose for Van Gogh. Gachet's wife proved more willing, as did his daughter who Van Gogh painted several times. This picture of Gachet's wife in her garden has a curious detachment. The figure in the garden is a symbol of a person, a suggestion rather than a character. His treatment of the foliage too was sparse with minimal use of line to suggest organic forms rather than actual plants. The canvas as a whole is an interesting disjointed statement. Van Gogh's characteristic trees pin down the background while the remaining components of the composition float somewhere between reality and suggestion. It is perhaps one of the clearest instances of the artist's unravelling personality.

CREATED

Auvers-sur-Oise

MEDIUM

Oil on canvas

SERIES/PERIOD/MOVEMENT

Last works

SIMILAR WORK

La Riviere by Raoul Dufy

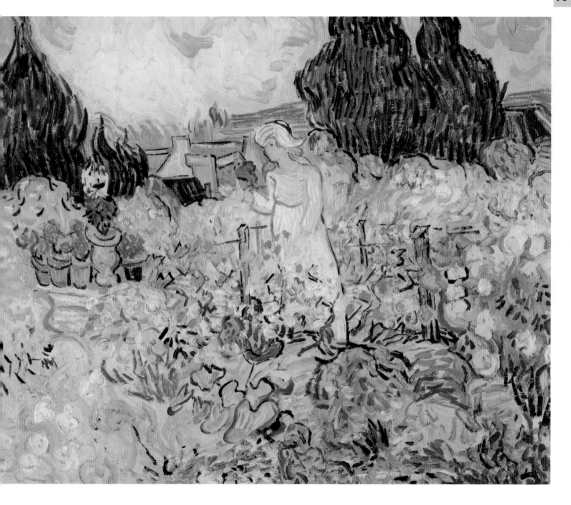

Child with an Orange, 1890

At the beginning of June Theo, Jo and the baby Vincent visited Van Gogh at the invitation of Dr Gachet. Van Gogh was delighted to see his family, and Theo promised to return soon. Later that month Van Gogh heard from his friend Gauguin who talked of his plans to establish an artists' studio in Madagascar. Van Gogh wrote back suggesting that he visit Gauguin in Brittany before he left for the tropics, but it seems that Gauguin was reluctant to welcome his friend. Van Gogh continued to paint almost ceaselessly, employing increasingly strident brushstrokes with his works showing the effects of his fragmented mind. This painting has an unsettling effect; the child, primitively drawn, appears to be directly below the feet of where the artist must have stood, with his viewpoint looking down on to her and the field of flowers. Her rosy cheeks matching the orange she clutches, rather than endearing, are alarming, glowing with a feverish tint. The lack of horizon and figure crowded in the foreground is claustrophobic and stifling, while the orange has been reduced to a flat disc-like orb.

CREATED

Auvers-sur-Oise

MEDIUM

Oil on canvas

SERIES/PERIOD/MOVEMENT

Last works

SIMILAR WORK

Girl's Head on the Beach by Edvard Munch, 1899

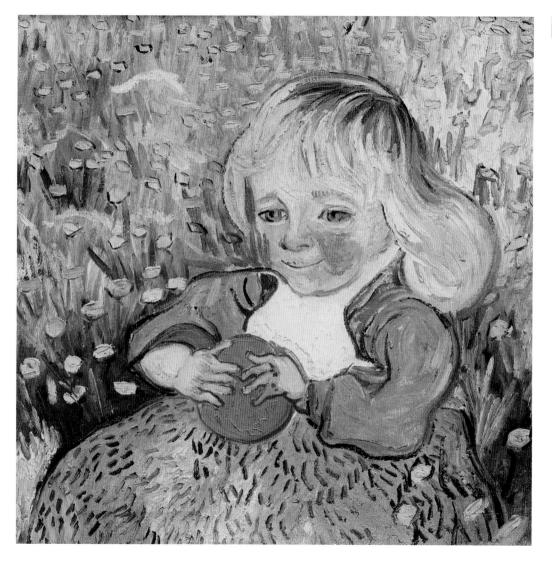

Wheat Field with Crows, 1890

In early July Van Gogh travelled to Paris, alone, to stay with Theo and Jo. Theo was in poor health and was having financial problems, which was an enormous worry to Van Gogh who was keenly aware of the burden he was on his brother and his family. In addition the baby was ill and Jo too was suffering from exhaustion. Van Gogh returned quickly to Auvers but rapidly became severely depressed, and had a terrible row with Dr Gachet. On 27 July Van Gogh started a letter to Theo that was never finished. Halfway through writing it he walked out to the fields behind the town and shot himself before staggering back to his room where he was discovered. Dr Gachet sent for Theo, who arrived, and on 29 July Van Gogh died in his brother's arms. Tragically within six months of his brother's death Theo, too, had been stricken with mental illness and died – the two brothers were later buried side-by-side at Auvers-sur-Oise.

Van Gogh described this painting as a reflection of his 'great sadness' and 'extreme solitude'.

CREATED

Auvers-sur-Oise

MEDIUM

Oil on canvas

SERIES/PERIOD/MOVEMENT

Last works

SIMILAR WORK

Despair by Edvard Munch, 1893–94

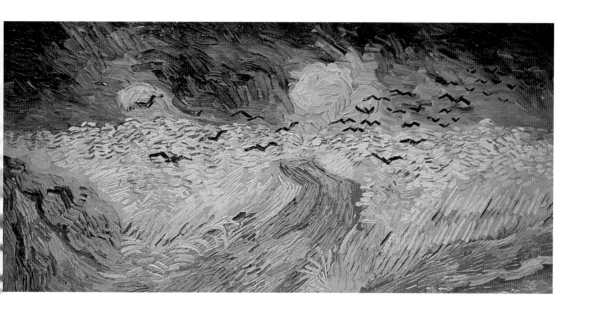

Van Gogh

Society

Miners' Wives Carrying Sacks of Coal, 1882

The nineteenth century was a period of enormous change, in great part sparked by the Industrial Revolution that affected technological advances, the socio-economic climate throughout Europe and cultural stabilities. When Van Gogh moved to The Hague in 1882 the city was experiencing massive growth in industry, and the population had increased dramatically as peasants and labourers from the surrounding countryside were drawn to the town with hopes of improved wages. Two of the most prevalent industries were mining and textiles, both of which provided Van Gogh with subject matter for his paintings. The artist felt a deep sympathy and connection with the people who struggled daily in their manual jobs, and saw them as honest in their labours. The women here who struggle under their heavy sacks have no identity, and Van Gogh has turned them into symbols of their class. The sacks and the figures are almost indistinguishable from each other, and with the procession of women disappearing away into the distance there is a tangible sense of infinity with no chance of change for their lives.

CREATED

The Hague

MEDIUM

Watercolour on paper

SERIES/PERIOD/MOVEMENT

Peasants and labourers

SIMILAR WORK

Winter, The Faggot Gatherers by Jean-François Millet, 1868–75

Vincent Van Gogh *Born* 1853 Groot-Zundert, The Netherlands

Died 1890

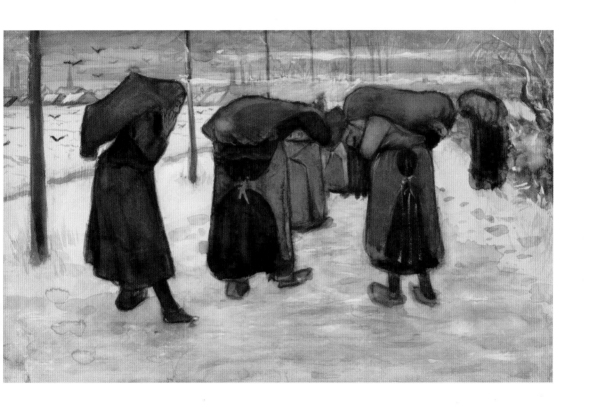

The Prayer, 1882

The population of The Hague grew from 45,000 to 200,000 people over the course of the nineteenth century, and by the time Van Gogh had moved there the city had developed beyond its original defence canals. There was a distinct class division, the middle classes had grown and were becoming wealthier while the lower classes were crammed together in primitive living conditions. Labourers and peasants were drawn to the city in search of better wages, and although their wages may have improved, their living conditions for the most part had not. Van Gogh, who was from a bourgeois family, found himself increasingly critical of the background in which he had been raised. He wanted to draw and paint those who worked long and hard for their living in such a way that people would recognize and respect their labour. This drawing of an old man praying before eating his meagre supper is particularly poignant. Van Gogh used the same model for several drawings, and though the artist was attracted to these subjects at this time, realistically these were the only people who he could afford to pay to model for him.

CREATED

The Hague

MEDIUM

Pencil, charcoal and ink heightened with white gouache on paper

SERIES/PERIOD/MOVEMENT

Peasants and labourers

SIMILAR WORK

Sunday at the Chelsea Hospital by Hubert von Herkomer, 1871

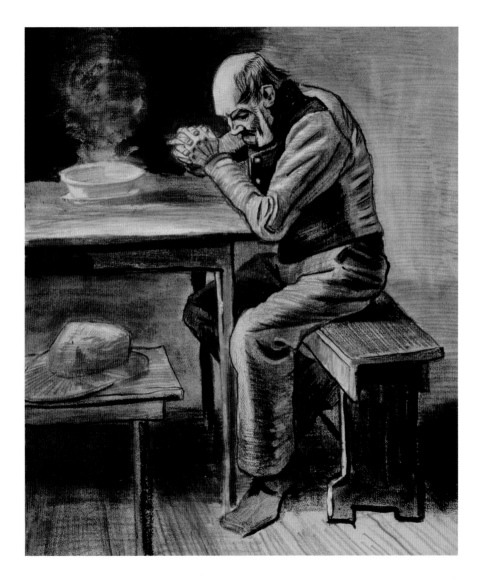

The State Lottery, 1882

Van Gogh's cousin the artist Anton Mauve (1838–88) had given Van Gogh some drawing lessons before his move to The Hague. Later when Van Gogh arrived in the city he again took up with Mauve, who initially helped him to find a studio. It was not long, however, before Van Gogh became involved with a local prostitute called Clasina Maria Hoornik (Sien), who was pregnant and already had a small child. The artist moved her and her family in with him and established some semblance of a domestic life. However, Van Gogh's family were appalled by the relationship, Mauve ceased to help him and he found himself ousted by members of the local community of artists. It was an relationship doomed to fail, and fraught with class issues for the artist, who struggled with the elitist attitudes of his contemporary cultural counterparts.

What is particularly evident in this painting is the suggestion that the group of huddled people milling around the lottery office could have spent their last pennies in a vain hope of winning. The figures are bowed and shuffling, and rather than a scene of expectant excitement, it is one of despondency.

CREATED

The Hague

MEDIUM

Watercolour on paper

SERIES/PERIOD/MOVEMENT

Peasants and labourers

SIMILAR WORK

A Soup Kitchen During the Siege of Paris by Henri Pille, after 1870

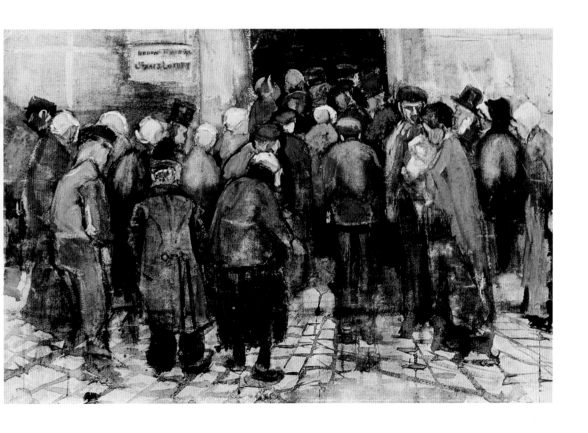

In the Moor, 1883

On the advice of his friend Anton von Rappard (1858–92), in September 1883 Van Gogh moved to Drenthe, a rural, sparsely populated area whose main industry was agriculture. The artist needed to reduce his expenditure, and the cost of living in The Hague was too great, especially since his works were not selling and he was financially reliant on his brother Theo. The small farming community of Drenthe were unwilling to welcome the eccentric artist in to their community, and he stayed there only three months before moving to Nuenen. While in Drenthe Van Gogh painted the wide-open and bleak landscape, often including labourers. Paralleling the distance he felt between the locals and himself, the figures in his paintings appear impersonal, becoming images of the concept of 'work', rather than individuals. The landscapes he made here with their low horizons and expanse of sky were essentially Dutch in feel, though he was also a great admirer of the French painters Jean-François Millet (1814–75) and Charles-François Daubigny (1817–78), and their influence can be clearly felt. This painting in particular is reminiscent of Millet, with the peasants adopting a monolithic solidity against the open sky.

CREATED

Drenthe

MEDIUM

Oil on canvas

SERIES/PERIOD/MOVEMENT

Peasants and labourers

SIMILAR WORK

The Gleaners by Jean-François Millet, 1857

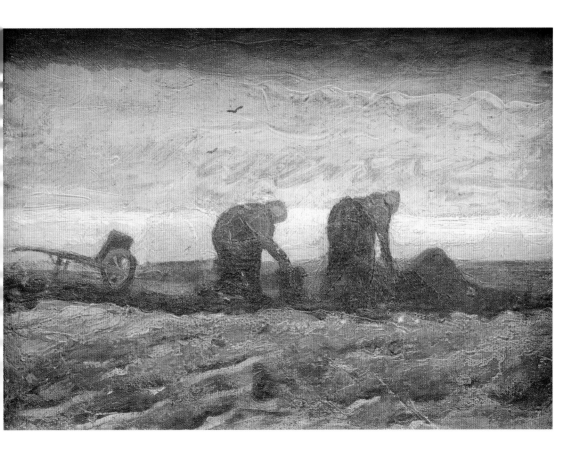

Weaver, The Whole Loom Facing Right, 1884

Weaving had for centuries been an important cottage industry in Nuenen and was still an important local industry at the time Van Gogh moved there. This was not true of everywhere, though, and with advances in technology, cottage industries such as weaving were being transferred to the cities and to factories, resulting in the decrease of employment for weavers in the rural community. There was therefore a nostalgia attached to the 'rural weaver' whose long tradition was beginning to die out. When Van Gogh moved to Nuenen in December 1883 he almost immediately started to concentrate on depictions of the local weavers at work, and though he also painted other subjects, this period was dominated by his images of men and women weaving. Unlike the distant treatment of his figures during his time in Drenthe, while in Nuenen he approached his figure studies with great detail and in close focus, and later worked on a series of peasant heads and hands. Interestingly his pictures of weavers at work, such as this, show the weaver as diminutive against the huge looms, dwarfed and almost obscured behind the great structures.

CREATED

Nuenen

MEDIUM

Oil on canvas

SERIES/PERIOD/MOVEMENT

Weavers

SIMILAR WORK

Weaver Workshop by Max Liebermann, 1882

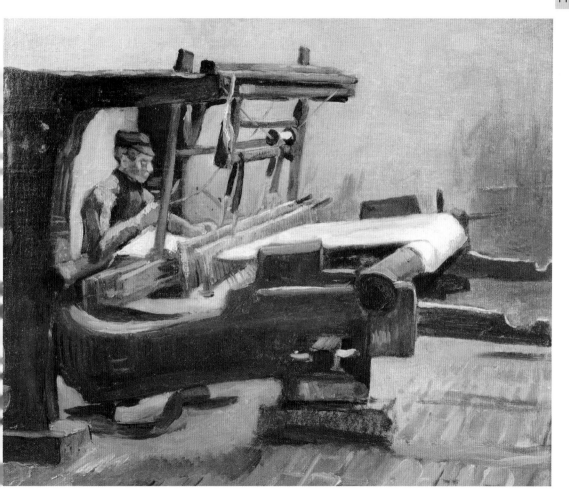

The Potato Eaters, 1885

© akg-images

This painting can be considered one of Van Gogh's early masterpieces, and was certainly a work that the painter himself was pleased with. In this respect it was one of the first paintings that he truly felt confident about, and when his friend Rappard criticized a lithograph of it, it led to the disintegration of their relationship. Van Gogh wanted to show the essence of peasant life, writing to his brother Theo, 'I have tried to emphasize that these people, eating their potatoes in the lamplight, have dug the earth with those same hands they put in the dish, and so it speaks of manual labour and of how they have honestly earned their food.' Rather than painting from life, as was his practice, he created the composition through individual studies of peasants. The figures are unerringly ugly, becoming almost like caricatures in the artist's effort to establish the very nature of the peasant, with whom he wanted to identify. There is the sense, though, that he has not captured the peasant, but in his efforts to do so instead created a parody of their life.

CREATED

Nuenen

MEDIUM

Oil on canvas

SERIES/PERIOD/MOVEMENT

Peasants and labourers

SIMILAR WORK

Lunch at a Farm in Karlshaven near Delden by Isaac Israëls, 1885

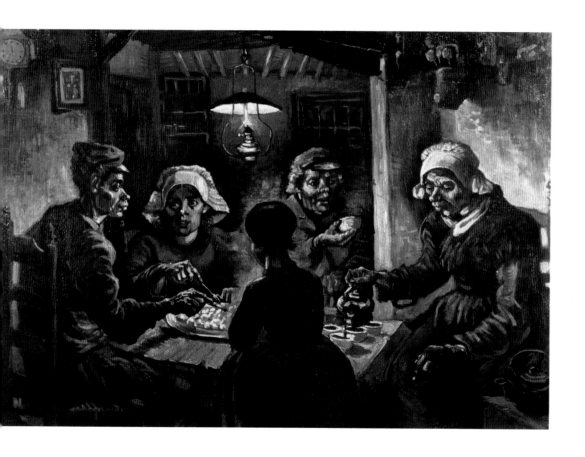

Le Moulin de Blute-Fin, Montmartre, 1886

Van Gogh arrived in Paris in 1886 to find a city rapidly evolving. The Industrial Revolution had led to a surge in commerce with manufacturing businesses taking off. There was great demand within the workforce for unskilled manual workers and for the white-collared skilled workers who were becoming a part of the swelling middle classes. Both the middle and the working classes were going through a period of intense expansion, and alongside this growth in numbers, there was a widening gap between the wealthy and the poor. Paris was expanding, and Montmartre, which was at one time a small hill village, had become a suburb of the city. Montmartre was a centre of artistic activity, and it was here that Van Gogh moved to with his brother Theo. Originally the area had 13 windmills, but by the time Van Gogh had arrived none of them were functional. Le Moulin de Blute-Fin and Le Radet are the only two to remain, and together form Le Moulin de la Galette, which was turned into a fashionable ballroom and cabaret in 1870.

CREATED

Paris

MEDIUM

Oil on canvas

SERIES/PERIOD/MOVEMENT

Parisian works

SIMILAR WORKS

La Moulin de la Galette by Pierre-Auguste Renoir, 1876

View of Montmartre by Paul Signac, 1884

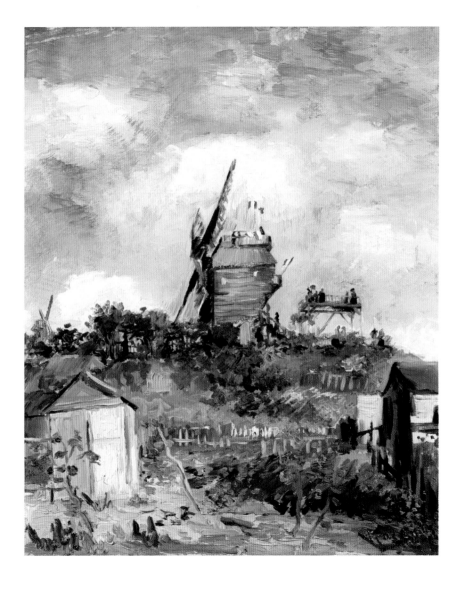

Le Moulin de la Galette, 1886

The year Van Gogh arrived in Paris, 1886, was also the last of the eight Impressionist exhibitions that were first staged in 1874. The unorthodoxy of the contributing artists and their radical approach to painting had opened the door for a whole new generation of innovative artists, and paved the way for the emergence of modern art. Van Gogh arrived as the Impressionist artists were reaching the height of their mature style, and other painters such as Paul Signac (1863–1935), Georges Seurat (1859–91), Odilon Redon (1840–1916) and Paul Gauguin (1848–1903) were investing a new and astonishing originality in their work. It was an atmosphere of intense artistic stimulation, and on arriving in the big city Van Gogh declared, 'The air of France is clarifying my ideas and is doing me good, a lot of good, all the good in the world.'

His studio in Montmartre was on the rue Lepic, the same road as the windmill Le Radet, which formed part of the nightclub Le Moulin de la Galette. It was an area that he painted frequently, and was the subject of many of his contemporaries' paintings.

CREATED

Paris

MEDIUM

Oil on canvas

SERIES/PERIOD/MOVEMENT

Parisian works

SIMILAR WORKS

The Moulin de la Galette, Montmartre by Antoine Vollon, 1861

At the Moulin de la Galette by Henri de Toulouse-Lautrec, 1899

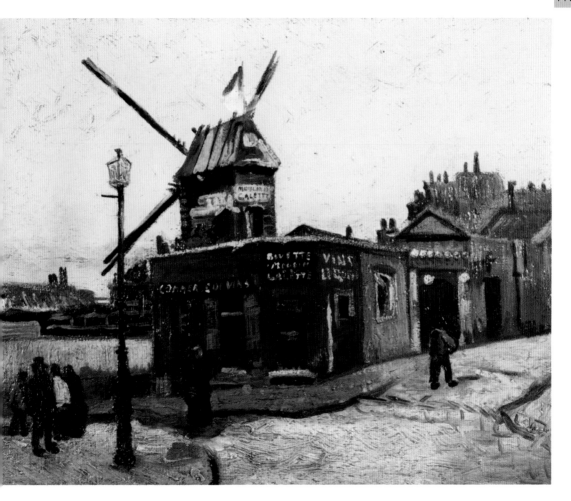

Quarry at Montmartre, 1886

© akg-images

The nineteenth century in Paris was an era of tremendous change that saw the rise of the Industrial Revolution, the rise and fall of the French Second Empire and the golden age, the 'Belle Epoque' that was crushed with the outbreak of the First World War. It was a century that saw one of the most dramatic changes in the cultural, social and economic balance, and though the end of this period was called the Belle Epoque, and did see a great flourishing in the arts, it was also marked by great unrest between the working and middle classes, with the gap widening between the Left and Right and the organization of socialist movements and militant groups.

Before Montmartre was enveloped by Paris it was an area of vineyards and gypsum quarries, with gypsum being used to produce plaster of Paris. In this painting Van Gogh has depicted an old quarry, and with the windmill punctuating the skyline and the sombre palette, it is an image strongly reminiscent of his Dutch heritage. He favoured paintings of windmills at this time, though when he had lived in the Netherlands they were not a motif he often referred to.

CREATED

Paris

MEDIUM

Oil on canvas

SERIES/PERIOD/MOVEMENT

Parisian works

SIMILAR WORK

Montmartre by Alfred Sisley, 1869

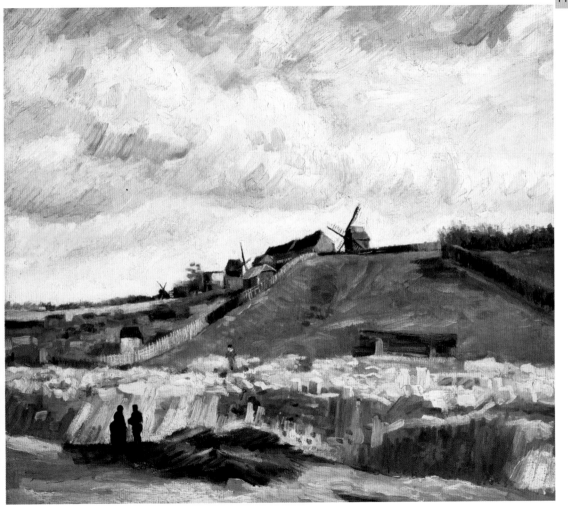

Pleasure Gardens at Montmartre, 1886

This was a time that saw an expansion of the middle classes, with this faction of people receiving higher wages and having more leisure time. This in turn stimulated the 'leisure industry', and there was a great increase in the amount of cafés, bars, restaurants, nightclubs, cabarets and theatre. Also, the improvement of transport enabled people to travel more cheaply and more easily, which in turn created the 'leisure resort'. Not only did this facilitate travel to the city, but also more importantly it allowed those with money to leave Paris for day trips and short holidays. The area of Montmartre had earned a bohemian and rather risqué reputation based on the pulsating nightlife, clubs and prostitutes that frequented the area, and had cultivated an active café scene. During the day the Montmartre pleasure gardens of Van Gogh's painting were a popular and fashionable meeting place, but by night the area adopted a mantle of lascivious entertainment. It was a poorer district, home to artists who frequently painted its streets, clubs and artisans, and it became the haunt of thrill-seekers.

CREATED

Paris

MEDIUM

Oil on canvas

SERIES/PERIOD/MOVEMENT

Parisian works

SIMILAR WORK

Women on a Café Terrace by Edgar Degas, 1877

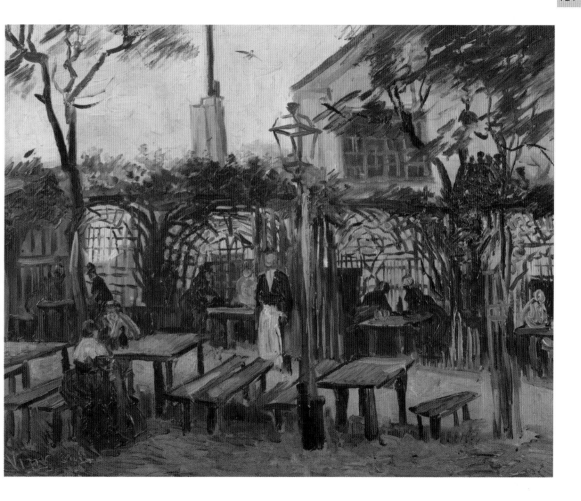

Reclining Nude, 1887

The cultural and artistic climate of Paris at this time was diverging in two distinct directions. There was a hotbed of developing artistic trends, with innovative ideas and techniques and progressive attitudes towards the arts, poetry, philosophy, literature and music. There also prevailed a mainstream conformity, a resistance to change and a stifling conventionality was present, especially in relation to the arts. Theo Van Gogh, Vincent's younger brother, worked as an art dealer for Boussod & Valadon, the successors of Goupil et Cie, who Vincent had worked for as a young man. Theo was not at this time allowed to display any paintings by the Impressionists or their counterparts on the main floor of the gallery, but had a separate room upstairs where he could hang their work. It was through Theo that Van Gogh became acquainted with a number of artists including Edgar Degas (1834–1917), Camille Pissarro (1830–1903) and Claude Monet (1840–1926), and also through the shop of Père Tanguy who sold artists' materials. This painting of a nude, which was a subject he explored during his second year in Paris, reflects his style evolving through his increasing awareness of influences around him.

CREATED

Paris

MEDIUM

Oil on canvas

SERIES/PERIOD/MOVEMENT

Parisian works

SIMILAR WORK

Bed-Time by Edgar Degas, 1883

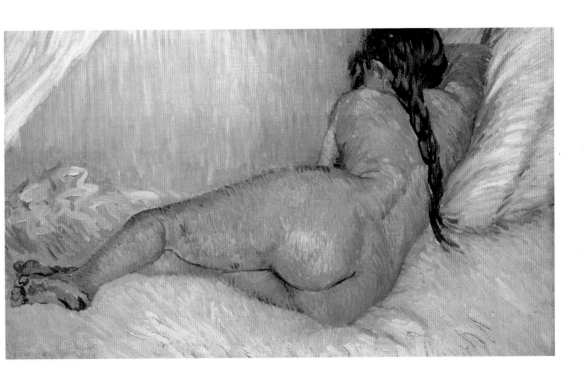

Woman in the Café Tambourin, 1887

Due to the reluctance of larger galleries to hang paintings by the avant-garde artists of the time, many artists resorted to persuading cafés and clubs to hang their works, or to staging their own exhibitions. Van Gogh hung a number of his works alongside paintings by Henri de Toulouse-Lautrec (1864–1901), Émile Bernard (1868–1941) and Louis Anquetin (1861–1932) at La Tambourin, a café owned by an exotic Italian woman, Agostina Segatori. La Segatori was an former artists' model, having modelled for Degas, and was according to Bernard, having an affair with Van Gogh. Certainly they had a professional relationship, and correspondence between Theo and Van Gogh would also seem to indicate a personal one. She is believed to be the model in this painting and in his *Portrait of an Italian Woman*, painted the same year. Van Gogh later fell out with La Segatori and is reputed to have removed all his paintings from the café, wheeling them away in a handcart. His interest and absorption of Japanese art is evident in this painting, and at around the same time as painting this, he organized an exhibition of Japanese prints to hang at the café.

CREATED

Paris

MEDIUM

Oil on canvas

SERIES/PERIOD/MOVEMENT

Parisian works

SIMILAR WORK

The Hangover (Suzanne Valadon) by Henri de Toulouse-Lautrec, 1887–89

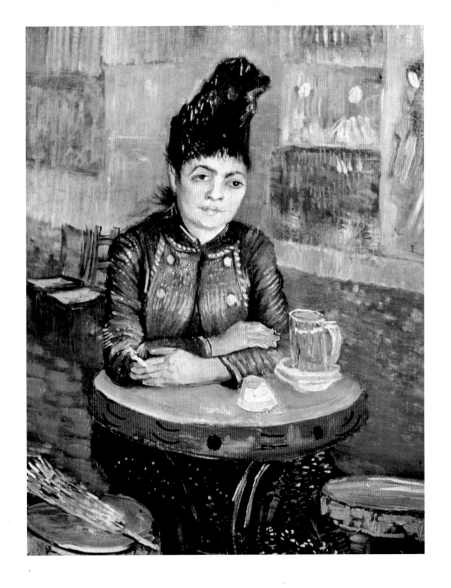

Factories in Asnières, 1887

As industry in Paris increased, factories were built in the surrounding areas, and Asnières situated to the west of Paris on the River Seine gradually evolved into an industrial suburb of the city. Though it was home to the factories painted by Van Gogh, the area was also a fashionable place for the inhabitants of Paris to go to on day trips. Situated along the Seine it was a popular place for promenading and bathing, and had been famously documented by Seurat in 1883–84 with his *Bathers at Asnières*. This painting was (inevitably) refused by the Salon in 1884, but was shown at the first exhibition of the Indépendents the same year and came to the attention of the young Signac, with whom Van Gogh had become friendly. The two artists made trips to Asnières together, painting side-by-side, and Signac's influence can be clearly felt in Van Gogh's canvases painted at this time. Van Gogh also made painting excursions to Asnières with his friend Bernard, who had taken a violent dislike to Signac and opposed his scientific approach to colour theories.

CREATED

Paris

MEDIUM

Oil on canvas

SERIES/PERIOD/MOVEMENT

Parisian works

SIMILAR WORKS

The Seine, Grenelle by Paul Signac, 1899

The Bridge at Asnières by Paul Signac, 1888

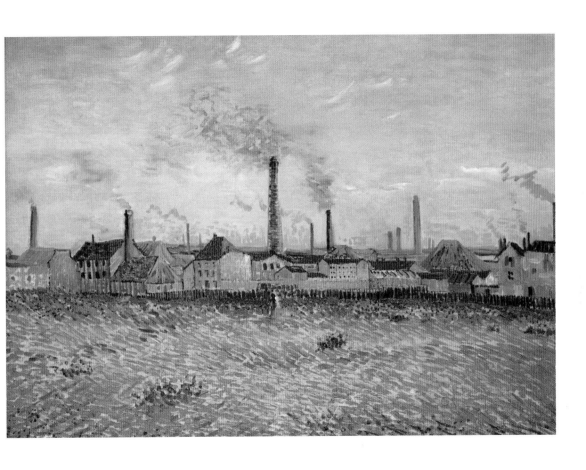

Pont de l'Anglois, 1888

© akg-images

After two years in Paris Van Gogh left the city, tired of the ceaseless activity and longing for a peaceful and calm environment to work in. His initial enthusiasm for the city had worn quickly and his relationship with his brother Theo, exasperated by their shared living arrangements, was under considerable strain. In February 1888 Van Gogh headed for the south of France, to Arles, a rural, agricultural town nestled between the River Rhône and the wild countryside of the Camargue. He arrived armed with romantic preconceptions: to him the south was an unpolluted haven, a place of pure, clear colours and translucent light – it was to him the Japan of France. Landscape scenes such as this, and paintings of trees and blossoms dominated his work as he immersed himself in the countryside, ignoring the ancient buildings and more popular tourist sites in the town. His palette had brightened and become bolder, and increasingly he drew on the influence of Japanese woodcuts, which can clearly be seen here. He painted a number of pictures of the little wooden drawbridge outside Arles, which ironically was very Dutch in design.

CREATED

Arles

MEDIUM

Oil on canvas

SERIES/PERIOD/MOVEMENT

Landscapes, works at Arles

SIMILAR WORK

Noblemen and Peasants on a Causeway near a Marsh by Katsushika Hokusai, 1839

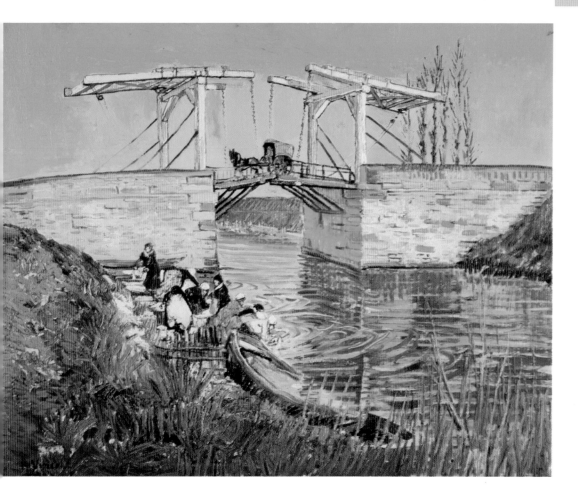

Still Life with Potatoes, 1888

Quite why Van Gogh chose Arles as his destination is unclear, though his enthusiasm for the south of France may have been partially fanned through Alphonse Daudet's novel, *Tartarin de Tarascon* (1872). The comic story of an affable, bumbling hero along the lines of Don Quixote was set in Tarascon, a town nearby to Arles, and it was a tale that Van Gogh was familiar with. On his arrival he threw himself into a frenzy of painting, and at first appears to have been content with allowing his work to consume his life. Though his art was developing in a new direction, there were still vestigial elements of his Dutch upbringing, and this still life in particular combines a Dutch echo with a new linear forcefulness. His romanticized social and political ideals that had inspired his early paintings of peasants at work could again be seen in some of his paintings done at Arles though in a less blatant manner. His landscapes included small figures busy working in the distance, though the landscape itself remained the motif with the peasant element now a subsidiary.

CREATED

Arles

MEDIUM

Oil on canvas

SERIES/PERIOD/MOVEMENT

Still lifes

SIMILAR WORK

Overturned Basket of Fruit by Paul Cézanne, *c.* 1877

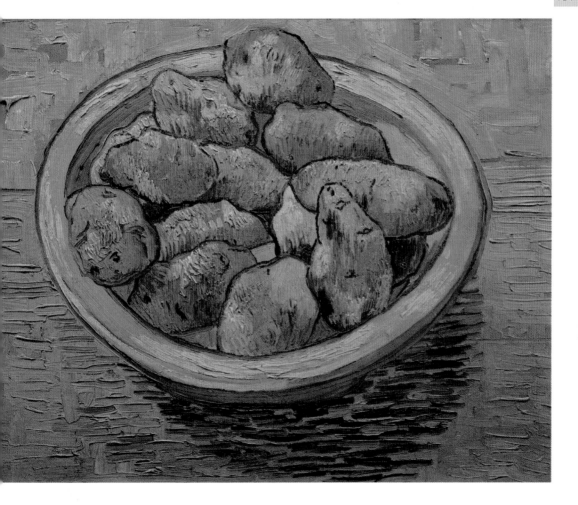

Harvest in Provence, 1888

The last few decades of the nineteenth century saw immense changes in almost all aspects of life, including the arts and music. Van Gogh's short career came as the Impressionists were disbanding, and even more avant-garde artists were emerging. Though it was one of Van Gogh's initial wishes to 'belong' to a group of artists, his work bridged a number of different movements, so that in just 10 years he managed to incorporate elements of the Impressionists, Post-Impressionists, Symbolists, Expressionists and Fauves within his art. It was this period that gave birth to modern art, and made the transition from traditional to new. Despite the innovations there was still an overriding lack of acceptance for these artists who were paving the way for the new century of art.

Harvest in Provence was one of many paintings that Van Gogh made of the countryside surrounding Arles, and reflects his experiments with flat areas of colour and bold outlines. He differentiated his brushstrokes, seen here in the spiky cut cornfield contrasted against the flat area of standing corn, and was applying his paint in great thick strokes that lend the picture plane a textural quality.

CREATED

Arles

MEDIUM

Oil on canvas

SERIES/PERIOD/MOVEMENT

Landscapes, works at Arles

SIMILAR WORK

Saint-Briac, The Sailor's Cross by Paul Signac, 1885

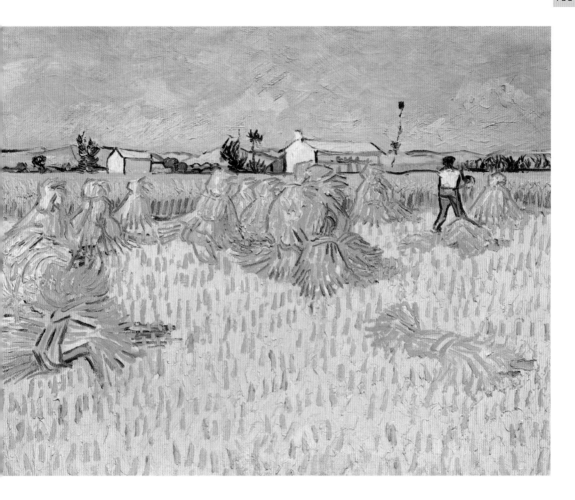

Portrait of Postman Roulin, 1888

Improving transport through the nineteenth century encouraged the growth of the leisure industry. People were able to travel more easily and quickly, and the middle classes had more time that allowed for holidays. Arles, with its beautiful countryside, historic town and gentle weather was starting to develop a growing tourist trade, and this in turn was bringing revenue to the town. The local women were allegedly famed for their beauty, and the local people would still have been, by and large, dressed in traditional clothing by the time Van Gogh arrived. Although the townsfolk were used to tourists trickling through, they were not used to such bizarre characters as the artist, and his erratic behaviour caused him to be quickly isolated from the local community. The exception to this hostile treatment came in the form of the local postman, Monsieur Roulin, who came to be one of the artist's most loyal friends. Van Gogh painted him many times, but in all the pictures the postman appears stiff and uneasy, and did not fall naturally into the role of artist's model.

CREATED

Arles

MEDIUM

Oil on canvas

SERIES/PERIOD/MOVEMENT

Portraits

SIMILAR WORK

Portrait of the Artist's Grandmother by Émile Bernard, c. 1887

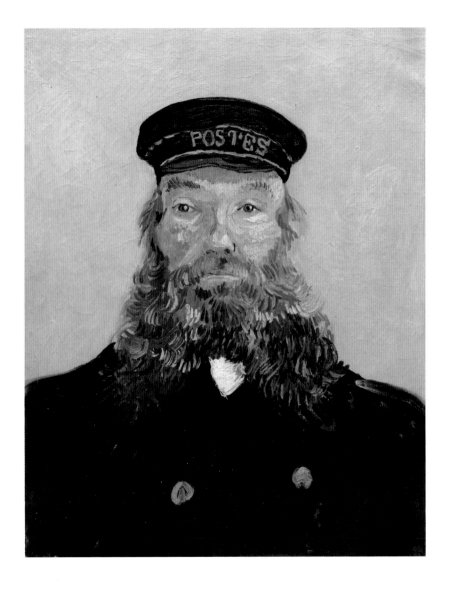

Portrait of Patience Escalier, 1888

Portraits were one of Van Gogh's favourite subjects, and it distressed him that he was not able to persuade more people to sit for him. During the summer of 1888 he painted a series of portraits of peasants, such as this one, in close focus and not dissimilar in concept to his early Dutch paintings of peasants and labourers. Now, however, his use of colour was as expressive as his use of line and form, and so it is that the simple complementary blues, oranges and yellows of this painting are as visually impacting as the sensitive depiction of an old, honest man. He wrote to Theo and explained, 'I should like to paint men and women with that certain something of the eternal, which the halo used to symbolize and which we seek to achieve by the actual radiance and vibration of our colourings.' He strove to paint the spirit of his subject and painted as things touched him in one way or another, so that every work he did was in some way a reflection of his own sub-conscious self.

CREATED

Arles

MEDIUM

Oil on canvas

SERIES/PERIOD/MOVEMENT

Portraits

SIMILAR WORKS

Portrait of Ambroise-Vollard by Paul Cézanne, 1899

Portrait of Toulouse-Lautrec in Oilskins, Cooking by Édouard Vuillard, 1898

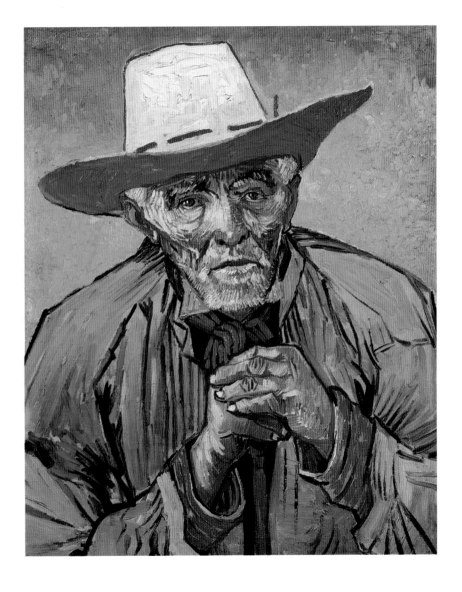

Gypsy Camp, Arles, 1888

There was a long tradition of gypsies living in the area surrounding Arles and into the wilds of the Camargue, and Van Gogh would have been drawn to what he perceived as their romantic and exotic life. The brilliant colours he painted them in parallels their rich and exciting culture, which was one that spanned many hundreds of years. There is an analogy to be drawn also between the gypsy and their isolated existence beyond the frame of a static community such as the town, and Van Gogh's own exclusion from the social network within Arles. His strange behaviour, and at times bizarre appearance had quickly set him apart from the conservative rural community, who were later instrumental in the artist leaving Arles. Van Gogh longed for the company of other artists and like-minded people, and felt totally cut off in Arles. He kept in touch with the art scene in Paris through his brother Theo, and corresponded with some of his artist friends including Gauguin and Bernard, but the lack of social contact heightened his despondency and depression.

CREATED

Arles

MEDIUM

Oil on canvas

SERIES/PERIOD/MOVEMENT

Landscapes, works at Arles

SIMILAR WORK

Gypsies at Port-en-Bessin by Paul Signac, 1883

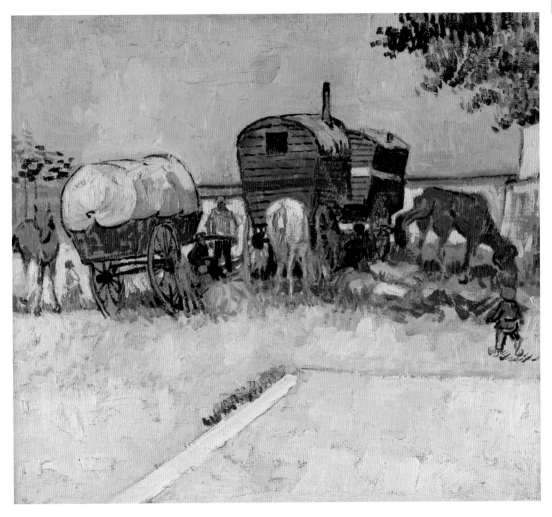

Interior of the Restaurant Carrel, Arles, 1888

© Christie's Images Ltd

In a way that had become typical of Van Gogh's work, the resonance of the artist's self is felt through this painting. He chose an unusual composition of strong parallel horizontal planes seen through the rows of tables, with a distant pocket of activity and strong social grouping in the background. The impression is left that the artist is far removed from the other diners, which indeed was how he felt in Arles. Further, his viewpoint is disturbingly from the middle of a table, rather than seated on the far side, which actually puts him in the position of one of the inanimate objects resting on the table. He made two paintings of this restaurant interior, this one and one that is much darker in tone and more sketch-like. It was a restaurant that he frequented regularly, despite his feelings of alienation from the townspeople, and wrote in a letter to Bernard, 'write to me soon, always the same address: Restaurant Carrel, Arles.' This restaurant was typical of a rural eatery, which invariably used long tables, in contrast to the separated tables of more salubrious establishments.

CREATED

Arles

MEDIUM

Oil on canvas

SERIES/PERIOD/MOVEMENT

Restaurants and cafés

SIMILAR WORK

Sketch for The Supper by Henri de Toulouse-Lautrec, 1887

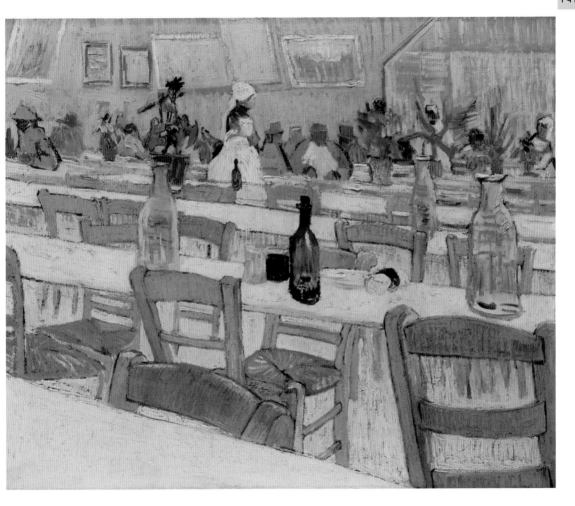

The Night Café, Arles, 1888

The powerful alcoholic drink absinthe, also called 'The Green Fairy', became the drink of choice in the nightclubs and cafés over the course of the nineteenth century, and was popular amongst artists, including Van Gogh. In the 1880s there was a shortage of wine and consequently the popularity of absinthe grew. Myths surrounded the drink, which was deemed conducive to violent, devilish behaviour and was widely criticized by conservative circles, and eventually banned altogether across Europe and America.

Unlike the normal depictions of clubs and restaurants as frivolous places of entertainment, Van Gogh chose to paint this picture, highlighting the darker side of nightlife, the loneliness, despair and isolation of the café stragglers. Giving his colours symbolic significance, he wrote about the painting, 'I have tried to express the terrible passions of humanity by means of red and green.' Later adding, 'I have tried to express the idea that the café is a place where one can ruin one's self, run mad or commit a crime ... and all this in an atmosphere like a devil's furnace, of pale sulphur, all under an appearance of Japanese gaiety ...'

CREATED

Arles

MEDIUM

Body colour on paper

SERIES/PERIOD/MOVEMENT

Restaurants and cafés

SIMILAR WORK

Melancholia by Edvard Munch

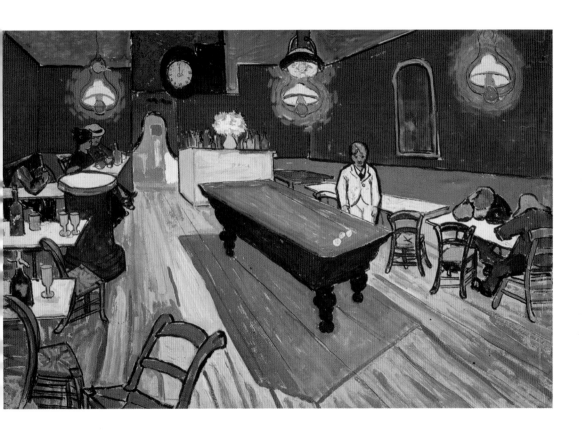

The Red Vineyard, 1888

© akg-images

In October 1888 Gauguin arrived in Arles and moved in with Van Gogh, who was beside himself with excitement and dreamt of starting if not an artists' colony, at the very least a shared studio. Van Gogh had met Gauguin two years previously and was in awe of the slightly older artist, whose own opinion of himself was greatly inflated. The stay ended in disaster culminating in Van Gogh's self-mutilation, but prior to this the two artists had worked on similar projects, and Gauguin's influence can be seen on Van Gogh's paintings of this time. Van Gogh was particularly enraptured with a local vineyard, whose colours were turning to autumnal reds and yellows as the days shortened into autumn. He painted *The Red Vineyard*, capturing the mellowed tones and glistening light of the early evening sun reflecting in the river, while Gauguin painted *Vineyard at Arles with Breton Women*, clothing the women in the traditional Breton costume of his home. Van Gogh's painting, which he was unusually pleased with, went on to be the only work he sold during his lifetime, and was bought for 400 francs by Anna Boch (1848–1936).

CREATED

Arles

MEDIUM

Oil on canvas

SERIES/PERIOD/MOVEMENT

Landscapes, works at Arles

SIMILAR WORK

Vineyard at Arles with Breton Women by Paul Gauguin, 1888

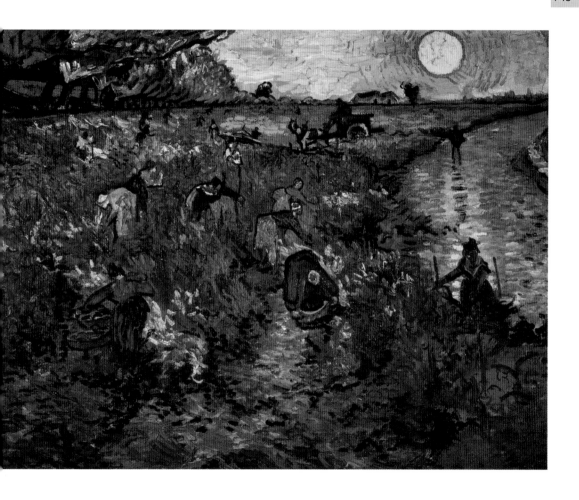

Portrait of a One-Eyed Man, 1888

© akg-images

Van Gogh and Gauguin's turbulent relationship while Gauguin stayed with Van Gogh was not entirely at the fault of latter, by all accounts Gauguin was a difficult character being arrogant, irascible and domineering. The two personalities together were incendiary though those short months were also highly productive in artistic terms. In November 1888 Gauguin finished Van Gogh's portrait, depicting the artist painting his beloved sunflowers, and on seeing it Van Gogh exclaimed, 'It is certainly I, but I gone mad.' It was a prophetic statement, with the artist suffering a terrible breakdown just one month later.

Van Gogh painted this portrait of a one-eyed man while he was hospitalized following the attack he made on himself. He took some comfort from those around him at the hospital because their afflictions made him feel less abnormal, and he wrote to his mother, 'At the moment I am working on a portrait of one of the patients here. It is odd that if one is with them for a time, and has grown used to them, one no longer thinks them mad.'

CREATED

Arles

MEDIUM

Oil on canvas

SERIES/PERIOD/MOVEMENT

Portraits

SIMILAR WORK

The Madman (Self Portrait) by Ferdinand Hodler, 1881

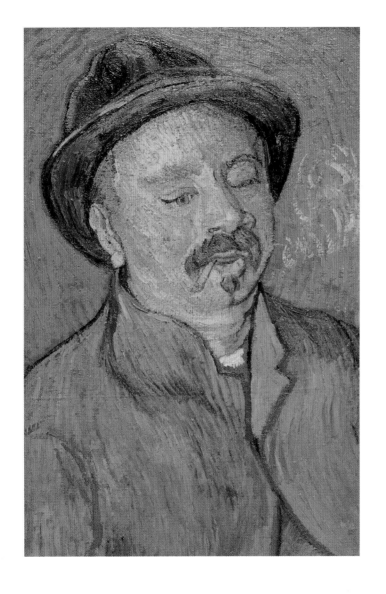

View of Arles, 1889

© akg-images

After Van Gogh's initial breakdown he was admitted to hospital, but released on 7 January and returned to painting for a brief intense period before being hospitalized again following a paranoia attack. Gauguin had abandoned him, his brother Theo was getting married and Van Gogh's dreams of an artists' enclave had crumbled. He was alone, depressed, in poor physical health and suffering from lack of nutrition, all factors that compounded his devastating mental illness. He heard voices, hallucinated and had vivid dreams of a distorted religious nature – in the present day he could have been greatly helped, but in nineteenth-century rural France his treatment in the hospital was at best sympathetic and at worst neglected. The local people organized a petition to have Van Gogh removed to his family or locked up, and consequently he was incarcerated in the hospital where he continued to paint, but struggled to recapture the glorious yellows and vibrant colours of the previous year. This landscape with its translucent purple haze of morning light poignantly reflects the artist's sense of isolation as his view to the fields is blocked by a symbolic grill of dark tree trunks.

CREATED

Arles

MEDIUM

Oil on canvas

SERIES/PERIOD/MOVEMENT

Landscapes

SIMILAR WORK

A Grey Day, Banks of the Oise by Camille Pissarro, 1878

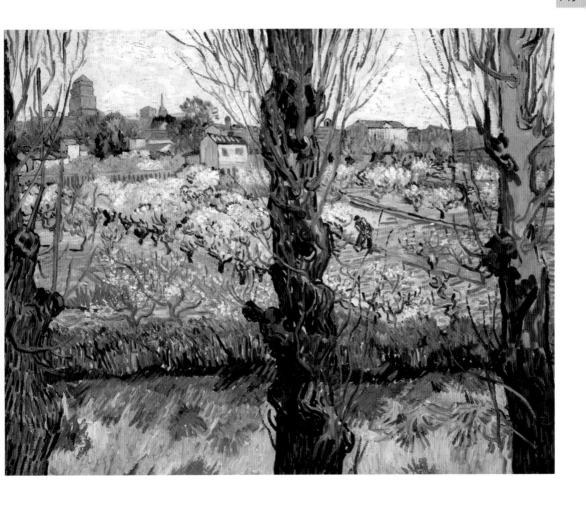

The Green Wheat Field Behind the Asylum, 1889

Van Gogh was quite aware of his problems, and disarmingly frank when talking about his madness, which he had come to consider an illness. He realized that he was incapable of functioning on his own and was unable to cope with the day-to-day necessities of life. On the advice of his friend the Reverend Salles he entered the asylum at Saint-Rémy voluntarily, which was not far from Arles. During the course of the nineteenth century in France there had been a gradual improvement in the treatment of patients in mental asylums, with groundbreaking laws introduced in June 1838 to establish institutions across France and to regulate and reform conditions for the mentally insane. Though this was the case, asylums, and particularly those in rural or remote areas, were still bare, sparse and poorly equipped.

Van Gogh immediately started to paint again. His painting had been the mainstay of his adult life and was a vehicle for his self-expression, but increasingly it became his life and his therapy. Paintings such as this were made looking through the barred window of his room, and show his use of heavy outline and simplified form.

CREATED

Saint-Rémy

MEDIUM

Oil on canvas

SERIES/PERIOD/MOVEMENT

Landscapes, works at the Saint-Rémy asylum

SIMILAR WORK

Pigeon Tower at Bellevue by Paul Cézanne, 1888–92

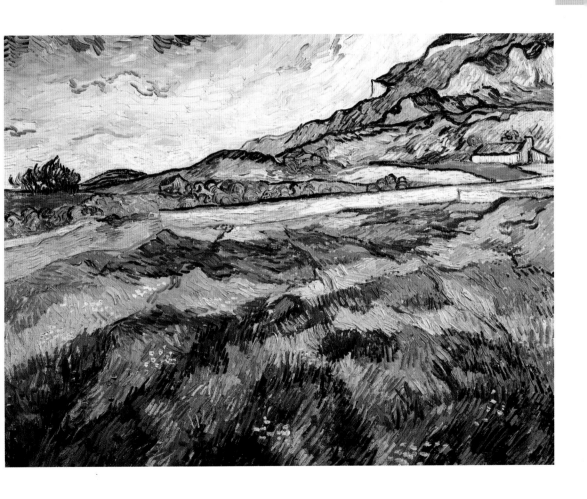

Studio Window, 1889

Upon his arrival at the asylum at Saint-Rémy Van Gogh threw himself into his paintings with a feverish intensity. He was allocated two rooms, side-by-side, one of which he used as a bedroom and the other as a studio, where he would shut himself in painting to drown out the screams and shouts of the other patients. It seems from correspondence between Van Gogh and Theo that the insanity of those around him did not initially much disturb the artist, and on the contrary, made him feel less abnormal and perhaps almost part of a 'group' – this feeling of belonging being one that had always affected the artist. Photographs of his rooms at Saint-Rémy show stark and grey interiors, but the paintings he made of his 'studio' and the hospital were enlivened with colour, here a square of lapis blue sky punctuating the window. His palette had become less pure and brilliant than his time at Arles, but was still vivid, and he was increasing his use of heavy dark outline delineating forms, that still harked back to his love of Japanese woodcuts.

CREATED

Saint-Rémy

MEDIUM

Oil on canvas

SERIES/PERIOD/MOVEMENT

Works at the Saint-Rémy asylum

SIMILAR WORK

Woman at the Window, Nice by Henri Matisse, 1926

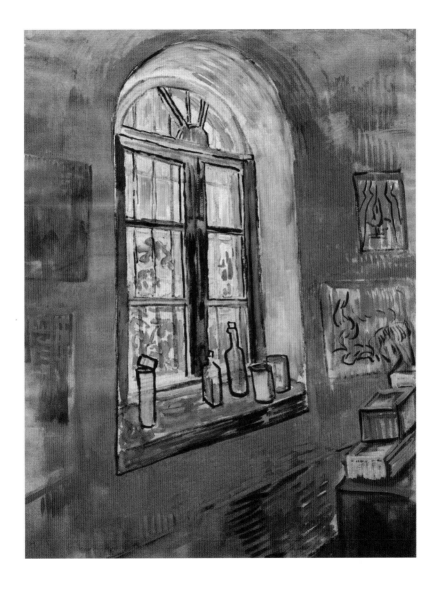

Road Works at Saint-Rémy, 1889

© akg-images

The asylum at Saint-Rémy was run by Dr Théophile Peyron, a former physician of the Navy, who appears to have been of minimal help medically to Van Gogh. The artist had formed a close relationship with an intern at the hospital in Arles, Dr Felix Rey, and had also been friendly with the pastor in Arles, Reverend Salles, but on arrival at Saint-Rémy he found himself isolated from any form of warm contact. He was unable to relate, intellectually or personally to the staff at the asylum, and this increased his sense of isolation. Though the asylum offered him a framework for his life, removing the pressures of daily living, providing his meals and a network of supervisors, he was without friends. His paintings, that were always a reflection of the artist himself, for the most part became subdued in tone, as seen in this painting made in the winter of November 1889. The overall yellow tonality pervading every aspect of the composition lends the whole a disquieting, sulphurous feel, while the dark outlined trees block the natural view into the scene and appear surreal.

CREATED

Saint-Rémy

MEDIUM

Oil on canvas

SERIES/PERIOD/MOVEMENT

Landscapes, works at the Saint-Rémy asylum

SIMILAR WORK

Branch of a Flowering Apple Tree by Ando or Utagawa Hiroshige

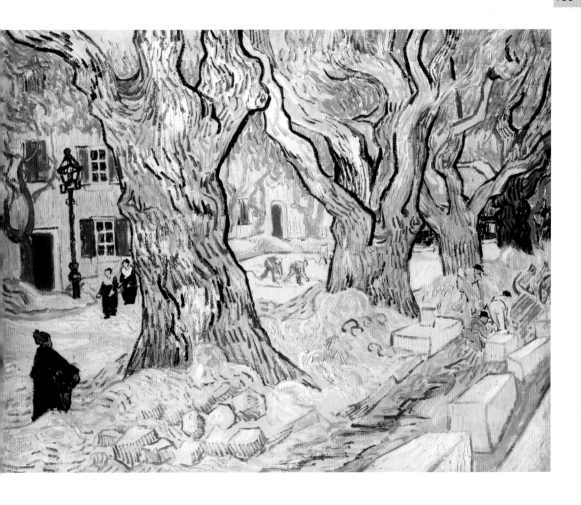

The Olive Pickers, 1889

Van Gogh was allowed to roam the asylum, paint in the gardens and go on painting excursions to the surrounding countryside when accompanied by a guard, which was probably a greater privilege than the other residents were allowed. It seems his care was not unsympathetic, but he wrote to Theo of the poor food, the lack of help and the ravings of his fellow patients. Throughout the year that he spent at Saint-Rémy he suffered several serious attacks during which he became violent towards others and himself, but in his lucid moments recognized that, despite his great unhappiness, he needed to remain there. Many of the landscapes that he painted during this period were devoid of figures, which was probably the reality of the rural situation. However, in the winter of 1889 he painted this picture of *The Olive Pickers*, using simplified forms that echoed the work of his friend Gauguin. His use of colour for the last several years had been of specific symbolic importance to the artist, and used to suggest a mood or feeling, and now his imagery, too, began to acquire symbolic significance.

CREATED

Saint-Rémy

MEDIUM

Oil on canvas

SERIES/PERIOD/MOVEMENT

Landscapes, works at the Saint-Rémy asylum

SIMILAR WORK

En Bretagne by Paul Gauguin, 1889

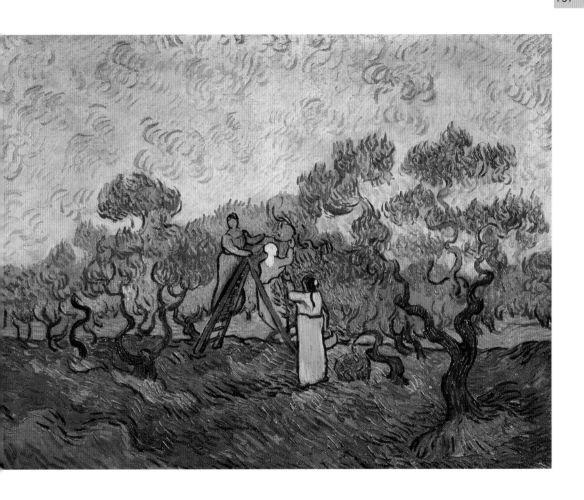

Old Man in Sorrow (On the Threshold of Eternity), 1890

Towards the end of 1889 the artist seemed to lose his inspiration and turned to making copies of his own paintings, and those of Millet, Eugène Delacroix (1798–1863) and Honoré Daumier (1808–79). This infinitely sad painting was taken from a drawing that he had done in The Hague between 1882 and 1885, and shows a man in mourning. It had become by now the ultimate expression of the artist's desolation, and no other image can reflect more succinctly the desperation and loneliness that Van Gogh felt. He had become increasingly unhappy at Saint-Rémy, and no longer wished to remain there, feeling stifled and desperate, even writing to Gauguin to suggest that he should join him in Brittany and they could establish a studio together again. It was an extraordinary reflection of the times that the artist, who was obviously mentally unstable, had made attempts on his own life and was allowed outside the asylum only when accompanied, was suddenly turned loose and dispatched to Paris alone to meet Theo. More bizarrely still on Van Gogh's release papers from the asylum, Dr Peyron wrote 'cured'.

CREATED

Saint-Rémy

MEDIUM

Oil on canvas

SERIES/PERIOD/MOVEMENT

Works at the Saint-Rémy asylum

SIMILAR WORK

Solitude by Pierre Puvis de Chavannes

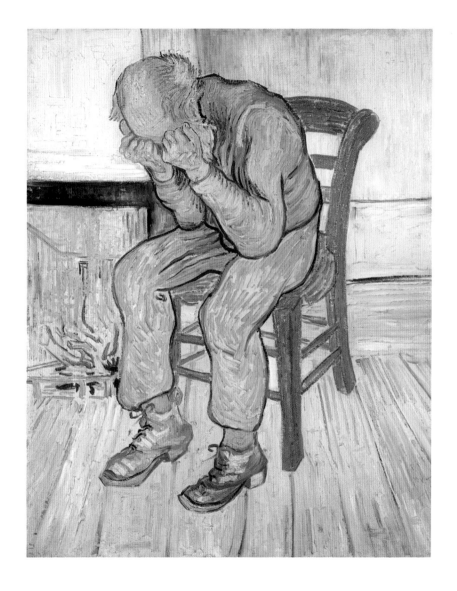

Landscape with Chariot, 1890

© akg-images

Van Gogh travelled to his new home in Auvers-sur-Oise in May 1890. He was to live here, on his own, but under the care of Dr Gachet, a strident republican and proponent of alternative and radical scientific theories. He had had a long association with a number of painters, and had been recommended to Van Gogh by Pissarro. Auvers itself was a rural town with a small, mostly agricultural-based community. It had a history of visiting artists, including Paul Cézanne (1839–1906), Jean-Baptiste Armand Guillaumin (1841–1927), Pissarro, and Daubigny, which might have led the townspeople to be more accepting of Van Gogh and his bohemian appearance and ways. They were also used to the eccentric Dr Gachet who was a well-known and popular local figure. Certainly there is little indication that the people themselves actively ostracized Van Gogh, and it seems his subsequent depression and suicide was beyond external stimuli. It can be assumed that by the time he arrived in the small town, his vortex of self-destruction was on an inevitable path.

This painting was typical of his landscapes of this period with their bold, slightly unsettling perspectives and tapestry-like blocks of colour and line.

CREATED

Auvers-sur-Oise

MEDIUM

Oil on canvas

SERIES/PERIOD/MOVEMENT

Final landscapes

SIMILAR WORK

View of Chatou by Maurice de Vlaminck, 1906

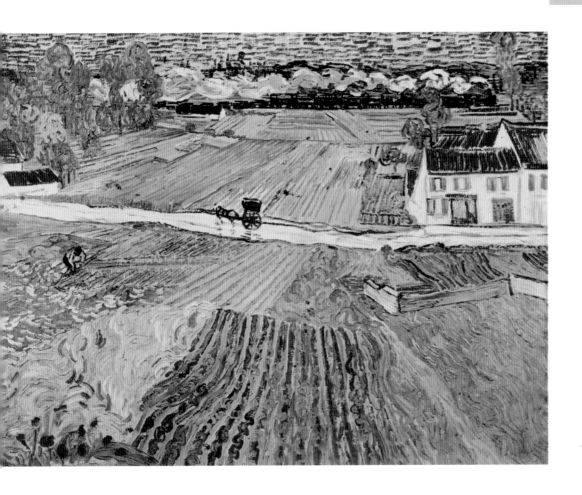

Bank of the Oise at Auvers, 1890

Van Gogh was an avid reader who absorbed a wide range of books by authors as diverse as Charles Dickens, Émile Zola, Shakespeare and Thomas Carlyle. Books had become more accessible and affordable, and art journals and periodicals had gradually begun to increase in number and distribution. By the second half of the century art books had also become popular, and it was through this combination of literature that Van Gogh was able to stay in touch with the world of fiction, art and politics when he was geographically and mentally isolated. He had been in the asylum at Saint-Rémy for a year and had had no stimulating relationship, so the well-read and opinionated Dr Gachet in Auvers was a welcome relief. Not only was the doctor an intellectual equal and versed in contemporary art, he was also enthusiastic about Van Gogh's paintings, and he and members of his family sat for several portraits. In this painting the identity of the models remains unknown and their form is sketchy with their features obliterated by the brilliant shaft of light that illuminates them. Surrounding this the dark tones of the trees, sky and river encroach oppressively.

CREATED

Auvers-sur-Oise

MEDIUM

Oil on canvas

SERIES/PERIOD/MOVEMENT

Final landscapes

SIMILAR WORK

Man Painting in his Boat by Georges Seurat, 1883

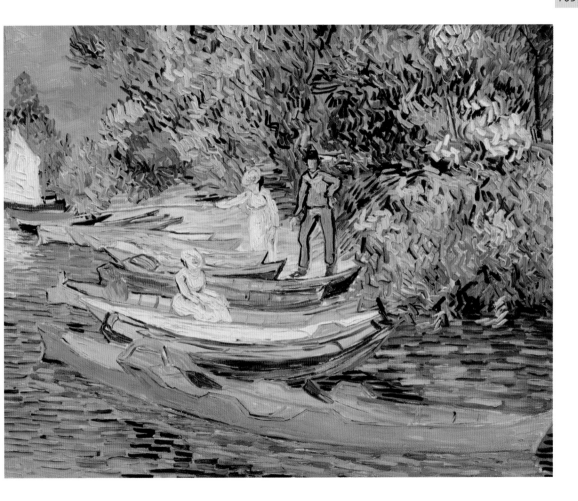

Thatched Cottages in Chaponval, Auvers-sur-Oise, 1890

© Kunsthaus, Zurich, Switzerland/The Bridgeman Art Library

This was one of the artist's last paintings, made shortly before he shot himself. It was painted at Chaponval, a small rural area very close to Auvers that was depicted by a number of artists including Pissarro and Henri Rousseau (1844–1910). However, where Pissarro's image is that of an idyllic agricultural setting, Van Gogh's illustrates the simple and impoverished houses of the local peasant community. The houses were built from sandstone with heavily thatched roofs that have assimilated an organic life in Van Gogh's painting, seeming to grow from the ground so that the dwellings are part of the landscape. The effect is one of a universal landscape where buildings and the two small peasant figures in the foreground become virtually indistinguishable against their natural surroundings. A direct railway line that had been built in 1846 had made travel between Paris and this area much easier, but it was still a place relatively untouched by modern advancements. Although the Industrial Revolution had created a surge of commercial, technical and economic changes, these were most apparent in the towns, and rural France remained inherently simple and untouched until well into the twentieth century.

CREATED

Auvers-sur-Oise

MEDIUM

Oil on canvas

SERIES/PERIOD/MOVEMENT

Final landscapes

SIMILAR WORK

Landscape at Chaponval by Camille Pissarro, 1880

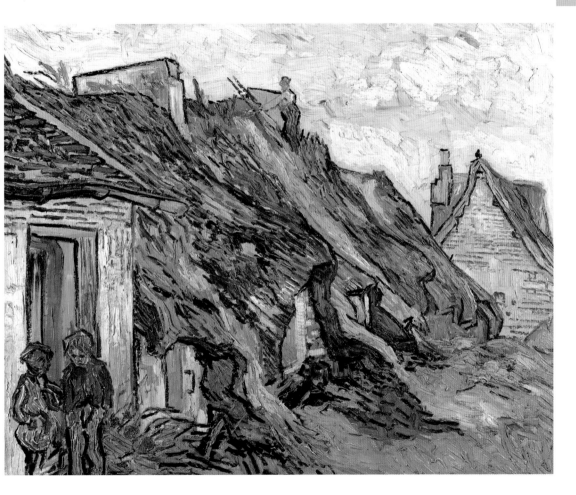

Van Gogh

Places

View of The Hague, 1882

© akg-images

When Van Gogh arrived at The Hague in December 1881, it was one of the art capitals of Europe, and was in Van Gogh's mind the right place to launch his artistic career. He also had contacts, namely his cousin Anton Mauve (1838–88) with whom he had previously taken a few drawing lessons. Mauve helped the young artist for a short period, until the two fell out over Van Gogh's refusal to copy plaster cast torsos, and provided some paints and further lessons. Initially Van Gogh was keen to become an illustrator, practising his drawing and concentrating on close-focus studies of working men and women. However, in January 1882 he turned to painting, working in oil and watercolour, and shortly afterwards produced this picture, which already shows the combination of his extraordinarily original voice with his Dutch heritage. It was during his time at The Hague that the foundations for his artistic career were laid, and in a letter to Theo he wrote, 'I feel ideas about colour coming to me as I paint, which I never had before.'

CREATED

The Hague

MEDIUM

Watercolour and ink on panel

SERIES/PERIOD/MOVEMENT

Dutch period

SIMILAR WORK

Fishing Boat on the Beach near Scheveningen by Anton Mauve, 1876

Vincent Van Gogh *Born* 1853 Groot-Zundert, The Netherlands

Died 1890

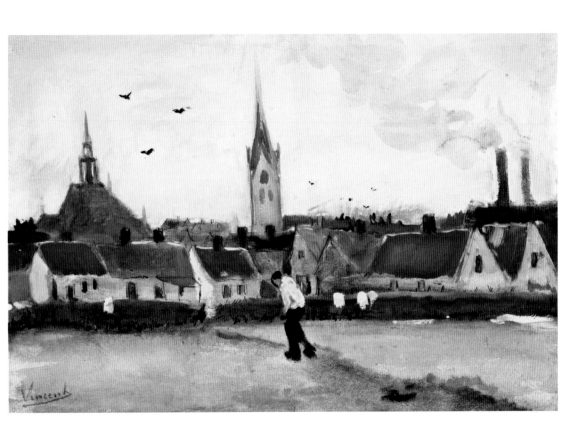

Girl in White in the Woods, 1882

© akg-images

In The Hague Van Gogh came into contact with a number of other artists whose work had some influence on the development of his style, and he was suddenly exposed to a richly artistic climate. He had also become acquainted with, and a great admirer of, a wide range of art through his work in London and Paris with the art dealership company Goupil et Cie. During his travels he frequented museums and galleries in search of Old Masters, and also collected a number of reproductions including those of Jean-François Millet (1814–75), Jean-Baptiste-Camille Corot (1796–1875), Charles-François Daubigny (1817–78), Rosa Bonheur (1822–99), and Jules Breton (1827–1906). The work of the Barbizon painters was important to artists working in The Hague, and Van Gogh absorbed this form of French Realism within his own oeuvre. There are elements of this present in the oil painting *Girl in White in the Woods*, which he painted in August 1882. The looming diagonal line of trees dwarfs the small figure in white who is a rather unsettling and lonely presence, with no particular reason for being alone in the woods.

CREATED

The Hague

MEDIUM

Oil on canvas

SERIES/PERIOD/MOVEMENT

Dutch period

SIMILAR WORK

Landscape with a Peasant Woman by Jean-François Millet, early 1870s

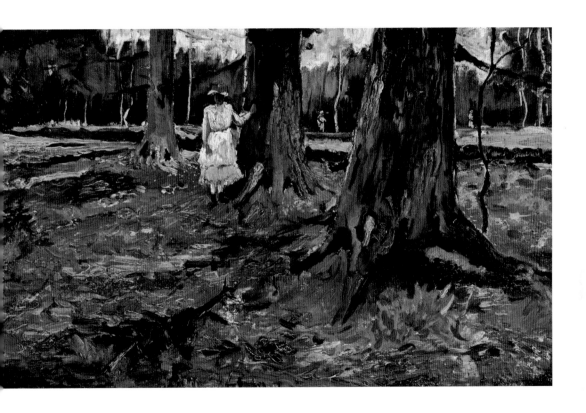

The Peat Boat, 1883

© Private Collection/The Bridgeman Art Library

Van Gogh moved to Drenthe in September 1883 with the intention of staying there and possibly encouraging the creation of a colony for artists. It was an area that several artists were moving to, in part to escape the high costs of living in The Hague. Van Gogh's friend Anton van Rappard (1858–92) had suggested the move to him, but it was to prove unfruitful. The artist found the area depressing: the local people were unwelcoming making it hard for him to find models, and he found the landscape uninspiring. He painted several pictures of labourers working in the peat fields, of which this is one. This is, however, a particularly unusual work due to the uniform areas of colour and lack of textured brushwork. During his short three-month stay in Drenthe his palette became noticeably darker and subdued, and his figures were more anonymous than those that he painted in close focus in The Hague. This was partly due to the lack of willing models he could find, and was also a reflection of his feeling of isolation from those around him.

CREATED

Drenthe

MEDIUM

Oil on canvas

SERIES/PERIOD/MOVEMENT

Dutch period

SIMILAR WORK

Old Woman on the Heath by Jozef Israëls

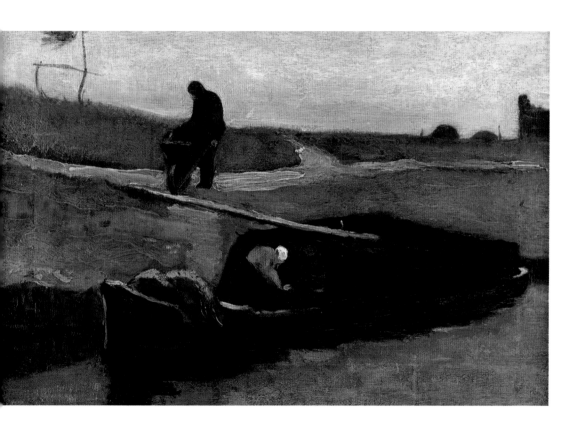

Jugs, 1884

© akg-images

Van Gogh moved to his family's hometown of Nuenen in December 1883. His father was the protestant pastor of the rural village, and undoubtedly had some misgivings about his errant son moving home. Van Gogh's behaviour in the past had earned his family's disapproval, especially his extended liaison with a prostitute in The Hague, and it seems the shared living arrangement was not without problems. Nuenen had an active weaving industry and it was to this that Van Gogh initially turned for inspiration, producing a series of drawings and paintings of weavers at work, and later studies of peasants' heads and hands. By the winter of 1884, however, he had alienated himself from the local people, and was falsely accused of impregnating a peasant girl. Finding it difficult to obtain models he turned again to still life painting, producing works such as this that were sombre in tone, with the forms built up from shades of the same colour. His technique of using one or two colours through a composition was one that he returned to frequently in varying forms.

CREATED

Nuenen

MEDIUM

Oil on canvas

SERIES/PERIOD/MOVEMENT

Dutch period, still lifes

SIMILAR WORK

Stoneware Jug and Egg by Antoine Vollon

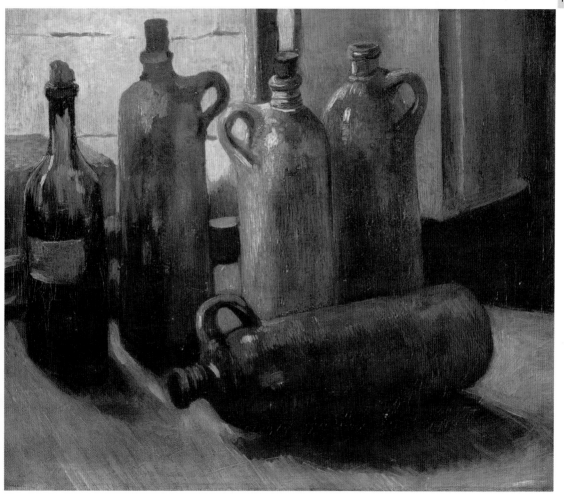

The Singel Canal, Amsterdam, 1885

© akg-images

In October 1885 Van Gogh travelled to Amsterdam with Anton Kerssemakers (1846–1924), a tanner and amateur painter. The two had met in Eindhoven, a town near Nuenen, and Van Gogh had started to give him painting lessons. It was a trip that greatly inspired Van Gogh, who spent much of it in museums studying the works of past masters. He was particularly taken with Rembrandt's (1606–69) *Jewish Bride*, and paintings by Frans Hals (*c.*1582–1666), Peter Paul Rubens (1577–1640), Jan van Goyen (1596–1656) and Jozef Israëls (1824–1911). This painting is still sombre in tone, but brighter colours were starting to emerge in the artist's palette, seen here in the pale blue and pink sky. At this time he was increasingly thinking of colour, and had become a fervent admirer of Eugène Delacroix (1798–1863), whose work he was familiar with through books. The painting was made during his brief stay in the city and shows his developing style prior to his introduction to Japanese art. Already his composition and grasp of perspective appear thoroughly understood, when in actuality the artist had only been painting for a few years.

CREATED

Amsterdam

MEDIUM

Oil on wood

SERIES/PERIOD/MOVEMENT

Dutch period

SIMILAR WORK

Salad Garden near The Hague by Jacob Hendricus Maris, *c.* 1878

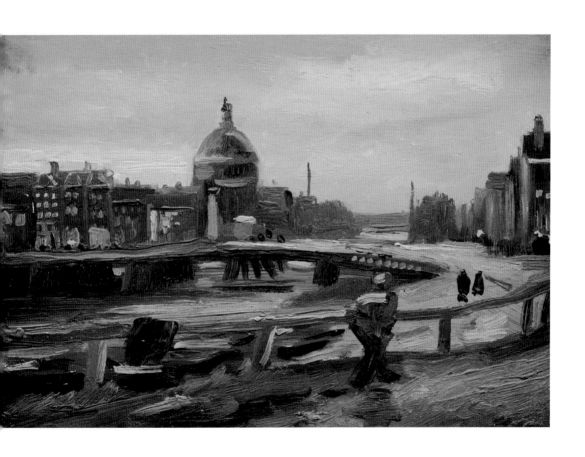

Portrait of a Woman with a Red Ribbon, 1885

It was in Antwerp that the artist is first thought to have become familiar with Japanese works of art, and it was there that he decorated his rented rooms with Japanese prints. The influence of Japanese art, in terms of colour, line and design was to have a profound effect on Van Gogh, and was one that he referred to throughout his career. On arriving in Antwerp his senses were immediately assailed by the lively vigour of the city: the girls, the sailors and the harbour and the sheer cosmopolitan atmosphere. His palette had again brightened, as seen in this portrait, and to some extent shows the influence of Ruben's colouration, as well as that of Delacroix. He was an enthusiastic portrait painter and tried to convey the spirit of the person and their essential qualities through his paintings. This technique became noticeably apparent through the numerous self portraits that he painted, which expressed the psychological state of the artist at varying stages of his short life. He briefly attended the Academy in Antwerp where he practised life drawing, before leaving and moving to Paris.

CREATED

Antwerp

MEDIUM

Oil on canvas

SERIES/PERIOD/MOVEMENT

Portraits

SIMILAR WORK

On the Bench by Édouard Manet, 1879

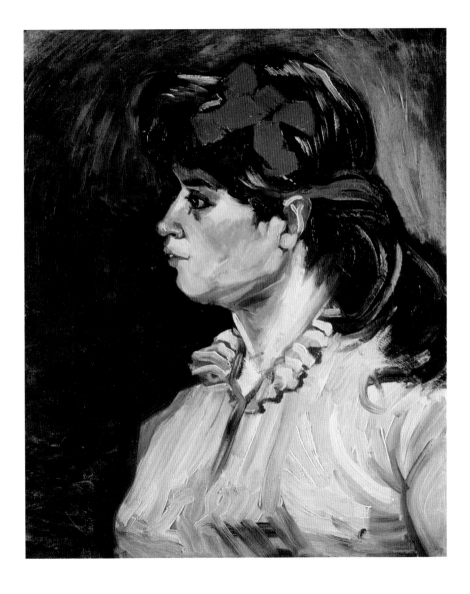

View of Montmartre, 1886

© akg-images

Van Gogh left Antwerp suddenly and arrived in Paris in February 1886, moving in with his brother Theo. The two would share accommodation for the next two years – an arrangement that was not without its problems. At this time Paris was one, if not the, artistic centre of Europe and was a melting pot of new ideas, cutting-edge art movements and strident young artists. There were a number of different 'circles' of artists, some of which overlapped, along with poets, writers, and social and political activists – it was a time of change in Paris and an atmosphere rich in stimulating art and philosophy. Alongside this there was a culture of nightlife, gaiety and entertainment, especially within the bohemian area of Montmartre. Montmartre sits on a hill and is the highest point in Paris, and at this time it was just being absorbed into the expanding city, but still contained rural areas. Van Gogh painted numerous views of Montmartre, such as this one that includes the famous windmills and looks across the city in a panorama of dotted and cubed buildings.

CREATED

Paris

MEDIUM

Oil on canvas

SERIES/PERIOD/MOVEMENT

Parisian works

SIMILAR WORK

Moulin de la Couleuvre at Pontoise by Paul Cézanne, 1881

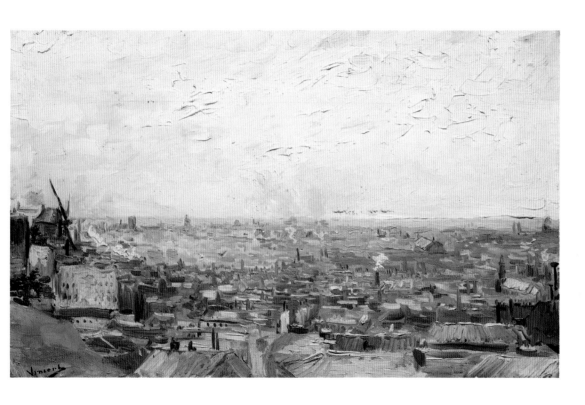

Still Life, 1887

Not long after Van Gogh arrived in Paris the Salon exhibition opened and at the same time the eighth Impressionist Exhibition was staged, although few of the original members exhibited and the 'group' of Impressionists disbanded. Then later in the year there was the Salon des Indépendants, an exhibition for those artists rejected by or reluctant to exhibit at the Salon. For Van Gogh Paris was initially a feast of artistic experiences, and he suddenly had all the artistic stimulation he could need at his disposal – it was a huge and eventually unwelcome change from the quiet rural areas he had spent much of his life in to this point. Theo and Van Gogh moved to an apartment in Montmartre at the centre of bustling Parisian life, and Van Gogh set up his studio. By the spring of 1887 Van Gogh had become friendly with Paul Signac (1863–1935) and his colours had become not only brighter but also more consciously symbolic of mood and feeling. He had also embarked on a series of exquisitely coloured still life paintings of flowers in vases that in concept echoed his Dutch background.

CREATED

Paris

MEDIUM

Oil on canvas

SERIES/PERIOD/MOVEMENT

Still lifes

SIMILAR WORK

Roses in a Vase by Pierre-Auguste Renoir, 1876

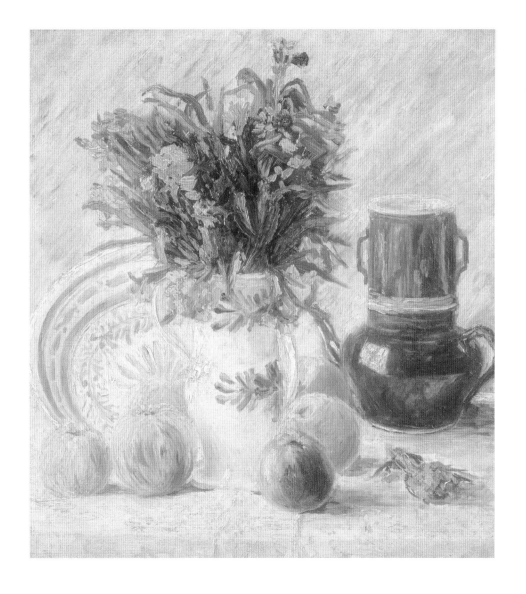

Wheat Field with Lark, 1887

In the autumn of 1886 Van Gogh became friendly with Émile Bernard (1868–1941) who he had first met through the studio of Félix Cormon (1845–1924) where both artists are thought to have taken lessons, and then in November he met Paul Gauguin (1848–1903). His brother Theo, with his contacts in the art world through his work as a dealer also tried to integrate Van Gogh to the artistic community. He met other artists through the shop of Père Tanguy, an elderly gentleman who ran an art supplies shop and dealt in paintings, often accepting works in lieu of payment for paints. This painting of a wheat field, which was a subject he painted several times, shows him assimilating various influences, especially those of Signac and Camille Pissarro (1830–1903), and expressing them in his own highly individual style. By the time of this painting Van Gogh's early wonder at Paris had dissipated and he was struggling with his inner demons, which in part can be felt through the restless wheat blowing in the wind and the lone lark set against a large and turbulent sky.

CREATED

Paris

MEDIUM

Oil on canvas

SERIES/PERIOD/MOVEMENT

Wheat fields

SIMILAR WORKS

View Towards Pontoise Prison, In Spring by Camille Pissarro, 1881

The Lighthouse at Gatteville by Paul Signac

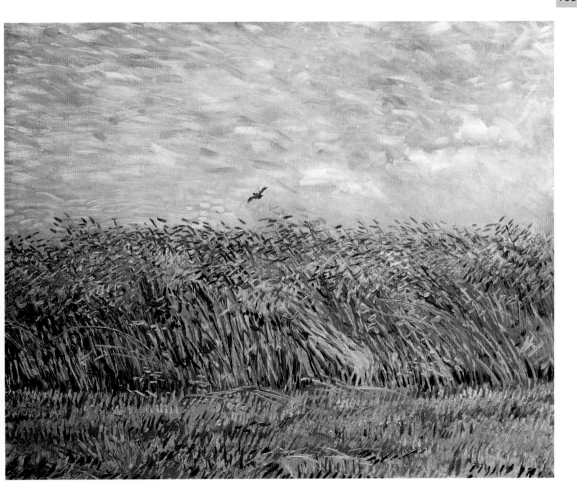

Restaurant de la Sirène, 1887

© akg-images

Van Gogh painted this picture of the popular Restaurant de la Sirène at Asnières, an area in the northwestern suburbs of Paris that sat alongside the River Seine. It had originally been a rural area that took its name from the Latin for donkey, thought to refer to the local breeding of donkeys, but as Paris had grown and spread Asnières became swallowed into the city. By the time Van Gogh arrived in Paris Asnières had a burgeoning population and was home to several large factories. It was also a fashionable place for day-trippers, and a number of artists frequented the area to paint. Van Gogh painted several views of Asnières, and was often accompanied on his trips by the young Signac. This view of the restaurant reflects the artist's absorption of the Impressionist techniques, taken to a different level. Van Gogh was less concerned with the fleeting effect of atmosphere, and focused more on colour, form and meaning in his work. At this time restaurant and café culture was at a high, and they often exhibited the works of contemporary painters.

CREATED

Paris

MEDIUM

Oil on canvas

SERIES/PERIOD/MOVEMENT

Parisian works

SIMILAR WORK

The Boulevards by Pierre-Auguste Renoir, 1875

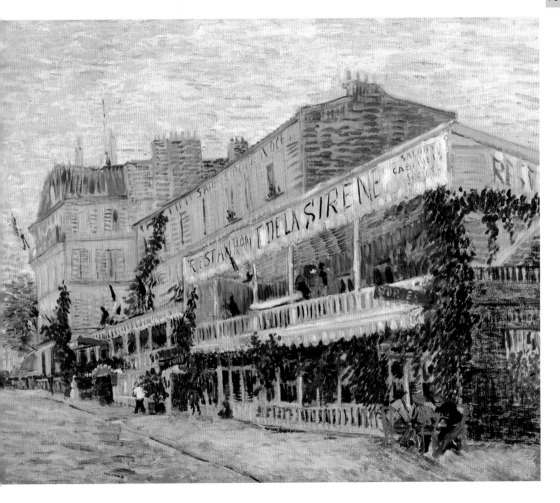

Portrait of Père Tanguy, 1887

© akg-images

This extraordinary man, Père Tanguy, was a colour grinder with an art supply shop in Montmartre who took the avant-garde artists of the day under his wing, often trading their works for art supplies. By accounts he was extremely kind with a socialist leaning and was sympathetic to the struggles that emerging artists had. He also collected a huge number of works, especially those by Paul Cézanne (1839–1906) as well as Van Gogh, Pissarro, Gauguin, Georges Seurat (1859–91), Signac, Jean-Baptiste Armand Guillaumin (1841–1927) and others. He bought and traded the paintings, selling them on for little profit and only just making a living himself. His shop became a gathering place for artists and the scene of lively debate and discussion, and it appears that he was a man who was universally admired and liked. This portrait of him, which was one of several Van Gogh did, shows him sitting calmly against a vivid wall of Japanese prints. Van Gogh was a great collector of these prints, and made several copies of them, as well as incorporating them into his other paintings.

CREATED

Paris

MEDIUM

Oil on canvas

SERIES/PERIOD/MOVEMENT

Portraits

SIMILAR WORK

Portrait of Père Tanguy by Émile Bernard, 1887

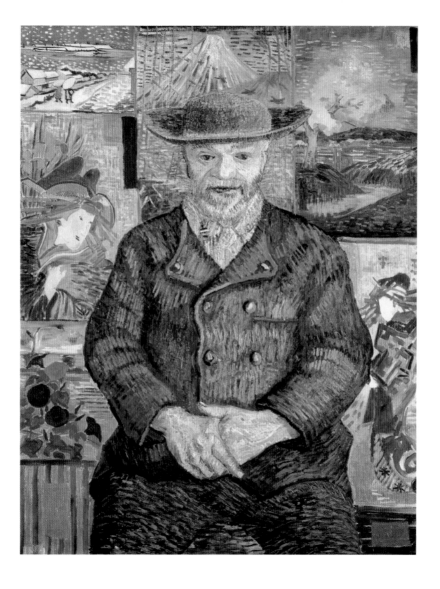

Eglogue En Provence, (A Pair of Lovers), 1888

© akg-images

In February 1888 Van Gogh left Paris for the south of France, embarking on a long train journey that would take him to the small rural area of Arles. Tensions between Van Gogh and Theo had made their shared living arrangements impossible, his friend Gauguin had also left the city and Van Gogh had grown weary of the Parisian bustle. All that had seemed so appealing to him on his arrival now exhausted him, and he longed for solitude and peace. It is ironic that the solitude that he longed for was one that would plague him. His increasingly irascible nature made contact with others difficult, and he eventually found himself ostracized from society and plunged into an inevitable lonely existence. This is an unusual work within Van Gogh's oeuvre showing a couple affectionately strolling along. Few of his paintings depicted human contact in this form, which was reflective of his own unhappy, and unfulfilled relationships. His arrival in Arles, however, saw a further brightening in his colours as seen here, and these early pictures were positive in form and spirit.

CREATED

Arles

MEDIUM

Oil on canvas

SERIES/PERIOD/MOVEMENT

Early works at Arles

SIMILAR WORK

Little Girls Walking by Édouard Vuillard, c. 1891

Blossoming Pear Tree, 1888

© akg-images

Van Gogh headed to Arles full of preconceptions about the area. He thought of the south of France as a type of idyll, a place where the sun shone and the landscape reverberated with beauty. He hoped that it would be his 'Japan' in France. On his arrival – unusually for that area – it was blanketed with snow, but when the snow melted the trees burst into blossom and for a time at least it seems that it lived up to his expectations. In the spring of 1888 he set about painting with renewed vigour and concentrated on blossoms and landscapes, taking long walks into the countryside and exploring with his paints and easel. The influence of Japan was highly apparent, and can be seen clearly in this painting of a pear tree in blossom. His work had become more stylized with a brilliant use of colour and bold outlined forms similar to those seen in woodcuts. These early works in Arles were amongst some of the most positive done by the artist, who briefly enjoyed something of a respite from the troubles that plagued him.

CREATED

Arles

MEDIUM

Oil on canvas

SERIES/PERIOD/MOVEMENT

Early works at Arles, blossoms

SIMILAR WORK

Plum Garden, Kamata, from 'One Hundred Famous Views of Edo' by Ando or Utagawa Hiroshige, 1857

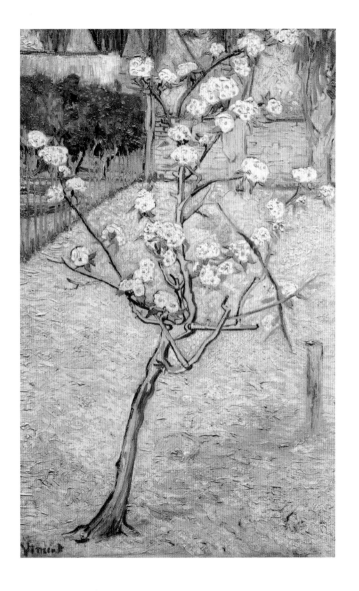

Sunset at Wheat Field, Arles, 1888

Though Arles was a small and primarily agricultural-based community, the town did boast some industry, which is seen in the smoking chimneys of this painting. The development of the railway had increased the town's commerce and made it more accessible, although it still remained essentially provincial. Seen here from across a broad expanse of restless wheat the town's dark silhouetted outline, lit by a giant moon lends it a mysterious, faintly haunting air. Wheat fields were a motif that Van Gogh used numerous times during his career, and they provided him with a perfect subject with which to expand his expressive use of short brushstrokes. Here, as in most of his paintings of wheat fields, the wheat is moving and restless, defined by swift dabs of paint that contrast with the still, dark and looming presence of the town on the horizon. He had become increasingly preoccupied by the expression of feelings through symbolic elements in his work, and here his first feelings of unrest in Arles are apparent through the dark town on the skyline.

CREATED

Arles

MEDIUM

Oil on canvas

SERIES/PERIOD/MOVEMENT

Landscapes

SIMILAR WORK

View of San Giorgio Maggiore, Venice by Twilight by Claude Monet, 1908

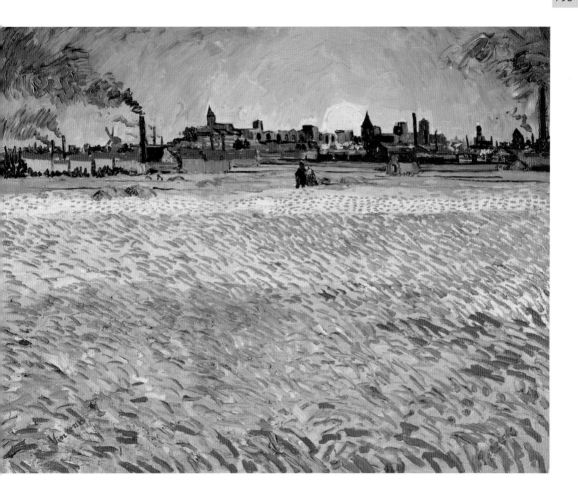

The Trinquetaille Bridge in Arles, 1888

Van Gogh's early delight with Arles began to tarnish when he realized that the local community were not ecstatic at having a difficult Dutch artist living in their midst. He made few friends, with the exception of Roulin the postman, Lieutenant Milliet and Madame Ginoux. In the middle of June, however, he did meet two artists, Eugène Boch (1855–1941) and Dodge McKnight (1860–1950), who were staying in the area and with whom he became friendly. He was not, however, short of inspiration and both the surrounding landscape and the town itself offered a seemingly inexhaustible supply of subjects to paint. His style had evolved from the Paris days, and he was moving away from the influence of the Impressionists. Here he has created a striking divergence in the picture plane between the strong vertical seen through the figures hurrying alongside the river, to the horizontally painted water. This in itself creates ambiguity between the direction the actual flow of the water should be taking, and that implied by his strongly horizontal short brushstrokes. The vivid colouring adds to the surreal and strange effect this painting produces.

CREATED

Arles

MEDIUM

Oil on canvas

SERIES/PERIOD/MOVEMENT

Townscapes

SIMILAR WORK

Three Girls on a Jetty by Edvard Munch

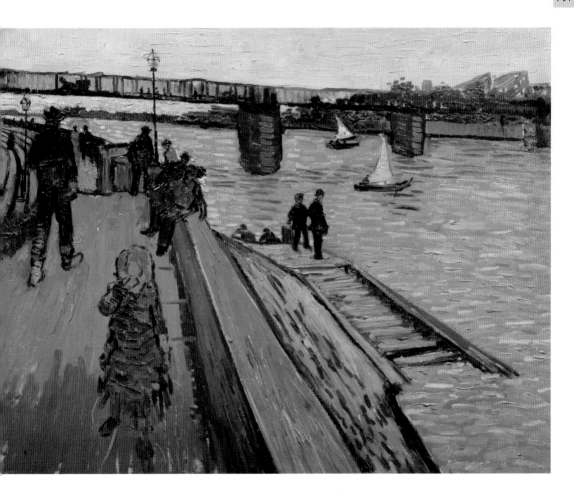

Farmhouses at Saintes-Maries, 1888

In June 1888 Van Gogh visited the small fishing village of Saintes-Maries on the Mediterranean shore where the Rhône runs into the sea, and spent a few days drawing and painting. It was a new world to him and he was instantly inspired from the brightly coloured fishing boats peppering the shoreline to the humble cottages, and all of it bathed in the brilliant Mediterranean sun. Saintes-Maries was not too far from Arles, and he had gone there while the 'Yellow House', his rooms and studio in the town, were being repainted, ostensibly in expectance of Gauguin who Van Gogh hoped to persuade to join him. During his stay Van Gogh wrote to Theo, and in the letter he sketched some of the paintings he was working on, including this one of cottages. On the sketch he noted the colours he was using in the painting so that Theo would be able to envisage the final work. The picture is a tapestry of primary colours and texture with broad areas of pure tone enlivened by contrasting spiky foliage and thickly applied brushwork.

CREATED

Saintes-Maries

MEDIUM

Oil on canvas

SERIES/PERIOD/MOVEMENT

Townscapes

SIMILAR WORK

Cliffs and Sea by Émile Bernard

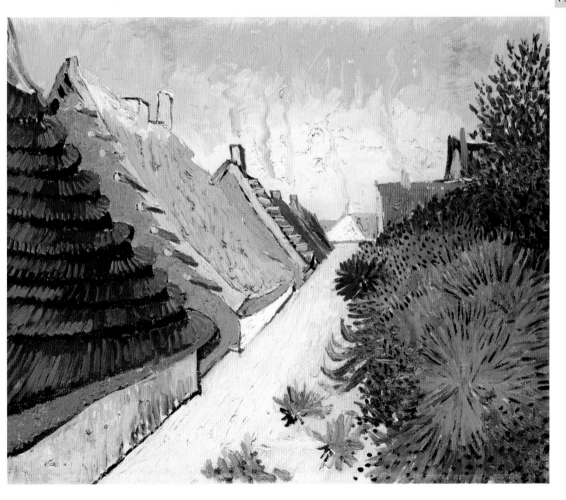

The Rocks, 1888

This painting of craggy rocks and a tree was made just outside Arles and demonstrates Van Gogh's wide use of different brushstrokes to create varying textures through the canvas. His work was increasingly stylized with a linear quality that was offset through his continued exploration of the effects of colour. The boldness of his brushwork and handling of paint, often applied in great thick streaks, is part of what makes his work so identifiably his, unique and beyond classification. He wrote to his brother Theo explaining his new developments, 'I feel that what I learned in Paris is leaving me ... and I should not be surprised if the Impressionists soon will find fault with my way of painting, which has been fertilized by the ideas of Delacroix rather than by theirs.' This is interesting because it illustrates that the artist felt himself more aligned with the Impressionists than any other group, though he also had reservations about their work and their expression of atmosphere at what he believed was the expense of form and content.

CREATED

Arles

MEDIUM

Oil on canvas

SERIES/PERIOD/MOVEMENT

Landscapes

SIMILAR WORK

Mont Saint Victoire by Paul Cézanne, 1900

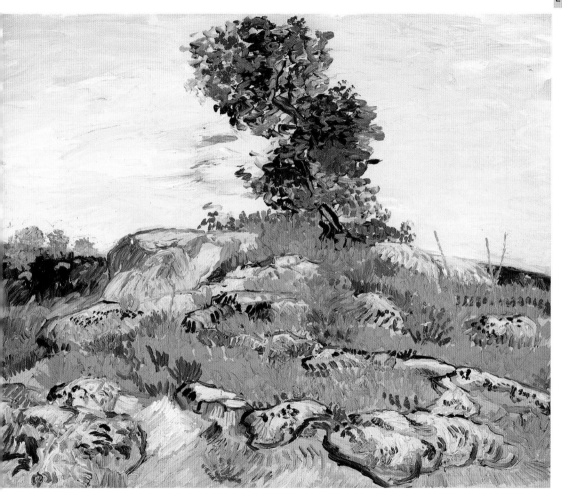

Barges on the Rhône River, 1888

Van Gogh painted this picture of busy barge activity in August 1888, and also made a pen and ink drawing of the same scene, altering a few details. He had heard the news that Gauguin would be joining him in Arles, and he was beside himself with nervous excitement at the thought of establishing a joint studio, and even perhaps an artists' colony of sorts. Here his colours are vibrant and pure, and sing with clarity. The summer was at its height and the strong sun illuminated all that he saw with a particular exoticism that he identified with Delacroix's experiences in Morocco. The very linear composition of these barges was typical of his style at this time, and combines a childlike simplicity with an accomplished eye for perspective and form. This can be seen in the busy figure wheeling a barrow, which is little more than outline with no sense of modelling, but retains its three-dimensionality through its suggested form. This synthesis of simple drawing with assured form and colour makes his paintings so convincing and distinct.

CREATED

Arles

MEDIUM

Oil on canvas

SERIES/PERIOD/MOVEMENT

Landscapes

SIMILAR WORK

The Seine by Jean-Baptiste Armand Guillaumin, 1867–68

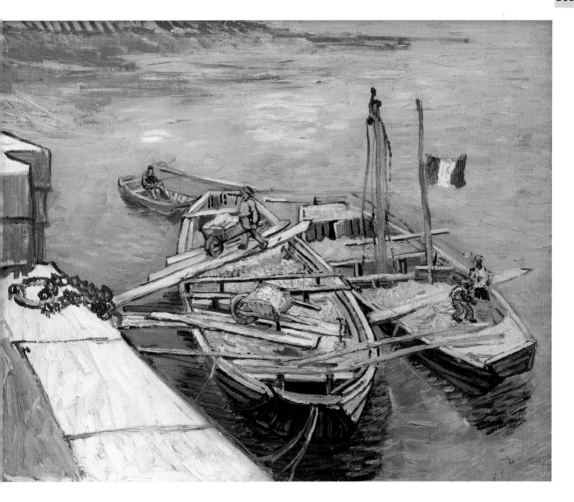

Terrace of the Café, 1888

© akg-images

In this painting the brightly lit café radiates with warmth and inviting light, becoming a beacon of yellow set against the rich, dark blue of a night sky, which in turn is illuminated with myriad bright stars. It is an image full of symbolism for the artist, whose works had gradually become more significant in this respect. The underlying symbolism in this and other paintings of a similar nature that he made, however, is one that was understood primarily by the artist, but was not necessarily so obvious to the impartial viewer. This in turn was a further reflection of the personal, almost therapeutic role that Van Gogh's painting had come to represent to him, and was one that would become increasingly so. The artist attached the colour yellow to feelings of religious inspiration, light and happiness and wrote regarding his 'Yellow House', 'I have had my little house painted yellow, because I want it to be a house of light for everyone.' He applied this feeling to the brightly lit yellow café that had been a welcoming haven of sorts for the artist.

CREATED

Arles

MEDIUM

Oil on canvas

SERIES/PERIOD/MOVEMENT

Landscapes

SIMILAR WORK

Street – Five O'Clock in the Evening by Louis Anquetin

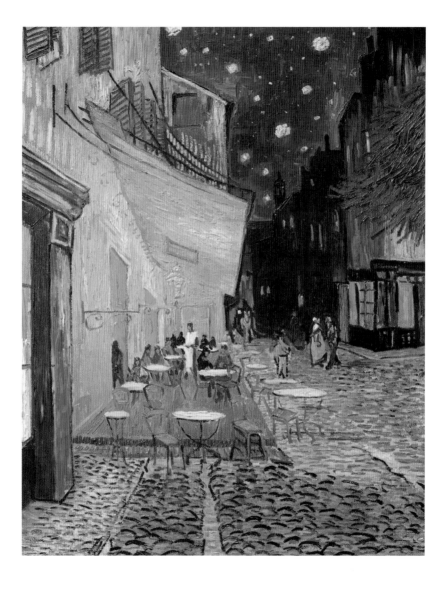

Trinquetaille Bridge, 1888

Historically Arles was an important town with a healthy economy, based primarily on the river trade, and was an important port on the Rhône. With the development of the railway in the nineteenth century traffic and trade on the Rhône was greatly reduced, and as a consequence Arles became much quieter. It was its reputation as a small, hassle-free place that was attractive to Van Gogh, who was seeking peace and a serene atmosphere to work in after chaotic Paris. The Trinquetaille Bridge that appears in this painting was an angular metal structure that spanned the river and joined the two sides of the town. The geometric pattern of the bridge in relation to the steps afforded Van Gogh a new and interesting motif, and the subject of bridges was one that he referred to several times during this period. In this painting a slight murky quality is evident in his colours, and this is something he increasingly employed.

Interestingly, although the bridge has since been rebuilt, there is a large tree now growing where the sapling appears in Van Gogh's painting.

CREATED

Arles

MEDIUM

Oil on canvas

SERIES/PERIOD/MOVEMENT

Townscapes

SIMILAR WORK

Footbridge over River with Wisteria in Foreground in Full Bloom by Ando or Utagawa Hiroshige

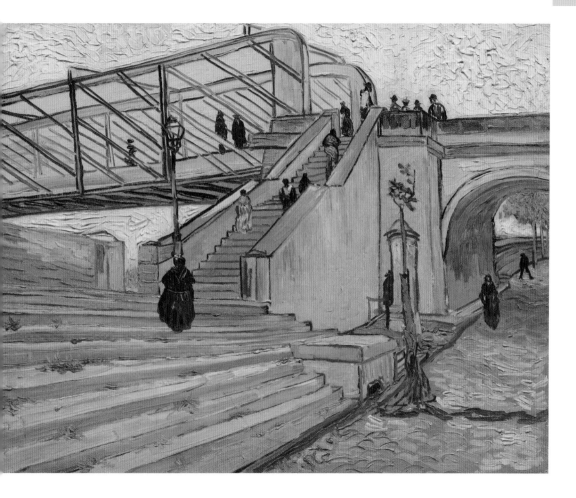

Les Alyscamps, 1888

Gauguin finally arrived in Arles on 23 October 1888 much to Van Gogh's delight. He had decorated and furnished the 'Yellow House' in preparation for his friend, and had his hopes pinned on establishing a joint studio and possibly even attracting other artists to the area. It was a rather different arrangement from Gauguin's perspective. Theo Van Gogh had come to an agreement with Gauguin, and was paying him a fee in return for 12 paintings a year. It was decided that by Gauguin and Van Gogh sharing their accommodation and studio their costs could be reduced, and so at base it was something of a financial decision for the artist to join Van Gogh. It also became quickly apparent that it was a situation that was not going to work.

This painting was one of several of the same subject and was one of the first paintings done with both artists working side-by-side. Their approach and concept of the same motif, however, was very different, even though Van Gogh subsequently worked partially under Gauguin's influence.

CREATED

Arles

MEDIUM

Oil on canvas

SERIES/PERIOD/MOVEMENT

Landscapes

SIMILAR WORK

Les Alyscamps by Paul Gauguin, 1888

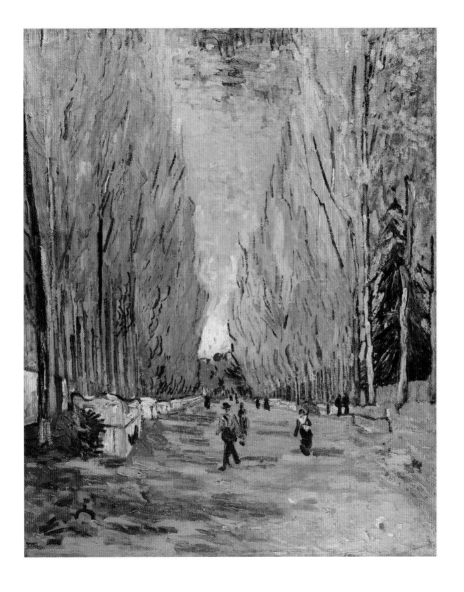

The Sower, 1888

Gauguin was not greatly impressed with Arles and the south of France, and even while there continued to paint figures in the traditional Breton dress from his familiar Brittany. The two artists' relationship was established with Gauguin in the role of leader/teacher, and Van Gogh as a pupil. Van Gogh unreservedly admired Gauguin, and seems to have been unfazed by him taking over control of life at the 'Yellow House'. From correspondence it appears that Gauguin was not altogether complimentary about Van Gogh's work (prior to his stay) and encouraged him to work from memory, which was a disaster for the Dutch artist. Gauguin also considered himself to be the single most important factor in the development of Van Gogh's work, which was certainly not the case.

The Sower was a motif that Van Gogh painted throughout his career, and was partly inspired by the works of Millet. In this painting he created a mystical image of the sower seen as a silhouette against a vast setting sun. The vivid colours and diagonal tree trunk with blossom add to the surreal image that is also reminiscent of Japanese woodcuts.

CREATED

Arles

MEDIUM

Oil on canvas

SERIES/PERIOD/MOVEMENT

Landscapes

SIMILAR WORK

The Sower by Jean-François Millet, 1850

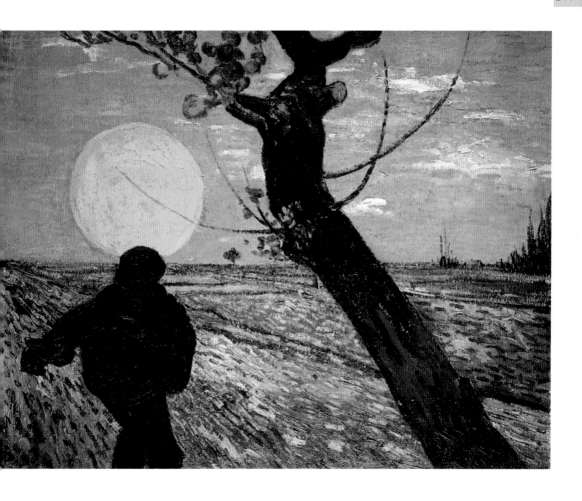

Young Man in a Cap, 1888

During November and December 1888 Van Gogh embarked on a long series of portraits. Portraiture was one of his favourite subjects, but throughout his life he struggled to find willing models, which resulted in multiple paintings of those that would sit for him. In Arles he had become friendly with the postman Roulin and painted him and many members of his family. His other companion was the Zouave officer Milliet who was on leave in Arles after fighting in Tonkin, and who also introduced Van Gogh to a Zouave bugler whom he painted. He painted this portrait of a boy in December, employing his often-used technique of applying a single unifying colour through the image. Here the sallow yellow of the boy's flesh carries on to the background, against which the deep blue hat presents a striking contrast.

During this period Gauguin painted Van Gogh at work, but Van Gogh did not paint Gauguin's portrait. This could perhaps have been a reflection of Van Gogh's lack of confidence in his works, and his reluctance to produce something that might offend his friend.

CREATED

Arles

MEDIUM

Oil on canvas

SERIES/PERIOD/MOVEMENT

Portraits

SIMILAR WORKS

Lady in Green with a Red Carnation by Henri Matisse, 1909

Van Gogh Painting Sunflowers by Paul Gauguin, 1888

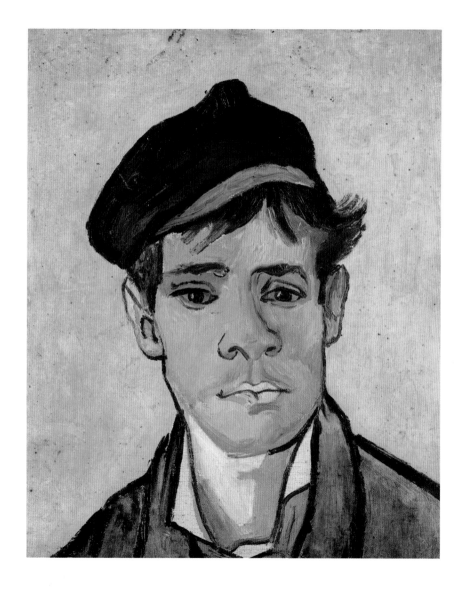

The Arena at Arles, 1888

The history of Arles stretches back to around the sixth century BC when it was established by the Greeks, and in 123 BC it was taken over by the Romans under whose direction it became an important city. Remnants of the town's ancient past, including its amphitheatre, Roman theatre and Necropolis (the Alyscamps), are still scattered through the area, and it is the arena or amphitheatre that Van Gogh has depicted here. The arena itself is not that evident at first glance, being tucked away in the top corner, what is more striking is the group of milling figures that crush into the foreground. The whole painting has an atmosphere of jittery activity, and the sketchy figures drawn in the middle distance and background compound this sense of motion. He used a similar approach in another painting done at around the same time of the dancehall at Arles. This second work is more highly finished, and reflects the influence of Gauguin to a greater degree, and indeed the dancehall was one of Gauguin's haunts while he was staying with Van Gogh.

CREATED

Arles

MEDIUM

Oil on canvas

SERIES/PERIOD/MOVEMENT

Works at Arles

SIMILAR WORK

At the Moulin de la Galette by Henri de Toulouse-Lautrec, 1899

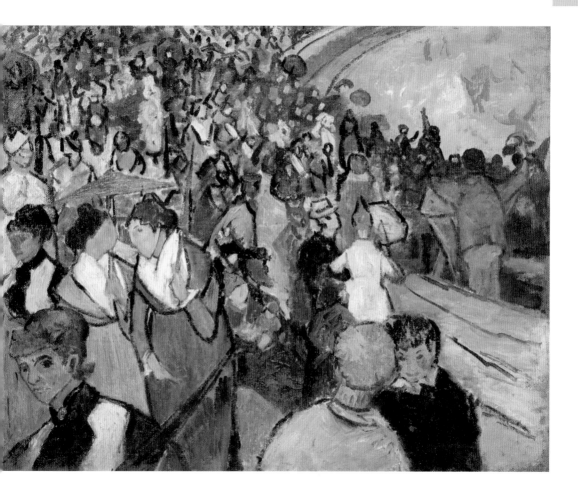

Lilac, 1889

Van Gogh arrived at the asylum of Saint-Paul-de-Mausole in Saint-Rémy in May 1889, and came under the supervisory care of Dr Peyron, a former naval doctor. It was a voluntary move for the artist, who had realized that he was unable to live alone, and had been shunned by the local people of Arles. He was allocated two rooms side-by-side, one to serve as a bedroom and one as a studio, and was allowed to wander the asylum and its garden at will, unlike most of the other patients who were more seriously disturbed. Later, Van Gogh would also be allowed on short painting excursions into the countryside while accompanied by an attendant. He threw himself into his work, painting the view from his barred window and produced several pictures of irises and this painting of lilac blossom shortly after his arrival. Over the course of the past few troubled years, spring had seemed to be the most positive time for the artist, who was always inspired by flowers and blossom. Here the lilac bush is delicately coloured with the whole painting having a cohesive green-blue scheme that makes it ultimately harmonious.

CREATED

Saint-Rémy

MEDIUM

Oil on canvas

SERIES/PERIOD/MOVEMENT

Blossoms

SIMILAR WORK

Spring by Claude Monet, 1875

Olive Trees, 1889

The asylum was situated in the countryside approximately 3 km (2 miles) outside the village of Saint-Rémy. Surrounding the building, which had been built in the twelfth century to house a monastery, were acres of wheat fields, cypress trees, olive groves and vineyards. It was a wild, rugged and beautiful place, though it was also lonely and remote. The artist's style again evolved here, with his increasing use of great rhythmic brushstrokes and swirling tumultuous forms. He took the natural object, such as the gnarled old olive trees seen here, and stylized it through the swells and curves of his circles of paint. The expression in his brushstrokes and the actual application of the strokes were indicative of his agitated and nervous mind, while there is a great sense of urgency and a frisson of barely contained feeling that is evident through his pattern of applied paint. At the same time his palette again became noticeably darker. He still favoured vivid colour, but the colour was less pure and startling and was imbued with an overall sombre quality.

CREATED

Saint-Rémy

MEDIUM

Oil on canvas

SERIES/PERIOD/MOVEMENT

Late landscapes

SIMILAR WORK

Landscape with Dead Wood by Maurice de Vlaminck, 1906

Self Portrait, 1889

In July 1889 Van Gogh suffered a serious attack following a brief trip back to Arles. The breakdown was accompanied by suicidal intentions and frightening religious hallucinations. Religious aspirations and ideals had been important to the artist whose father had been a Protestant pastor, and it is possible that these recent hallucinations were partly a product of the religious atmosphere of the asylum that was once a former monastery and remained strongly Catholic. His recovery was slow, and following it he painted several religious pictures after Delacroix and Rembrandt, and several self portraits. This particular painting is unusual in that it depicts the artist clean-shaven and bereft of his usual flame-coloured beard. It is an extraordinarily moving painting that was painted with brutal honesty reflecting the artist's extreme despair and resignation to his plight. The white glimpsed at his neck suggests the white of a dog collar, possibly a reference to the recent religious manifestations that he had found so deeply disturbing. The second self portrait of this period shows a deathly pale figure, with beard and artist's palette, set against a deep blue background.

CREATED

Saint-Rémy

MEDIUM

Oil on canvas

SERIES/PERIOD/MOVEMENT

Late self portraits

SIMILAR WORK

The Old Farmer by Paula Modersohn-Becker, 1903

Wheat Field Behind St Paul's Hospital, Saint-Rémy, 1889

Despite the beauty of the countryside surrounding the asylum, Van Gogh began to lose his inspiration towards the end of 1889, and dreamt of leaving and returning to the north of France. He had no stimulating company at Saint-Rémy, no one to discuss and debate art with and no one with whom he made a connection. His associations with Dr Peyron were amicable, but not close, and likewise with two of the guards, but that was the extent of his circle. Lacking subjects to paint he turned to making copies of works by Millet, returning to the peasant/labourer theme that had dominated his early career. He also made several paintings of the wheat field that appears here. Many of these versions are almost identical and all include the huge glowing orb of the sun, which he had come to view with a religious symbolism. The overall yellow tonality of this picture, bar the strip of mountains, makes the peasant toiling in the field almost a part of the wheat itself, and similarly the lines of the figure match the fluid curves of the bending wheat shafts.

CREATED

Saint-Rémy

MEDIUM

Oil on canvas

SERIES/PERIOD/MOVEMENT

Wheat fields

SIMILAR WORK

Landscape near Chatou by Maurice de Vlaminck, 1906

Hospital of Saint-Paul, 1889

© akg-images

The original buildings of the asylum dated back to the twelfth and thirteenth centuries, and were built to house an Augustine monastery. Over the years the building was added to and modified, and in the nineteenth century when the monastery was converted to the asylum two wings were added to either side of the main building. The façade that Van Gogh painted in this picture shows an elegant front with traditional French shutters and a 'classicized' portico. It is a painting of a fine looking house in pleasant settings, and even the smart figure in the foreground has something of the air of a country gentleman. The painting was strange in relation to Van Gogh's particularly unhappy period during the time it was painted. Compared to many of his paintings of this time there is little of the obvious anguish and turmoil that one would expect, especially in relation to the subject of the hospital, which itself was causing him such misery. What is apparent in the picture is a sense of oppressiveness, though in a more understated manner than was usual for the artist.

CREATED

Saint-Rémy

MEDIUM

Oil on canvas

SERIES/PERIOD/MOVEMENT

Works at the Saint-Rémy asylum

SIMILAR WORK

Restaurant de la Machine at Bougival by Maurice de Vlaminck, c. 1905

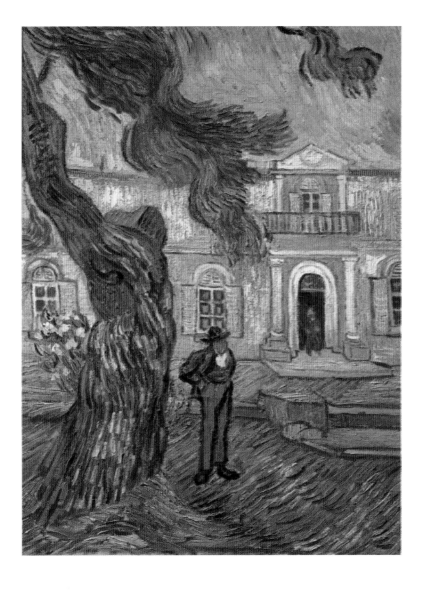

The Bench at Saint-Rémy, 1889

By the autumn of 1889 Van Gogh had wearied of asylum life and longed to leave and return to the north. His illness, which was variously described as epilepsy, schizophrenia and acute mania, had not improved. In fact, during the course of 1889 he had become progressively worse and his attacks more frequent. From correspondence between Van Gogh and Theo it seems that Dr Peyron did little to further his understanding of the artist's condition and gave him sparse treatment. The asylum had become unbearable to Van Gogh and the constant clamour of the other patients, the lack of social or artistic inspiration and the ceaseless depression compounded his urge to leave. In November, the month of this painting, Dr Peyron advised Van Gogh that he was too unstable to leave and suggested that he spent the winter there before reviewing the situation the following spring. It must have been a devastating blow, and this picture done in the asylum gardens reflects something of this desolation. It has a strange perspective and no horizon, which makes it oppressive and emphasizes Van Gogh's own feelings of being trapped.

CREATED

Saint-Rémy

MEDIUM

Oil on canvas

SERIES/PERIOD/MOVEMENT

Works at the Saint-Rémy asylum

SIMILAR WORK

At the Bottom of the Gulf by Paul Gauguin, 1888

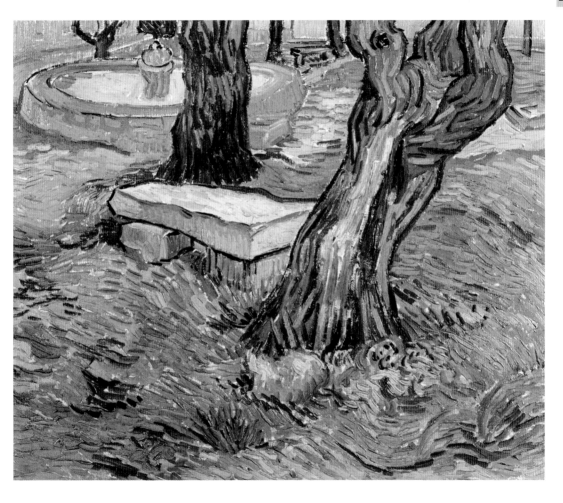

Dr Gachet's Garden, 1890

Van Gogh arrived in Auvers-sur-Oise in May 1890, and came under the independent care of Dr Gachet, an eccentric and lively character. Auvers was a popular place for artists, being a small rural, scenic and tranquil village, yet still only approximately 26 km (16 miles) from Paris. It was served by a good rail link that made trips out from Paris easy and fast, and was a popular destination. As a consequence, the local people of Auvers were somewhat more used to unusual artistic characters and new faces, which made Van Gogh less of an anomaly here than he was in Arles. Dr Gachet's house was one of the larger structures in the village and boasted an impressive garden that Van Gogh painted several times. By this stage, although Van Gogh was living and apparently functioning on his own, his illness had deteriorated and his paintings had become further reflections of his state of mind. His palette, though strong, has an overall dark inflection seen here, and his forms had become further stylized and simplified with a greater expression through his brushstrokes.

CREATED

Auvers-sur-Oise

MEDIUM

Oil on canvas

SERIES/PERIOD/MOVEMENT

Last works

SIMILAR WORK

The Hill at Bougival by Maurice de Vlaminck, 1906

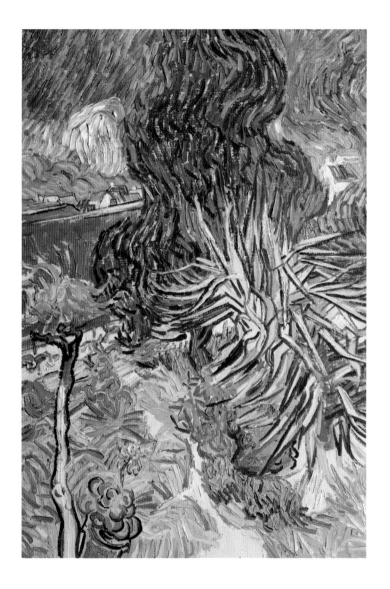

Houses in Auvers, 1890

The quiet dirt streets of Auvers were lined with old traditional French cottages, as seen here, with their charming rustic coloured shutters. It was not a wealthy area and the houses were for the most part small, with a number of poorer peasant cottages with thatched roofs. The village was dominated by two larger structures: the church and Dr Gachet's house, and was surrounded by open wheat fields and the Oise valley. In spite of Van Gogh's increasing mental instabilities he was enthusiastic about Auvers and wrote to Theo, 'It is of grave beauty, the real countryside, characteristic and picturesque.'

He painted the village and cottages numerous times. In most of these paintings the slightly ramshackle buildings huddle together in a mass of leaning, uneven rooflines and blend into their surroundings so that they become a part of the landscape from which they rise. Here the overall tonality encompasses buildings, sky and greenery, though the colours are lighter and more delicate then many of his works. There is also a finer quality to the drawing with less of the heavy outline that came to characterize his later paintings.

CREATED

Auvers-sur-Oise

MEDIUM

Oil on canvas

SERIES/PERIOD/MOVEMENT

Last works

SIMILAR WORK

View of Auvers-sur-Oise by Paul Cézanne

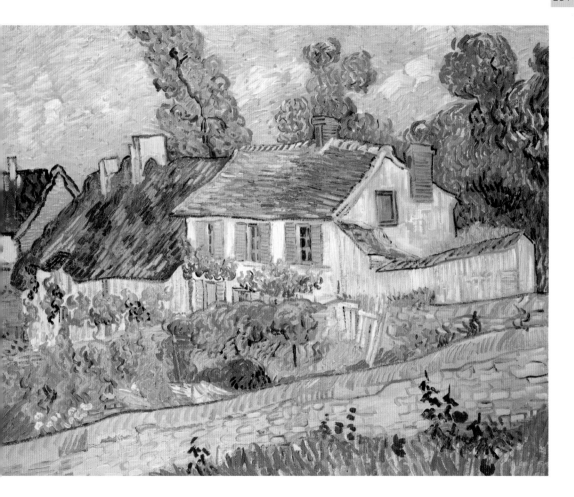

Roses and Anemones, 1890

© Musée d'Orsay, Paris, France, Giraudon/The Bridgeman Art Library

In the days before leaving Saint-Rémy Van Gogh had embarked on a series of still-life paintings of cut flowers. This was a subject that he had periodically turned to through his short career, and one that he returned to in Auvers. In June he painted a number of pictures of flowers in vases, including this one with a strong Oriental feel and a strange distorted perspective. This was a short period of relative calm and happiness for the artist, who had characteristically thrown himself into his work. He had also planned to start drawing again while at Auvers, and his interest in drawing is discernible in this work. He had written to Theo full of enthusiasm for his new friend Dr Gachet and had described how the doctor's house was full of art and 'full of useful things to arrange flowers in or to compose still lifes', suggesting that he painted this work at his house. Van Gogh's initial happiness at Auvers was in good measure linked to his rapport with Dr Gachet, who provided him with stimulating company, and more importantly was full of praise for his work.

CREATED

Auvers-sur-Oise

MEDIUM

Oil on canvas

SERIES/PERIOD/MOVEMENT

Last works, still lifes

SIMILAR WORKS

Flowers in a Green Vase by Odilon Redon, 1910

Dahlias by Paul Cézanne, c. 1873

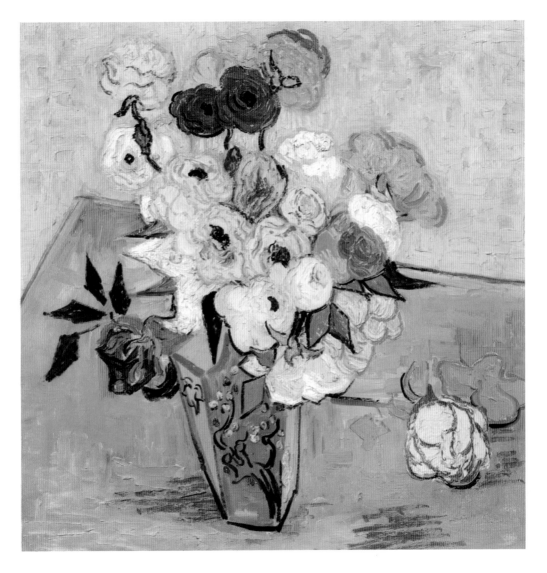

Cows, 1890

© Musée des Beaux-Arts, Lille, France, Lauros/Giraudon/The Bridgeman Art Library

Dr Gachet was friendly with a number of artists, including Pissarro, who had recommended the doctor to Theo Van Gogh, Cézanne, Guillaumin, Édouard Manet (1832–83), Gustave Courbet (1819–77), Pierre-Auguste Renoir (1841–1919) and others. He was a keen amateur painter, and had a large collection of paintings, prints and antiques, all of which were of tremendous interest to Van Gogh, especially in relation to his previous year spent in the asylum of Saint-Rémy that was devoid of such treasures. Included amongst Gachet's works was a print of *Cows* by Jacob Jordaens (1593–1678), from which Van Gogh made this painting. The work is unresolved in composition, although it follows the original closely, and the forms are sketchy with an unnatural colour scheme that lends the painting a surreal effect. Van Gogh included a wheeling crow, which has something of an ominous presence, and was a motif that he used quite often in his final works. *Cows* was also an unusual choice for the artist, who rarely painted animals and certainly not in such close focus. Interestingly, there have been doubts raised about the authenticity of this work, although it remains attributed to Van Gogh.

CREATED

Auvers-sur-Oise

MEDIUM

Oil on canvas

SERIES/PERIOD/MOVEMENT

Last works

SIMILAR WORK

Cows by Jacob Jordaens

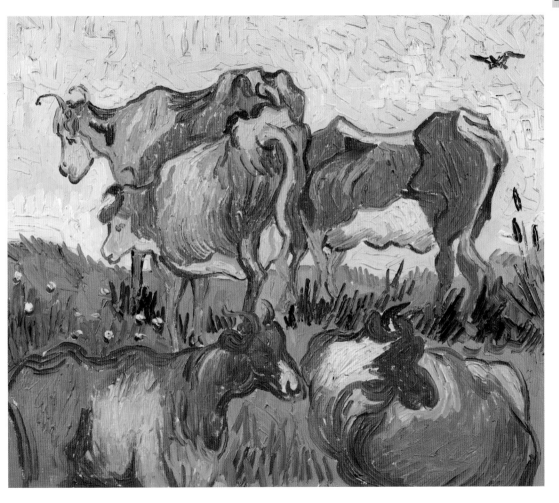

Fields with Blooming Poppies, 1890

© akg-images

The area surrounding Auvers afforded Van Gogh plenty of scenery for inspiration, and during his last months the artist painted numerous scenes of wheat fields and wide-open, windy countryside. The sky here has an oppressive weight, and seems to bear down on the vast expanse of land, while both the sky and the land have been painted with an undulating rhythm that suggests great movement. The picture has an uneasiness, which is compounded by peculiar perspective. The field delineated to the right of the picture appears to jump forward, while those to the left that should be on the same plane rush backwards, and there is a spatial ambiguity between the area of poppies in the foreground and the fields in the distance. The whole presents a turbulent image that is unsettling and unconvincing. The painting was done in the weeks prior to him taking his own life, and at a time when his world was falling in. He was extremely anxious about his brother Theo and his family, and had fallen out with Dr Gachet – he felt alone and ultimately unable to cope.

CREATED

Auvers-sur-Oise

MEDIUM

Oil on canvas

SERIES/PERIOD/MOVEMENT

Last works

SIMILAR WORK

Landscape at Collioure by Henri Matisse, 1905

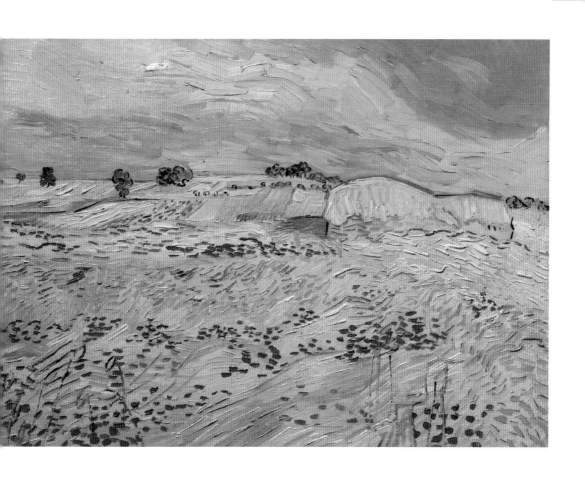

Van Gogh

The Gleaners, 1857

© akg-images

Jean-François Millet (1814–75) perhaps above all other artists had the most profound effect on Van Gogh, and it was an effect that spanned the artist's career from the beginning to the last months of his life. Millet and other members of the French Barbizon School (*c.* 1845–70) became known for their form of romantic naturalism, depicting peasants and labourers hard at work against the wide-open countryside. These were images that became very popular amongst painters in The Hague in the second half of the nineteenth century, at the time Van Gogh was starting to establish his career. Millet's peasants in particular are monumental figures, addressed romantically with an earthy worthiness and a sense of their eternal condition. These are not paintings that rise up against the social conditions of the workers, but rather honour the tradition of their work and identify them as caught in this perpetual cycle. Van Gogh had accumulated a collection of prints by 1875 of works by Millet, Jean-Baptiste-Camille Corot (1796–1875), Charles-François Daubigny (1817–78), Jules Breton (1827–1906) and more, and by 1880 was copying them to aid the development of his style.

CREATED

Barbizon

MEDIUM

Oil on canvas

SERIES/PERIOD/MOVEMENT

Barbizon School

SIMILAR WORK

Calling the Gleaners Home by Jules Breton, 1859

Jean-François Millet *Born* 1814 Gréville-Hague, France

Died 1875

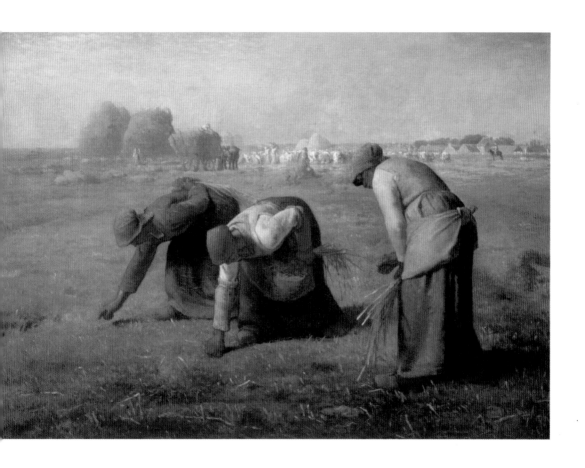

The Sower (after Millet), 1889

This painting from near the end of Van Gogh's career was of a subject that the artist had painted many times over the preceding years, and is an almost exact copy of one of his works painted in 1881. Peasant imagery was of great importance to Van Gogh, who began his career by copying prints of Millet, Corot and other members of the Barbizon School. Van Gogh was a particular admirer of Millet, and once wrote about painting that, 'since Millet we have greatly deteriorated'.

Although Van Gogh was born into a middle-class family, he came from a small town, Nuenen where agriculture and therefore hard labour was a prevalent industry, and he later worked in areas of great poverty. He developed a strong sympathy and respect for the peasants that he saw, and was socialist in his opinions and outlook. His depictions of peasants remained similar in concept to those of Millet, in that he gave his figures an eternalizing, romantic spirit that emphasized their long history rather than using his paintings to advocate change.

CREATED

Saint-Rémy

MEDIUM

Oil on canvas

SERIES/PERIOD/MOVEMENT

Peasants and labourers

SIMILAR WORK

The Sower by Jean-François Millet, 1850

Vincent Van Gogh *Born* 1853 Groot-Zundert, The Netherlands

Died 1890

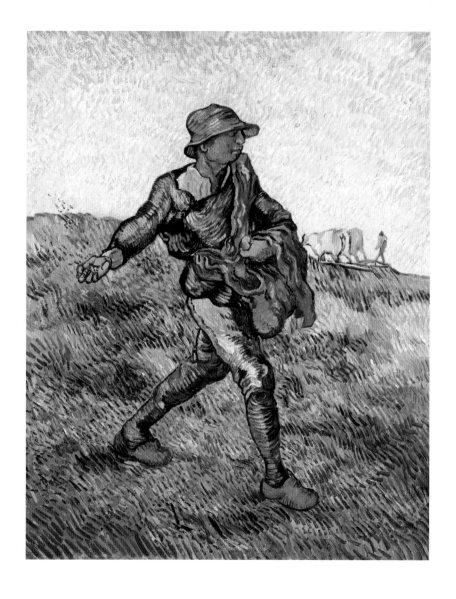

Noon: Rest from Work (after Millet), 1890

© akg-images

In the autumn of 1889 and into 1890 Van Gogh embarked on a series of paintings taken from his collection of prints that included above all Millet, but also, Eugène Delacroix (1798–1863), Rembrandt (1606–69), Honoré Daumier (1808–79) and Gustave Doré (1832–83). It was a period when the artist was lacking in inspiration from external motifs – he had been at the asylum at Saint-Rémy since May – and he was profoundly depressed. He once again turned to peasant subjects, and painted this picture after Millet's. The prints from which he worked were black and white, and consequently Van Gogh had to devise his own colour system, which undoubtedly he would have done anyway. Moving away from the Dutch colouring of his earliest peasant images, Van Gogh had now become greatly concerned with colour and its function on a symbolic and metaphysical level. Here the scene is drenched in the brilliant yellow of the field and sparkling blue of the sky, both of which were naturally occurring under the strong Mediterranean sun. However, his colours are beyond natural and are an exaggeration or a distillation of the world he saw.

CREATED

Saint-Rémy

MEDIUM

Oil on canvas

SERIES/PERIOD/MOVEMENT

Peasants and labourers

SIMILAR WORKS

Noonday Rest by Jean-François Millet, 1866

Noon (after Millet) by John Singer Sargent, *c.* 1875

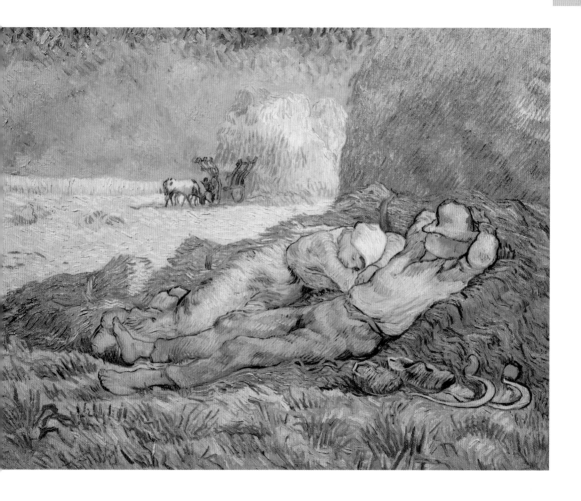

Boat on the Beach at Scheveningen, 1876

© Museum of Dordrecht, The Netherlands, Lauros/Giraudon/The Bridgeman Art Library

Anton Mauve (1838–88) was a successful artist in The Hague and was married to Van Gogh's cousin, Jet Carbentus. Mauve worked in the realist manner of The Hague School under the influence of the French Barbizon painters, and later moved to Laren, where he established the Laren School with Albert Neuhuys (1844–1914) and Jozef Israëls (1824–1911), who were also influential on the development of Van Gogh's peasant interiors. When Van Gogh moved to The Hague he was briefly taken under Mauve's wing, and the older artist's work became of some influence on his early style. Mauve's work was primarily of subjects such as this, of peasants at work, sheepherders and labourers, and was commercially popular. Mauve is reputed to have given Van Gogh his first lesson in oil painting and helped him to set up his first studio. The relationship was to be short lived, and the pair parted company after an argument about Van Gogh's refusal to draw from plaster casts. Van Gogh retained some fondness and acknowledgement of the older artist's help, and when Mauve died in 1888, he painted *Pink Peach Trees* that he dedicated to Mauve's memory.

CREATED

Scheveningen

MEDIUM

Oil on canvas

SERIES/PERIOD/MOVEMENT

The Hague School

SIMILAR WORK

Beach at Scheveningen in calm Weather by Vincent Van Gogh, 1882

Anton Mauve *Born* 1838 Zaandam, The Netherlands

Died 1888

The Angel (after Rembrandt), 1889

Of all the Old Masters, it was Rembrandt that Van Gogh most admired and who had the greatest effect on his work. In 1885 Van Gogh travelled to Amsterdam specifically to visit the galleries and museums, and while there his affinity for Rembrandt's work was reaffirmed. To Van Gogh Rembrandt's paintings provided an unsurpassable model of colouring and realism, which like the romantic colouring of Delacroix and Adolphe Monticelli (1824–86) was to influence the young Dutchman. He painted this angel after Rembrandt at a time when he was making copies of prints by other artists. He had been in the asylum at Saint-Rémy for some months and was suffering greatly from his mental illness, which had recently included episodes of distressing religious manifestations. Religion had formed a large part of Van Gogh's life, and it was a subject that he approached with his own form of spirituality, transferring religious feelings of 'awakening' and 'light' for example to his symbolic depictions of glowing stars and the sun. Here he has combined a naturalistic head in the manner of Rembrandt with a shimmering transcendental colouring, and the whole is rather disturbing and unresolved.

CREATED

Saint-Rémy

MEDIUM

Oil on canvas

SERIES/PERIOD/MOVEMENT

Religious works

SIMILAR WORK

Matthew and the Angel by Rembrandt, 1661

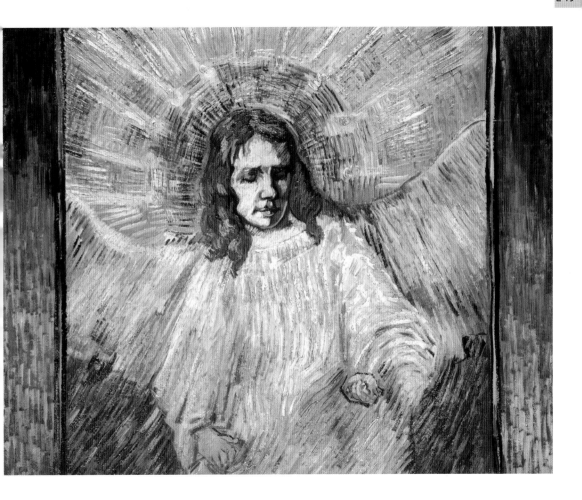

Dr Gachet's House, c. 1873

In 1872 Paul Cézanne (1839–1906) moved to Auvers-sur-Oise where he became acquainted with Dr Gachet, who would later look after Van Gogh in the last 70 days of his life. During his time in the rural village Cézanne worked alongside his mentor Camille Pissarro (1830–1903), whose work influenced much of his later style. It is documented that Van Gogh met Cézanne at least once at the art supplies shop owned by Père Tanguy, who was also one of the few people to deal in Cézanne's work. Cézanne would later refer to Van Gogh's paintings as the 'work of a madman', but Van Gogh admired much of Cézanne's work, and in particular this painting of *Dr Gachet's House*. After Van Gogh moved to Auvers and had met Dr Gachet, he wrote to Theo and mentioned this painting and *Geraniums and Coreopsis in a Small Delft Vase*, and *Bouquet in a Small Delft Vase*, all done in 1873. It was Cézanne's synthesis of nature into art, and simplification of the natural form to its basic components, combined with his colours that were of significant influence to Van Gogh's evolving visual language.

CREATED

Auvers-sur-Oise

MEDIUM

Oil on canvas

SERIES/PERIOD/MOVEMENT

Impressionism

SIMILAR WORK

Houses in Auvers by Vincent Van Gogh, 1890

Paul Cézanne *Born* 1839 Aix-en-Provence, France

Died 1906

Boulevard de Rocheouart in Snow, 1878

© Private Collection/The Bridgeman Art Library

Pissarro by substantiated accounts was not only an extraordinary painter and influential in the development of modern art, but was also an extraordinary man. He was strongly moral, politically an anarchist, and was unfailingly charitable and kind to everyone, being one of the few people able to stay friendly with such difficult characters as Cézanne and Van Gogh. Referred to as the 'Father of Impressionism' his interest in painting techniques and effect and colour theories had a profound effect on his fellow Impressionists. As his style developed and he turned towards increasing experimentation with colours and a Neo-Impressionistic style and even Pointillism, his range of influence extended to the new generation of Post-Impressionistic artists. He was one of the first painters actively to befriend Van Gogh on the Dutchman's arrival in Paris, and remained friendly with him through his life – it was Pissarro who suggested Van Gogh should come under Dr Gachet's care in Auvers. Van Gogh both admired and respected Pissarro, and absorbed elements of his style, especially while he was living in Paris and working in a manner more in line with the Impressionists.

CREATED

Paris

MEDIUM

Oil on canvas

SERIES/PERIOD/MOVEMENT

Impressionism

SIMILAR WORK

Boulevard de Clichy by Vincent Van Gogh, 1887

Camille Pissarro *Born* 1830 Charlotte Amalie, The Virgin Islands

Died 1903

Tulip Fields with the Rijnsburg Windmill, 1886

© Musée d'Orsay, Paris, France/The Bridgeman Art Library

When Van Gogh arrived in Paris in 1886, the same year Claude Monet (1840–1926) painted this picture, it was a city in the midst of a major revolution in the arts, and the paintings that he saw would have a pronounced effect on his work. His palette, which had to this point been dark and tonal, lightened dramatically and his style became directly influenced by the painting techniques of the Impressionists. Monet was one of the leading and most influential of the Impressionist painters – it was his painting, *Impression, Sunrise*, 1872 that gave the group their name when it was jokingly ribbed by the critics after the First Impressionist Exhibition in 1874.

Although Monet and the Impressionists had a profound effect on Van Gogh's style, especially in relation to brightened colour and brushwork, he was never as interested in the fleeting effects of light and atmosphere, and put more store in form, and colour symbolism. He actively disagreed with some of their theories on colour, and actually defined his style through his unique synthesis of different sources of influence.

CREATED

Holland

MEDIUM

Oil on canvas

SERIES/PERIOD/MOVEMENT

Impressionism

SIMILAR WORK

Windmill on Montmartre by Vincent Van Gogh, 1886

Claude Monet *Born* 1840 Paris, France

Died 1926

Rice Powder, 1889

Ostensibly one of the main reasons for Van Gogh travelling to Paris, other than the presence of his brother Theo, was to study at the studio of Félix Cormon (1845–1924). Although it cannot be proved, it is generally accepted that he did enter this studio, and there he would have met a number of artists including Henri de Toulouse-Lautrec (1864–1901), Louis Anquetin (1861–1932), Émile Bernard (1868–1941) and John Russell (1858–1930). Van Gogh and Toulouse-Lautrec enjoyed an uneasy friendship based on their opposing characters, but it was enough of a friendship that when Van Gogh made a brief day trip to Paris in June 1890, just weeks before his suicide, he met up with Toulouse-Lautrec.

Both artists were keen 'people' painters and they both strove to paint the spirit, mood and essence of their models, depicting them with the nitty gritty details of real life. Van Gogh was attracted to Toulouse-Lautrec's combination of naturalism, seen here, with a modern delivery that gave figural paintings a new dimension. Elements, too, of Toulouse-Lautrec's graphic works and his Cloisonnism were absorbed by Van Gogh, whose own work had evolved rapidly with his assimilation of the artistic scene in Paris.

CREATED

Paris

MEDIUM

Oil on cardboard

SERIES/PERIOD/MOVEMENT

Impressionism

SIMILAR WORK

Agostina Segatori Sitting in the Café du Tambourin by Vincent Van Gogh, 1887

Henri de Toulouse-Lautrec *Born* 1864 Albi, France

Died 1901

Flowering Plum Tree (after Hiroshige), 1887

© akg-images

Although Van Gogh had encountered Japanese art before, when he arrived in Paris he was surrounded by it. Japanese art went on to become one of the most profound and sustained influences on Van Gogh's work, and was something that he referred to throughout his career. In 1854 Commodore Perry had opened up trade doors with Japan, and there followed an almost instant interest in Japanese art. Madame Desoye opened a shop dealing in Oriental pictures and artefacts in the rue de Rivoli in 1862, and this made Japanese art noticeable and accessible to artists of the day.

Van Gogh absorbed the style of the Japanese woodcut, employing motifs of the woodcut into his own work, such as this painting of a plum tree in blossom. He also developed his style using a distinct outline, similar to that seen in some woodcuts, and used areas of pure colour as he incorporated elements of Cloisonnism into his works. He made several direct copies of Japanese prints, and included Japanese prints in the background of some of his paintings, noticeably in a portrait of Père Tanguy done in 1887–88.

CREATED

Paris

MEDIUM

Oil on canvas

SERIES/PERIOD/MOVEMENT

Japanese works

SIMILAR WORK

Branch of a Flowering Apple Tree by Ando or Utagawa Hiroshige

Bathers at Asnières, 1884

Two years before Van Gogh went to Paris a young painter exhibited an enormous canvas at the first exhibition of the Salon des Artistes Indépendants in 1884, amidst great consternation. The painter was Georges Seurat (1859–91) and the picture is the one seen here. He based his approach to painting on strict scientific laws and colour theories, and developed what came to be known as Pointillism, or Divisionism as he himself called it. Many of the Impressionist painters were fiercely critical of this new approach to painting light and atmosphere and refused to exhibit at their eighth exhibition after Pissarro invited Seurat and Paul Signac (1863–1935) to show with them.

Van Gogh is not thought to have met Seurat until the autumn of 1887, although he was familiar with and an admirer of his work, and only visited his studio once, on the day he left Paris for Arles. Undoubtedly Seurat's work was of influence to Van Gogh, who experimented with the same subject matter and use of colour, though Van Gogh did not approach his colours with the same degree of scientific exactitude.

CREATED

Asnières

MEDIUM

Oil on canvas

SERIES/PERIOD/MOVEMENT

Pointillism

SIMILAR WORK

Lane in Voyer d'Argenson Park at Asnières by Vincent Van Gogh, 1887

Georges Seurat *Born* 1859 London, England

Died 1891

The Buoy, 1894

Van Gogh enjoyed a relatively close relationship with Signac, and during the spring of 1887 the two spent some time painting together at Asnières, where they painted similar motifs, in a similar manner. Later, in March 1889 after Van Gogh's first breakdown Signac visited him at the hospital in Arles and helped him retrieve his belongings from his house.

Signac was a follower of Seurat, but gradually moved away from the strict scientific approach to the use of colour and became more decorative in his work with a freer application of his paint. His work was absorbed by Van Gogh who was more akin to Signac in his use of colour than to Seurat. Van Gogh was particularly taken with the effect caused by theories on complementary colours, used by both Seurat and Signac, and referred to them frequently through his career. Van Gogh came most under the influence of Signac when the two worked together, and after he left Paris for Arles, his style developed away from Signac's, and his colours became more personal, and imbued with a symbolism not present in the young Pointillist's work.

CREATED

France

MEDIUM

Lithograph

SERIES/PERIOD/MOVEMENT

Pointillism

SIMILAR WORK

The Banks of the Seine with Boats by Vincent Van Gogh, 1887

Paul Signac *Born* 1863 Paris, France

Died 1935

Pietà (after Delacroix), 1889

Van Gogh had admired the work of Delacroix long before he arrived in Paris, and was greatly impressed with the subtle vibrancy of his palette. Delacroix's work, with reference to his understanding of colour, had also been influential on the work of the Impressionists, the Neo-Impressionists and the Pointillists such as Seurat and Signac. It was Delacroix's romantic colouring that was of primary influence on Van Gogh, who was not so drawn to his choice of subjects, and mostly based his paintings on the world at large rather than religious, romantic or mythical topics. There were a few exceptions, with this *Pietà* being one. At the time Van Gogh painted this he was suffering a period of tormented religious dreams, and it is probable that this Pietà was as a result of this. Ironically, the print of Delacroix's work that he had was in black and white and therefore denied the artist the one element that he was so influenced by. As a consequence Van Gogh's *Pietà* was based on an assimilation of his interpretation of colour, and recollections of Delacroix's colouring from originals he had seen previously.

CREATED

Saint-Rémy

MEDIUM

Oil on canvas

SERIES/PERIOD/MOVEMENT

Religious works

SIMILAR WORK

Pietà by Eugène Delacroix, *c.* 1850

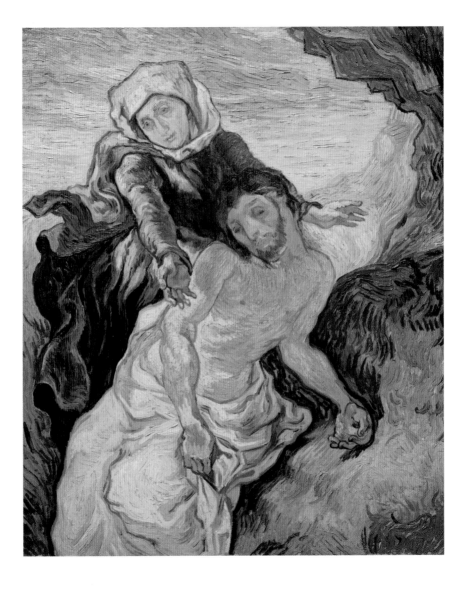

Prisoners Exercising (after Doré), 1890

© akg-images

There is little doubt to the significance of this painting that was done in February 1890, at a particularly troubled time in Van Gogh's life. He was severely depressed and desperate to leave the stultifying environs of the asylum at Saint-Rémy, but it had been decided that he would not be fit to cope alone until the spring. His feelings of being physically trapped, and mentally caught in a perpetual cycle of mental illness beyond his control are clearly evident. The painting was actually made after a print of Newgate Prison in London by Doré, whose work Van Gogh had admired for some years. Van Gogh had begun to collect graphic illustrations from magazines in the early 1880s, and added prints of Daumier, Paul Gavarni (1804–66) and Doré to his collection. He then referred to these works in later years (as well as multiple prints of Millet's paintings), often making several copies of a single image. The prints were in black and white, so Van Gogh improvised with the colour, and gave the paintings his own visual interpretation.

CREATED

Saint-Rémy

MEDIUM

Oil on canvas

SERIES/PERIOD/MOVEMENT

Copies of prints

SIMILAR WORK

Newgate Prison Exercise Yard by Gustave Doré

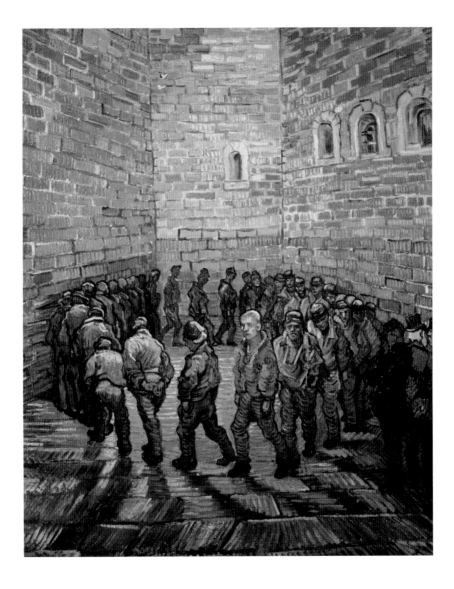

Self Portrait (Les Miserables), 1888

In 1888 Van Gogh suggested to Paul Gauguin (1848–1903) and Bernard that they should paint each other's portraits and send them to him, while he would paint his own portrait and send it to Gauguin. The concept of exchanging paintings and sharing artistic theories was one that Van Gogh had absorbed through his study of Japanese art, where artists tended to work as a brotherhood. This was an idea that had appealed to Van Gogh for some years and was reflected by his ambition to form an artists' colony, or at least have a shared studio. Eventually Gauguin painted this self portrait with a small picture of Bernard in the background. He wrote to Van Gogh that 'Les Miserables', as written on the painting alluded to Victor Hugo's novel and the tortured hero Jean Valjean, who was a character that Gauguin had identified with, and he described the figure as having, 'the mask of a badly dressed bandit ... The hot blood pulsates through the face and the tonalities of a glowing forge which surround the eyes indicate the fiery lava that kindles our painter's soul.'

CREATED

Pont-Aven

MEDIUM

Oil on canvas

SERIES/PERIOD/MOVEMENT

Self Portraits

SIMILAR WORKS

Self Portrait by Vincent Van Gogh, 1888

Self Portrait by Émile Bernard, 1888

Paul Gauguin *Born* 1848 Paris, France

Died 1903

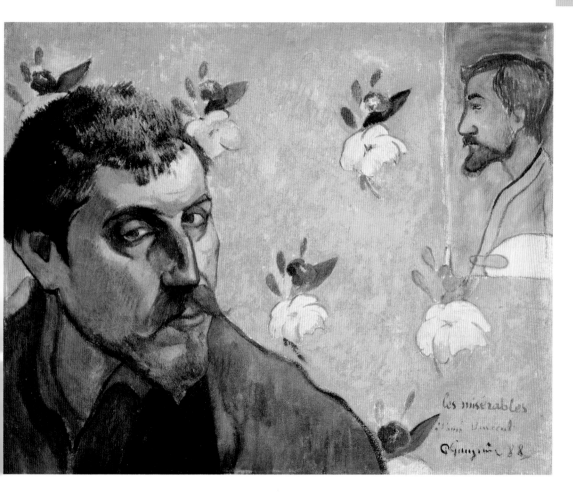

Van Gogh Painting Sunflowers, 1888

© akg-images

It is interesting that Van Gogh never finished a portrait of Gauguin, and when he asked Bernard to paint Gauguin's picture the artist declined, fearing he would not be able to do a good enough job. Such was Gauguin's temperament that both Van Gogh and Bernard quavered before committing his likeness to canvas. Gauguin painted this portrait of Van Gogh during his brief stay in Arles, at a time when his work was most influential on the Dutch artist. Van Gogh perceived Gauguin as his teacher and was full of unstinting admiration for his work. It was no doubt a role that flattered Gauguin's ego. He later even took credit for Van Gogh's still-life paintings of sunflowers, writing, 'From that day Van Gogh made astonishing progress; he seemed to become aware of everything that was in him, and thence came all the series of sunflowers after sunflowers in brilliant sunshine ...' Van Gogh had of course been painting sunflowers for some time prior to Gauguin's trip, and had already established his use of brilliant colour.

CREATED

Arles

MEDIUM

Oil on canvas

SERIES/PERIOD/MOVEMENT

Portraits

SIMILAR WORK

Portrait of a Man by Vincent Van Gogh, 1886–87

Paul Gauguin *Born* 1848 Paris, France

Died 1903

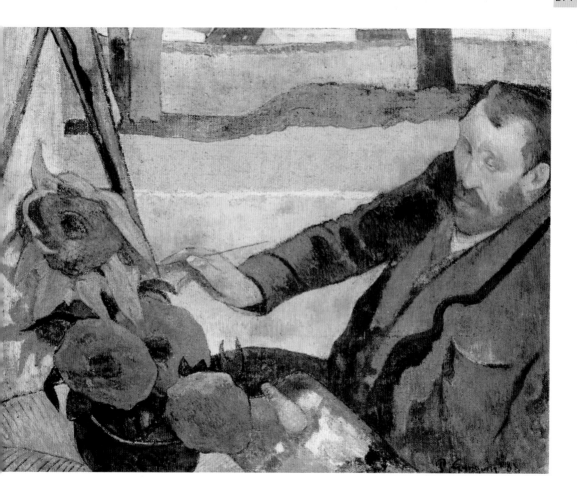

Café at Arles, 1888

'Van Gogh, without losing an inch of his originality, gained a fruitful lesson from me. And each day he would thank me for it ...' The extraordinary arrogance of Gauguin seems not to have overly concerned Van Gogh, who acknowledged the debt he owed to studying Gauguin's work and treated the artist with the same type of reverence he had reserved for Millet and Delacroix. However, not all of Gauguin's lessons were so readily absorbed by Van Gogh, who struggled with his friend's Synthetism and was happier and more successful in painting directly from the motif, rather than from memory.

Gauguin was not particularly pleased with this painting, but Van Gogh greatly admired it and painted *L'Arlésienne* in 1890, modelling his figure on that of Gauguin's. Gauguin did not share his friend's enthusiasm for Arles and the south of France, although he was drawn to the local women, who were renowned for their beauty. He also liked the traditional simple black and white dress that the women wore, partly because it was similar in many ways to the Breton women from Gauguin's stay in Brittany.

CREATED

Arles

MEDIUM

Oil on canvas

SERIES/PERIOD/MOVEMENT

Works at Arles

SIMILAR WORK

L'Arlésienne by Vincent Van Gogh, 1890

Paul Gauguin *Born* 1848 Paris, France

Died 1903

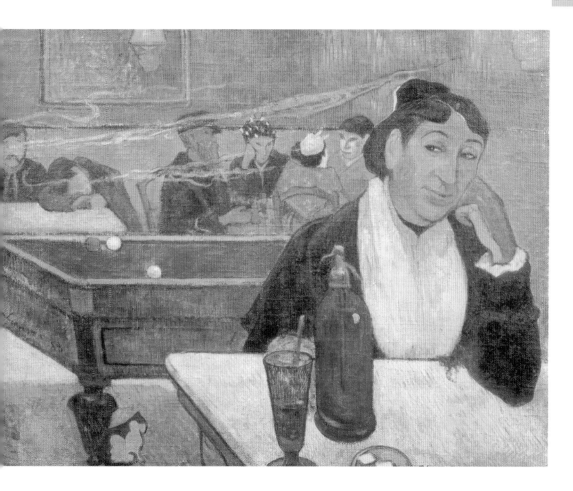

L'Arlésienne (after Gauguin), 1890

This was one of a series of five paintings that Van Gogh made of Marie Ginoux, in February 1890 while he was at the asylum of Saint-Rémy. He was profoundly depressed at this time and keen to escape from the asylum and return to the north of France, but eventually ended up staying until the spring. This, and the other pictures of Madame Ginoux are reminisces of a happier time for the artist, and look back to the period in 1888 when Gauguin was staying with him in Arles. The paintings reflect Gauguin's influence strongly, and were modelled on the figure in his painting, *Café at Arles*, 1888. Van Gogh painted one of the paintings for Gauguin, who liked it, and wrote to him saying, 'take this as a work belonging to you and me as a summary of our months of work together.'

Madame Ginoux was the proprietress of the Café de la Gare in Arles, which was a place frequented by Van Gogh and Gauguin, and is depicted in Van Gogh's paintings as kind, comforting and almost maternal.

CREATED

Saint-Rémy

MEDIUM

Oil on canvas

SERIES/PERIOD/MOVEMENT

Portraits

SIMILAR WORK

Café at Arles by Paul Gauguin, 1888

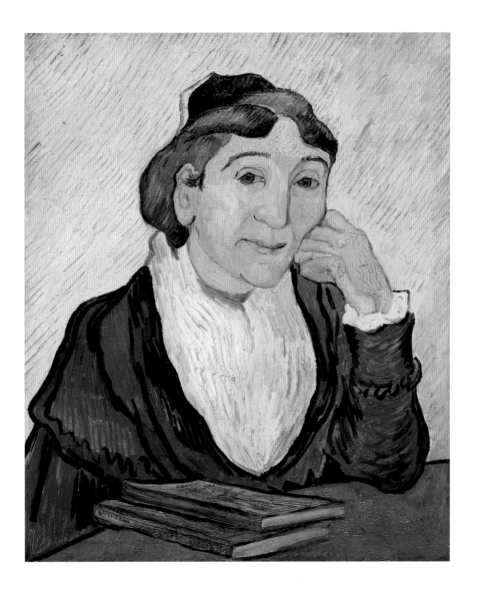

Breton Women with Umbrellas, 1892

Bernard's painting was defined by an extraordinary originality that saw his forms simplified and monumental, and colours flat and forming pattern. He believed in minimizing line and content, simplifying forms and by so doing lend them a greater symbolic and aesthetic significance. Together with the artist Anquetin, with whom Van Gogh was also friendly, the two worked in a new style that was later called Cloisonnism. Initially, Gauguin had been unimpressed with Bernard, but when Bernard moved to Pont-Aven they became friendly and Gauguin's work incorporated some of the elements seen in Bernard's, and vice versa. Increasingly, as is demonstrated here, Bernard experimented with abstracting the natural form and approached his works with a greater sense of pattern and ornament. Van Gogh had been friendly with Bernard since 1883 when they had met at Cormon's studio, and he admired much of Bernard's style, even on occasion rating Bernard's painting above Gauguin's. During his time at Pont-Aven Bernard and Gauguin stayed in close contact with Van Gogh through a series of letters, and the three constantly exchanged their theories on art.

CREATED

Pont-Aven

MEDIUM

Oil on canvas

SERIES/PERIOD/MOVEMENT

Cloisonnism

SIMILAR WORK

Copy after Bernard's Breton Women in the Meadow by Vincent Van Gogh, 1888

Émile Bernard *Born* 1868 Lille, France

Died 1941

The Port of Collioure, 1905

Courtesy of Musée National d'Art Moderne, Centre Pompidou, Paris, France, Lauros/Giraudon/The Bridgeman Art Library/© DACS 2007

The year this painting was done was the year the French artist André Derain (1880–1954) first came to the attention of the art world at large. He exhibited his strikingly new paintings alongside those of Henri Matisse (1869–1954) and others at the Paris Salon d'Automne in 1905, and their exaggerated and emotive colours caused the art critic Louis Vauxcelles to dub them 'Les Fauves', the wild beasts. Significantly it was also the year of Van Gogh's second large retrospective exhibition at the Salon des Indépendants in Paris. At this point in his career and until around 1909 Derain's paintings were defined by their explosive searing reds, orange and blues that captured the sparkling colours of landscape under the light of a brilliant sun. His use of colour in this painting, and of others done at the same time at Collioure, demonstrate a clear debt to Van Gogh's treatment of colour, especially during 1888 and his time at Arles. The work of both Van Gogh and Gauguin was influential on the development of the Fauves' approach to art, as were the paintings of Cézanne.

CREATED

Collioure

MEDIUM

Oil on canvas

SERIES/PERIOD/MOVEMENT

Fauvism

SIMILAR WORKS

View of Arles with Tree in Blossom by Vincent Van Gogh, 1888

View of Collioure by Henri Matisse, 1905

André Derain *Born* 1880 Chatou, France

Died 1954

Masked Ball at the Opera House, 1905

The Dutch artist Kees van Dongen (1877–1968) first trained in Rotterdam before visiting Paris in 1897, and later moving there in 1900. He supported himself through his illustrations that appeared in popular journals, and experimented with his painting, first starting in an Impressionist manner before incorporating the bolder colours of Van Gogh with an expressive free approach. He was also attached to the group known as the Fauves, exhibiting alongside them at the Paris 1905 Salon d'Automne, and was briefly a member of the German Expressionist group Die Brücke. In this painting his simplified figural forms echo those of Van Gogh, Gauguin and Bernard, and his use of brilliant colour to produce an ornamental decorative effect is again reminiscent of these artists. However, it was his landscape paintings done in 1905 that are most obviously influenced by Van Gogh, with *Corn and Poppy*, 1905 in particular reflecting his approach to colour. The Fauves was a short-lived movement in modern art and only held three exhibitions, but it developed the expression of colour from Van Gogh and Gauguin and took it to a new level.

CREATED

Paris

MEDIUM

Oil on canvas

SERIES/PERIOD/MOVEMENT

Fauvism

SIMILAR WORKS

The Red Vineyard by Vincent Van Gogh, 1888

Breton Landscape with Children and Dog by Paul Gauguin, 1889

Kees van Dongen *Born* 1877 Delfshaven, The Netherlands

Died 1968

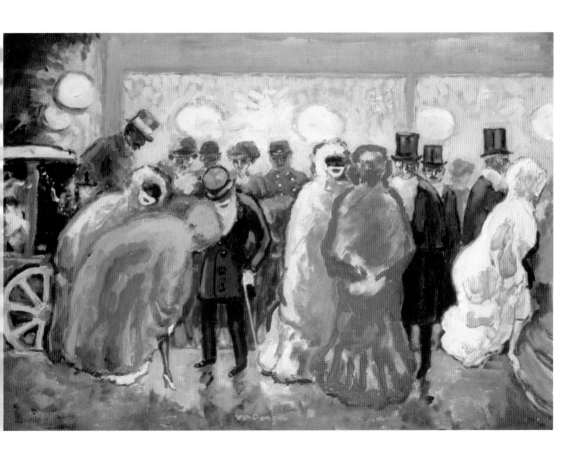

Still Life, c. 1906

The exuberant Maurice de Vlaminck (1876–1958) first trained as a professional cyclist but later met Derain while on leave from the military and was inspired to take up painting, renting a studio with the artist. Vlaminck had little artistic training, but tackled painting with resolute ambition and was quickly realized to have considerable talent. He worked in the manner of the Fauves, drawing on the colours of Van Gogh and working with pure and undiluted tones. On occasion he applied his paint directly on to the canvas from the tubes, and it is the element of vibrant, intense colour that so defines his work. He was greatly influenced by Van Gogh's work after seeing the Van Gogh retrospective exhibition at the Paris Salon des Indépendants, and was also influenced by Gauguin, and later by Cézanne. This still life reflects elements from all three of these artists, and shows his abstraction of form and perspective. He gradually moved away from the extreme colour of his works in 1905, and had adopted a more tonal palette of blues and browns by 1908.

CREATED

Chatou

MEDIUM

Oil on canvas

SERIES/PERIOD/MOVEMENT

Still lifes

SIMILAR WORKS

Potatoes in a Yellow Dish by Vincent Van Gogh, 1888

Still Life with Teapot and Fruit by Paul Gauguin, 1896

Still Life with Onions by Paul Cézanne, 1890–95

Maurice de Vlaminck *Born* 1876 Paris, France

Died 1958

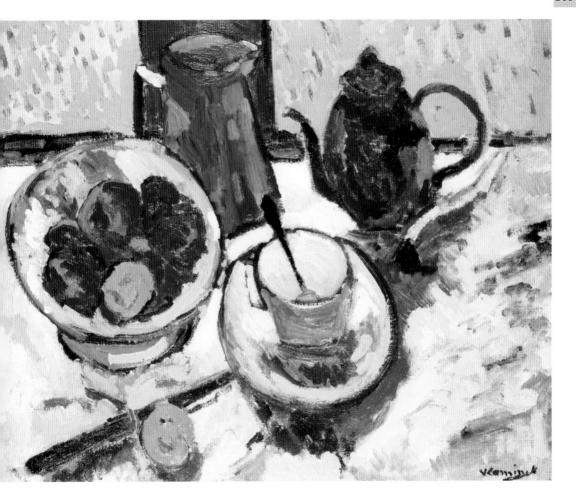

The Red Room, 1908–09

Matisse was regarded as one of the founding members of the Fauves, and was one of the most original and inspired artists of the twentieth century. He was greatly influenced by the Post-Impressionists, Van Gogh, Gauguin, Cézanne and Signac, and like Van Gogh was an ardent admirer of Japanese art and motifs. He developed his style using areas of flat, brilliant and often unnatural colour and invariably outlined his forms in a manner similar to Van Gogh. His early works up to 1905 also reflect his interest in colour theories and show him experimenting with a type of Pointillism that he had become familiar with through Signac. In 1904 he spent the summer with Signac at Saint-Tropez and then in 1905 spent the first of many summers at Collioure where he painted alongside Derain. It was during this period that his palette became so vivacious, a quality seen in this decorative and Japanese-inspired painting done in 1908–09. After the decline of the Fauves around this time his style continued to develop with his forms gaining greater simplicity.

CREATED

Paris

MEDIUM

Oil on canvas

SERIES/PERIOD/MOVEMENT

Fauvism

SIMILAR WORKS

Houses at Chatou by Maurice de Vlaminck, 1905–06

Augustine Roulin (La Berceuse) by Vincent Van Gogh, 1888

Two Milliners by Paul Signac

Henri Matisse *Born* 1869 Le Cateau-Cambrèsis, France

Died 1954

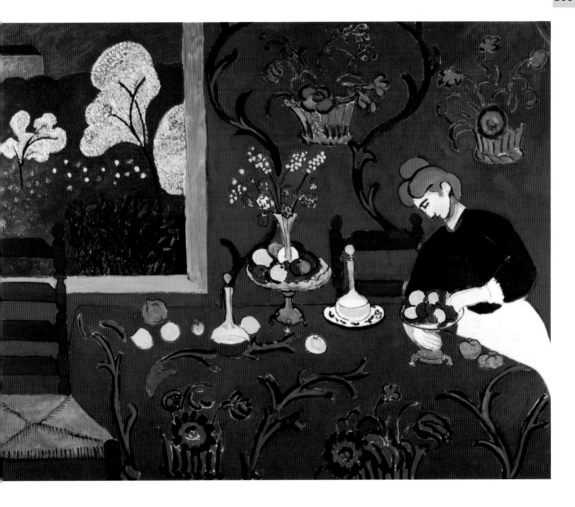

Old Peasant Woman, c. 1905

The German artist Paula Modersohn-Becker (1876–1907) grew up in Dresden and Bremen, and trained first in London for a short period and then had private painting tuition in Bremen. She later moved to the artists' colony at Worpswede where she furthered her training with lessons from Fritz Mackensen (1866–1953). Between 1900 and 1907 she travelled to Paris several times and on these extended visits she became familiar with the work of Cézanne, Van Gogh and Gauguin. Her work was also profoundly influenced by Millet, who had also had an enormous effect on Van Gogh's work. Modersohn-Becker primarily chose peasant subjects and agricultural scenes from her north German home, and often employed a heightened, sharpened colour that gave her some connection to the Fauves in France, combined with the strongly emotive feel characteristic of German Expressionism. This painting in particular is reminiscent of Van Gogh, in subject matter and depiction. The simple, monumental form of the peasant woman with her clear outlines set against a patterned background recalls paintings such as *Augustine Roulin (La Berceuse)*, 1889 and *Portrait of Dr Felix Rey*, 1889.

CREATED

Paris

MEDIUM

Oil on canvas

SERIES/PERIOD/MOVEMENT

Portraits

SIMILAR WORKS

Augustine Roulin (La Berceuse) by Vincent Van Gogh, 1889

Portrait of Dr Felix Rey by Vincent Van Gogh, 1889

Paula Modersohn-Becker *Born* 1876 Dresden, Germany

Died 1907

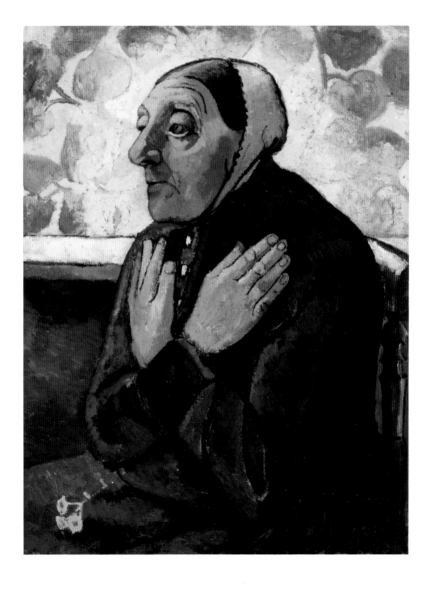

Coastal Scene with Fishing Boats, 1909

Courtesy of New Walk Museum, Leicester City Museum Service, UK/The Bridgeman Art Library/© DACS 2007

Max Hermann Pechstein (1881–1955) came to be recognized as one of the leading artists of the German Expressionist movement, and joined the Die Brücke group of artists and architects in 1906. This group Die Brücke, the Bridge, aimed to span the gap between traditional German painting and modern painting, and led the way towards the turbulent work of the Expressionists. German Expressionism evolved at around the same time as the Fauves were working in France, and took the example of the Fauves' work and that of Van Gogh, Gauguin and Cézanne as their point of departure. The Expressionists used the same intense colours and agitated brushstrokes and strove to depict the emotional response or reaction to their subject over the realism of the subject itself. The Fauves, however, were more concerned with the spatial organization of the picture and the aesthetics, and concentrated on simplified compositions that were easily read.

Pechstein was familiar with Van Gogh's work early in his career, and was influenced by his use of colour to expand his art and develop towards the Expressionist style that he is now associated with.

CREATED

Eastern Prussia

MEDIUM

Oil on canvas

SERIES/PERIOD/MOVEMENT

German Expressionism

SIMILAR WORKS

The Port of Honfleur by Albert Marquet, *c.* 1911

Boats on the Beach by Vincent Van Gogh, 1888

Max Hermann Pechstein *Born* 1881 Zwickau, Germany

Died 1955

Still Life with Masks IV, 1911

Courtesy of Private Collection/The Bridgeman Art Library/© Nolde-Stiftung Seebüll 2007

The use of brilliant yellow and red set against a dark tonal background was a technique employed frequently by Emil Nolde (1867–1956), and was also one used by Van Gogh, as in *Portrait of a Woman with a Red Ribbon*, 1885, for example, though to a less extreme degree. Van Gogh's use of colour was of enormous influence to subsequent emerging artists, and together with Gauguin and Cézanne he was one of the most significant figures in the development of modern art. Nolde, who was one of the first German Expressionist artists, concentrated on the evocation of extreme feeling in his paintings, so that here he has combined happiness and sadness in one image. He painted a series of still-life pictures with masks, and in each he creates a different response, such as horror, revulsion, fear, joy and depression. Like Pechstein, Nolde was a member of Die Brücke, but unlike Pechstein he was also an ardent supporter of the Nazis. He considered Expressionism to be the artistic language of Germany, and to be distinctly and identifiably German in character. Despite his support of the Nazis, Hitler declared all modern art as degenerate and Nolde's paintings were removed from museums.

CREATED

Germany

MEDIUM

Oil on canvas

SERIES/PERIOD/MOVEMENT

German Expressionism

SIMILAR WORKS

Portrait of a Woman with a Red Ribbon by Vincent Van Gogh, 1885

The Signal by Henri Le Fauconnier, 1915

Emil Nolde *Born* 1867 Nolde, Germany

Died 1956

First Spring, 1911

Karl Schmidt-Rottluff (1884–1976), who trained in Dresden as an architect, was one of the founding members of the Die Brücke group, and worked in a stridently Expressionist manner. Formative influences on the development of his art were the works of the Fauves, the Post-Impressionist artists, Van Gogh, Gauguin and Cézanne, and later in his career he absorbed elements of African tribal art and Cubism. This particular painting is reminiscent of Van Gogh's last works, such as *The Church at Auvers*, 1890, and employs a similar warped perspective and use of heavy outlining with brilliant colour. He was a loner and spent much of his time painting in solitude on the Baltic coastline, but in 1911 he moved to Berlin where he came into contact with the contemporary avant-garde art movements.

In 1938, 608 of his paintings were confiscated from German museums, and he was labelled a degenerate artist by the Nazi government. He was later banned from painting and his studio in Berlin was bombed in 1943. After the Second World War he was reinstated as an artist and invited to become a professor at the Academy of Fine Arts in Berlin.

CREATED

Germany

MEDIUM

Oil on canvas

SERIES/PERIOD/MOVEMENT

German Expressionism

SIMILAR WORKS

The Church at Auvers by Vincent Van Gogh, 1890

Blue Mountain by Erich Heckel

Karl Schmidt-Rottluff *Born* 1884 Rottluff, Germany

Died 1976

Dancers in Red, 1914

Courtesy of Private Collection, Turin, Italy, Peter Willi/The Bridgeman Art Library/© Ingeborg and Dr Wolfgang Henze-Ketterer, Wichtrach/Bern 2007

Ernst Ludwig Kirchner (1880–1938) studied architecture in Dresden and became friendly with Schmidt-Rottluff, Erich Heckel (1883–1970) and Fritz Bleyl (1880–1966). The four young men founded the Die Brücke group of artists that were searching for a new expression in the arts, and who drew on painters such as Van Gogh, Gauguin, Edvard Munch (1863–1944) for inspiration. Though much of the Die Brückes' work also reflects that of the Fauves in France, Kirchner in particular denied any influence from them and even predated some of his works to before those of the French artists.

There are a number of interesting parallels to be drawn between the life and work of Kirchner and Van Gogh. Kirchner was initially greatly influenced by woodcuts, especially those of Albrecht Dürer (1471–1528), and Van Gogh had sustained admiration for the Japanese woodcuts, both artists drawn to the deliberate definition of line and form. Kirchner, like Van Gogh experimented with the effects of colour and developed a vibrant palette and energetic application with often frenzied brushstrokes. More poignantly, Kirchner also suffered from severe depression following the First World War, and eventually committed suicide.

CREATED

Germany

MEDIUM

Oil on canvas

SERIES/PERIOD/MOVEMENT

German Expressionism

SIMILAR WORKS

Groteske Sangerin by Emil Nolde, c. 1910

The Dancehall at Arles by Vincent Van Gogh, 1888

Ernst Ludwig Kirchner *Born* 1880 Aschaffenburg, Germany

Died 1938

Marilyn Monroe, 1954

It is testament to Van Gogh's extraordinary vision and innovation that his work came to be so influential on the development of modern art. He was, along with Gauguin and Cézanne whose importance cannot be diminished, truly one of the founding fathers of a new expression, and broke the rules of his day to open up a whole new avenue of experimentation and progress in the arts. Even to the present day his artistic language is seen and felt, sometimes just fleetingly, in the images of emerging generations of artists. Willem de Kooning (1904–97) is just one such example. Born in Rotterdam the Dutch artist arrived in America as a stowaway in 1926 and set himself up as a house painter at first, before he was able to devote himself to art. His particular brand of Abstract Expressionism that retained a figural quality developed from the early influences of the avant-garde painters working in France, and especially the non-French artists in Paris, such as Van Gogh, Matisse, Pablo Picasso (1881–1973), Marc Chagall (1887–1985) and Piet Mondrian (1872–1944).

CREATED

United States of America

MEDIUM

Oil on canvas

SERIES/PERIOD/MOVEMENT

Abstract Expressionism

SIMILAR WORKS

Portrait of Adeline Ravoux by Vincent Van Gogh, 1890

Queen Isabeau by Pablo Picasso, 1909

Willem de Kooning *Born* 1904 Rotterdam, The Netherlands

Died 1997

297

Homage to Van Gogh, 1960

Francis Bacon's (1909–92) confrontational abstracted modern art was based on minimal formal training, and was the extension of the artist's reflections and personality. Not unlike Van Gogh, Bacon's work is a frank display of the artist's innermost grapplings with his life, and in many instances evokes his unsettled and at times violent past. Rather than academic foundations his work emerged from a plethora of influences and specific images that inspired sudden, intense reactions in the artist. In particular the work of Picasso, Eadweard Muybridge (1830–1904), Velasquez's (1599–1660) portrait of *Pope Innocent X* and Van Gogh's painting of *The Painter on the Road to Tarascon*, 1888 were significant to Bacon who had eclectic tastes. In his *Homage To Van Gogh* he addresses the position the artist has played in the development of modern art, through a strikingly disparate portrait that combines humour with piercing distress. The painting is a tangible expression of what Bacon called his 'riotous despair', and reflects the artist building up a convincing likeness, to destroy it gradually until it lingers on the verge of disintegration, but retains its viable character that makes it recognizably Van Gogh.

CREATED

England

MEDIUM

Oil on canvas

SERIES/PERIOD/MOVEMENT

Abstraction

SIMILAR WORK

Self Portrait with a Bandaged Ear by Vincent Van Gogh, 1889

Francis Bacon *Born* 1909 Dublin, Ireland

Died 1992

Van Gogh

Styles & Techniques

Seamstress from Scheveningen, 1881

Van Gogh's early works, commonly referred to as his 'Dutch period', are defined by their sombre palette and sustained use of certain subject matters. This image of a seated woman is one such motif that he returned to often, particularly during his time spent in The Hague. At this inaugural point of his career he was concentrating on drawing and illustration, and the graphic quality of this watercolour is very evident. It was Van Gogh's intention to earn a living through illustration, and during the 1870s and 1880s he amassed a substantial number of the magazines, *Graphic* and *Illustrated London News*, and studied the illustrations in them. He also had a large collection of prints, acquired through his work and travels with the art company Goupil et Cie, after Jean-François Millet (1814–75), Charles-François Daubigny (1817–78), Jacob Izaaksoon van Ruysdael (1628–82) and others, and studied these in his endeavour to educate his art. His specific training was minimal, taking the form of a few lessons from his relative Anton Mauve (1838–88), and referencing a number of 'teach yourself' manuals.

CREATED

The Hague

MEDIUM

Watercolour heightened with white

SERIES/PERIOD/MOVEMENT

Dutch period

SIMILAR WORK

The Seamstress, Jean-François Millet

Vincent Van Gogh *Born* 1853 Groot-Zundert, The Netherlands

Died 1890

Beach at Scheveningen, 1882

© akg-images

This painting done early in Van Gogh's career reflects the artist still learning and formulating his style. His stay in The Hague was an important period for him, and was a time during which he set the foundations for his later development as an artist. It was an active centre for the arts and The Hague School was widely admired. Although his formal training with Mauve was truncated due to an argument, Van Gogh was nonetheless surrounded by a nurturing artistic climate. The figures here are sketchily drawn, in an Impressionistic manner though he was not truly exposed to their techniques for some years. He was still unsure of himself working in paints, being more accomplished in drawing, and with the added pressure of the expense of paints. The group of figures that form a frieze arrangement indicate his grasp of perspective, though the specifics of their physical location in relation to the scene are unclear. Interestingly the inclusion of the bright red figure in the middle distance is a clue to the manner in which his art would take form, and his subsequent experimentation with colour.

CREATED

The Hague

MEDIUM

Watercolour

SERIES/PERIOD/MOVEMENT

Dutch period, landscapes

SIMILAR WORK

Wood Gatherers on the Heath by Anton Mauve

Turf Huts, 1883

© akg-images

Van Gogh's cousin Mauve gave the artist his first lessons in oil painting, and it was a medium that he would come to embrace. However, at this early stage of his career, still lacking confidence in his painterly skills and the expense of oil paints made embarking on a full-scale painting project a precarious venture. Although Van Gogh had sold several drawings, he was not in a position to support himself and was being financially aided by his brother Theo. He had immediately recognized the scope that oil painting offered, and wrote with enthusiasm of the clarity of colour that this medium afforded. Even though his works such as this sombre landscape remained essentially dark in tone, he was already starting to experiment with colour, reflected here in the soft glow of the sky. This work is broadly painted and strongly horizontal with simplified forms, all of which were consistent with his landscape works of this time. Interestingly the evolution of Van Gogh's style can be linked to the different areas where he lived and with each move his art changed perceptibly.

CREATED

The Hague

MEDIUM

Oil on canvas

SERIES/PERIOD/MOVEMENT

Dutch period, landscapes

SIMILAR WORK

Boat on the Beach at Scheveningen by Anton Mauve, 1876

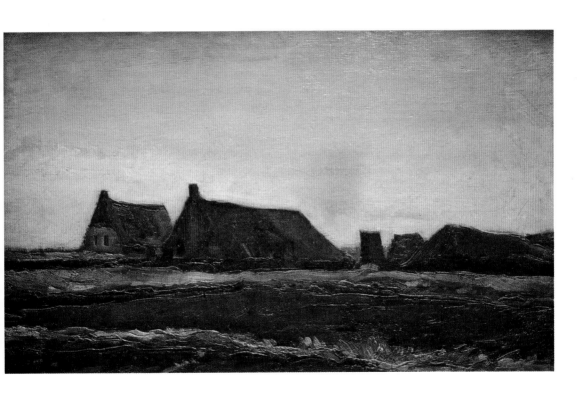

Peasant Woman with Dark Bonnet, 1885

© akg-images

The strength of Van Gogh's unique visual language is foremost in this painting of a peasant woman, her face emerging from a dark and gritty background. He has used thickly applied paint in strong, confident strokes, building up the three-dimensionality of the face so that it looms out of the canvas. Every brushstroke has a distinct purpose, a characteristic that would become typical of his work. During this period at Nuenen Van Gogh concentrated on depictions of weavers and peasants. He initially painted scenes of them at work, but later reduced the subjects to a series of studies of heads and hands, throwing them into close focus as seen here. The area itself had a prominent weaving industry, and also a large peasant population who worked in agriculture. It was a place with pockets of extreme poverty and it was these people and scenes that Van Gogh was drawn to. He wrote to Theo, 'When I call myself a peasant painter, it is a real fact, and it will become more and more clear to you in the future that I feel at home there.'

CREATED

Nuenen

MEDIUM

Oil on canvas

SERIES/PERIOD/MOVEMENT

Dutch period, peasants and labourers

SIMILAR WORK

Portrait of an Old Man with a Stick by Paul Gauguin, 1889–90

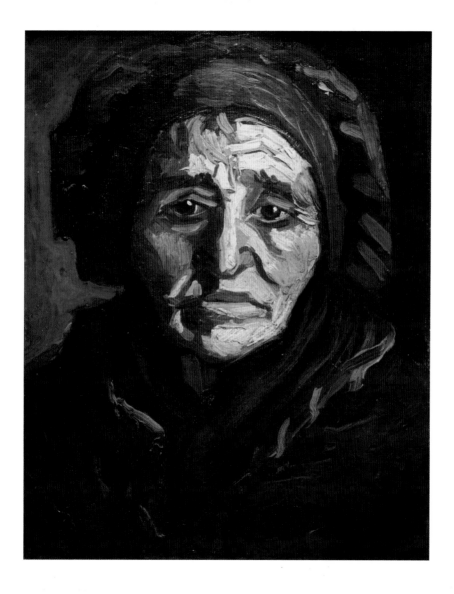

Autumn Landscape, c. 1885

This painting was done in October 1885, and the following month Van Gogh left Nuenen and travelled to Antwerp. By this time he had been ostracized by the local people of Nuenen, who falsely believed him to be responsible for a peasant girl's illegitimate pregnancy, and the local clergy were advising people to stay away from him. As a consequence he had run out of models to paint, and so turned towards still life pictures and landscapes. *Autumn Landscape* reflects his increasing use of colour, a factor that would truly manifest itself after his arrival in Paris. He has painted the ground as a flat area of colour from which the spindly trees rise up. The junction of tree to ground is rather unnatural, but the trees themselves are fluently painted and realistic, and the sense of distance created through the long avenue of trees is convincing. He has included wheeling birds in the sky, which was a motif that he frequently used and that on occasion suggested a threatening or uneasy presence, though this is not the case here.

CREATED

Nuenen

MEDIUM

Oil on canvas laid down on panel

SERIES/PERIOD/MOVEMENT

Landscapes

SIMILAR WORK

Avenue in the Woods, near Chaville by Jean-Baptiste-Camille Corot, c. 1824

Plaster Torso, 1886

© akg-images

Van Gogh arrived in Paris in March 1886, and lived there with his brother Theo for the next two years. It was arguably this period in his career that formulated his mature style of painting, and was of the greatest influence on his emerging visual language. He is thought to have enrolled in the studio of Félix Cormon (1845–1924) for approximately four months. During this time he was taught the principles of 'academic' art, and was required to make copies from plaster torsos, as seen in this painting. This was normal practice within the French art academies, and preceded drawing from life models. It had been Van Gogh's reluctance to do this very thing that had led to his falling out with Mauve in The Hague, yet once in Paris the artist applied himself and made numerous drawings and paintings of casts similar to this. Cormon's studio was steeped in traditional values and from accounts was a place gripped by restraint. The plaster casts were set against drab backcloths, so Van Gogh's brilliant blues and greens show the artist already revelling in his newly brightened palette.

CREATED

Paris

MEDIUM

Oil on canvas

SERIES/PERIOD/MOVEMENT

Parisian works

SIMILAR WORK

After the Bath, Woman with a Towel by Edgar Degas, *c.* 1885–90

Vase with Gladioli, 1886

Although Van Gogh had a wider experience than most of different paintings through his work and travels with the art dealership Goupil et Cie, his early work had been almost solely influenced by Dutch paintings and the French Realists. However, in Paris he came into contact with, was submerged almost, in the work of the Impressionists and the Post-Impressionists. 1886 was the year of the last Impressionist exhibition, although many of the original Impressionists had withdrawn due to the inclusion of works by the Pointillist artists Georges Seurat (1859–91) and Paul Signac (1863–1935). Also on exhibition were the mysterious works of the Symbolist artist Odilon Redon (1840–1916), a series of studies of women by Edgar Degas (1834–1917) and some of Paul Gauguin's (1848–1903) work. For the provincial Dutchman Paris was an artistic eye-opener, and he quickly absorbed elements of this sea of avant-garde art into his style. Here his work can be seen to have taken on some of the Impressionist techniques, with swift brushstrokes and strong complementary colours, and at this early point he identified himself most with the Impressionists.

CREATED

Paris

MEDIUM

Oil on canvas

SERIES/PERIOD/MOVEMENT

Still lifes, Parisian works

SIMILAR WORK

Purple Poppies by Claude Monet

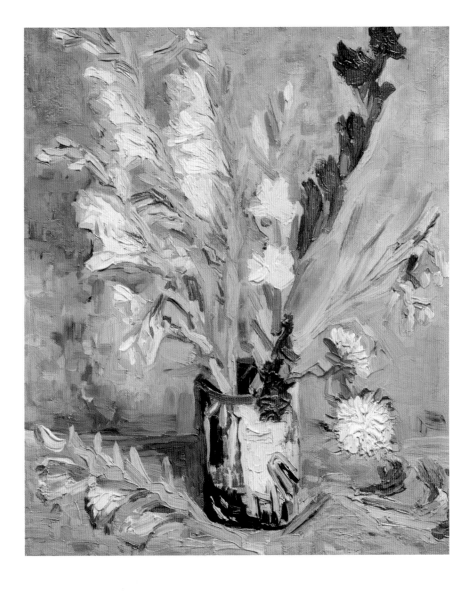

The 14th of July, 1886

© akg-images

At first Van Gogh was reticent about the quality of the Impressionists' work, but after studying their paintings, and seeing them on exhibition he quickly revised his opinion. Though the Impressionists and Post-Impressionists irrefutably influenced the development of his style, it is of note that his Dutch paintings, done prior to his exposure to the Parisian art scene, were already reflecting a strongly personal approach of deliberate, quick brushstrokes and simplified forms that matured after his exposure to Impressionist works. One of the defining elements of his style is its uniqueness, and even when openly influenced, or even making direct copies of paintings, his work remains identifiably Van Gogh. This painting for example is Impressionist in feel and reminiscent of *The Rue Montorgeuil, 30th June 1878* by Claude Monet (1840–1926), though less convincingly conceived. Each coarse stroke of Van Gogh's paint is designed to conjure up the atmosphere of the celebratory day, but also shows his concern with form and structure. It is not entirely successful in conception, with too great a disparity in style between the Impressionist flags and lights and the street scene.

CREATED

Paris

MEDIUM

Oil on canvas

SERIES/PERIOD/MOVEMENT

Impressionism

SIMILAR WORK

The Rue Montorgeuil, 30th June 1878 by Claude Monet, 1878

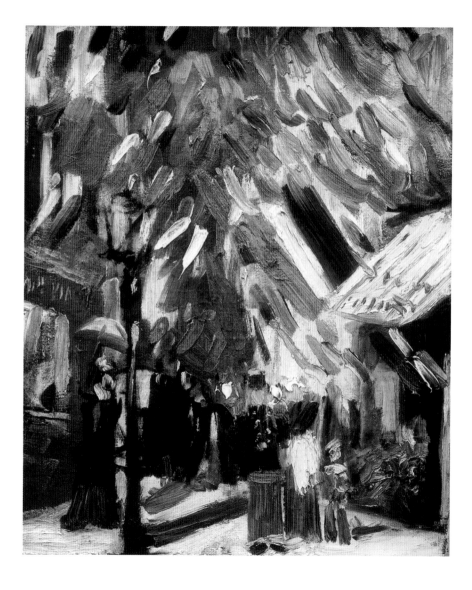

Moored Boats, 1887

One of the first painters to befriend Van Gogh in Paris was the amiable Camille Pissarro (1830–1903), whose son Lucien also became friendly with the difficult artist. Pissarro, who was one of the founding Impressionists, was nonetheless very progressive in his approach to art, and had absorbed the theories of Seurat and Signac, both of whom Van Gogh came to admire greatly. This painting with its wonderful array of colours, many of which seem to have materialized from a soft purple, calls to mind the works of all these artists. Van Gogh has in this instance tempered his brushwork, which was characteristically very tangible and expressive. There is a restraint in his application of paint and communion of colours that suggests his experimentation with the ideas of Signac. He has used washes of colour enlivened with short, sharp and contained brushstrokes seen in the spiky foliage in the foreground and to denote the shifting water that reflects the atmospheric sky. It is a particularly peaceful painting for the artist and was done at a time when he was regularly painting alongside Signac at Asnières.

CREATED

Paris

MEDIUM

Oil on canvas

SERIES/PERIOD/MOVEMENT

Impressionism

SIMILAR WORK

The Clipper, Asnières by Paul Signac, 1887

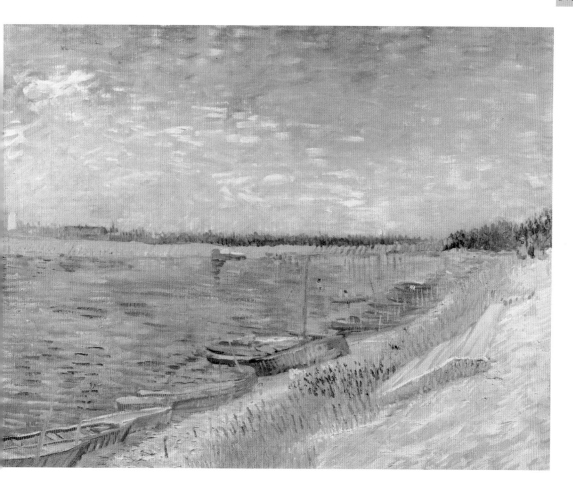

Fritillaries in a Copper Vase, 1887

Still-life pictures and in particular those of flowers were something that Van Gogh addressed throughout his career, often, it must be said, due to the lack of willing models or inspiring scenes. However, he is known to have had an abiding love of nature and flowers, which partly explains his frequent depiction of them. By the time of painting this picture Van Gogh's strong use of colour was becoming very evident. He had absorbed the ideas of Seurat and Signac, and though his temperament was unsuited to their varying precise style and articulation of scientific theories, he was much taken with the concept behind the theories, i.e. that of complementary colours. Here the dynamic yellow of the flowers set against the vibrant blue background is a case in point. He had also become increasingly interested in pattern and the effect of pattern, and in direct relation to this with Japanese art. There is a distinctly Oriental feel to this work, which although keeping its roots grounded in naturalism has gone beyond this form to become a highly aesthetic and patterned image.

CREATED

Paris

MEDIUM

Oil on canvas

SERIES/PERIOD/MOVEMENT

Post-Impressionism, still lifes

SIMILAR WORKS

Chrysanthemums by Paul Cézanne, *c.* 1896–1900

Exotic Flowers in a Pot by Odilon Redon

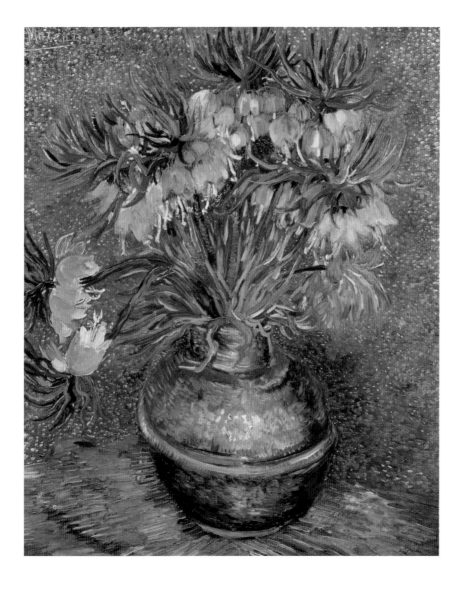

Still Life with Quinces, 1888

One of the most striking aspects of Van Gogh was his ability to absorb and appreciate a wide range of influences, and take these and mould them into his own form. He never became affiliated with one particular group, but drifted between the different art circles, which in part reflects his very eclectic approach to his art. The Impressionists, for example, would not dream of mixing with the Pointillists (with the exception of Pissarro) and the Pointillists were averse to the Cloisonnists, and so on, with the exception of Van Gogh whose style could then be seen as simply universally avant-garde.

He had become familiar with Paul Cézanne's (1839–1906) paintings, primarily through the art shop owned by Père Tanguy. Van Gogh admired his painting, though this was not reciprocated, and there is something of Cézanne in this still life. Here, however, Van Gogh has combined a highly realistic depiction of the softly moulded quinces with an individualistic painting of the cloth on which they sit. His short sharp strokes of colour in the foreground suggest a shifting bright light and evoke a sense of pattern.

CREATED

Paris

MEDIUM

Oil on canvas

SERIES/PERIOD/MOVEMENT

Post-Impressionism, still lifes

SIMILAR WORK

Four Peaches by Paul Cézanne

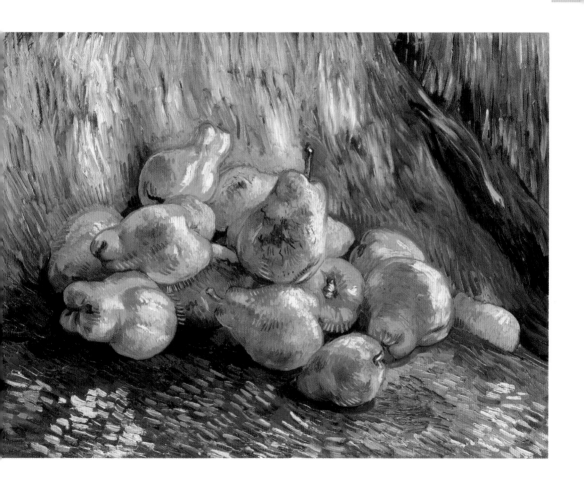

The Gleize Bridge over the Vigneyret Canal, near Arles, 1888

© Private Collection, Lefevre Fine Art Ltd, London/The Bridgeman Art Library

Van Gogh left Paris in February 1888, and arrived at Arles in the south of France, full of hope for a new start in the peaceful rural community. He was initially greatly taken with the beauty of the area. The strong Mediterranean sun lent everything a particular vibrancy that had been missing in Paris, and it is likely that Van Gogh drew parallels between this and the effect that Morocco had on Eugène Delacroix's (1798–1863) art. The move to Arles again signalled a development in his art, and his palette became increasingly bright and brilliant, as can be seen here. He also began to see colour in terms of symbolic significance, and the use of symbolism crept quietly into his work. These first works done at Arles exhibit a great enthusiasm for the area, which manifests itself through the free brushstrokes and application of paint. There is a fluidity here through the surface of the paint that suggests the subject was painted quickly, but exactly as the artist wanted. There is no hesitation and every brushstroke is definite and pertinent to the overall composition.

CREATED

Arles

MEDIUM

Oil on canvas

SERIES/PERIOD/MOVEMENT

Post-Impressionism, landscapes

SIMILAR WORK

Seashore at Martinique by Paul Gauguin, 1887

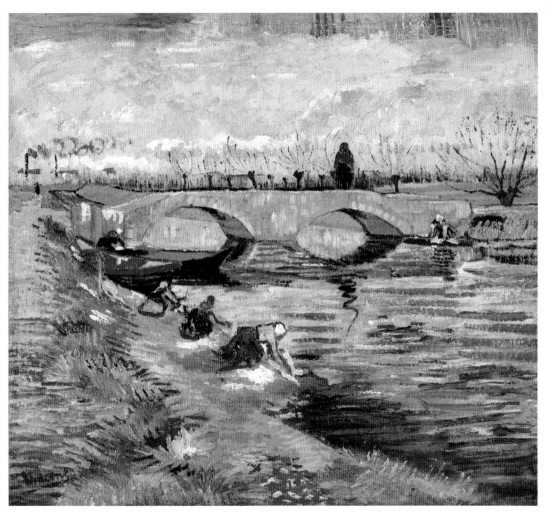

The Zouave, 1888

At Arles Van Gogh's palette became more intense and at the same time he began to reduce the number of colours that he used making the paintings more direct and concentrated. This technique is seen here in the picture of the Zouave that revolves around black and red and variants thereof, making it immediately striking. At this time he also moved towards painting areas of flat colour that were sharply defined (in a similar manner to the Cloisonnists), which was a method that he gradually expanded. This was also a technique that his two friends Émile Bernard (1868–1941) and Gauguin were employing in their paintings.

Portraiture was one of Van Gogh's favourite subjects, and he was always searching for people willing to sit for him. He described his approach to portraiture in a letter to Theo, 'I do not endeavour to achieve this by a photographic resemblance, but by means of our impassioned expressions – that is to say, using our knowledge of and our modern taste for colour as a means of arriving at the expression and the intensification of the character.'

CREATED

Arles

MEDIUM

Oil on canvas

SERIES/PERIOD/MOVEMENT

Post-Impressionism, portraits

SIMILAR WORK

Study of a Mulatto Woman by Émile Bernard, 1895

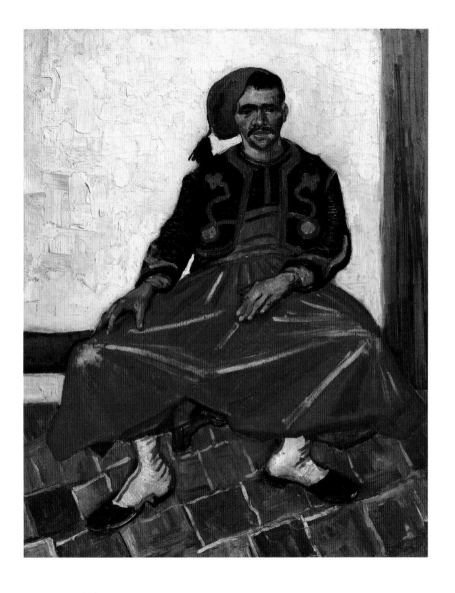

Boats at Saintes-Maries, 1888

© TopFoto

Near to Arles was the fishing village of Saintes-Maries, a small, rural place full of charming cottages and brightly coloured boats. It was an area that Van Gogh found greatly inspiring and he made a number of paintings and sketches here, all executed rapidly. In this painting he has used broad areas of flat colour and enlivened the surface with textured brushwork. The boats have a sharp outline, something that he worked increasingly towards, and are faintly reminiscent of the Japanese woodcuts of which he was so fond. His treatment of the beach, sky and sea with lively dabs of paint contrasts effectively with the still flatness of the boats that seem to sit on the scene, rather than into it. He described his approach as, 'instead of trying to reproduce exactly what I have before my eyes, I use colour more arbitrarily so as to express myself vigorously.' It was this goal of 'expressing' himself that was such a characteristic of his work. In every painting he strove to capture what it was about the scene that had inspired him, rather than producing a simple physical rendition.

CREATED

Saintes-Maries

MEDIUM

Oil on canvas

SERIES/PERIOD/MOVEMENT

Post-Impressionism, landscapes

SIMILAR WORKS

Harbour Scene, Dieppe by Paul Gauguin

Boats on a Shore by Ando or Utagawa Hiroshige

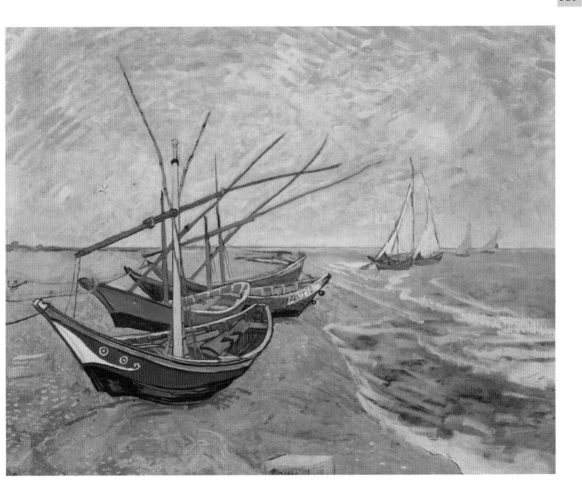

Seascape at Saintes-Maries, 1888

© akg-images

The thickness with which Van Gogh applied his paint in this energetic scene has built up a very textured and almost three-dimensional quality to the picture surface. He frequently used this approach, loading his brush with enormous quantities of thick paint that was then rapidly daubed on to the canvas. There is great rhythm through the application of paint, which was one of his defining qualities in these later works. The waves in the foreground, for example, have been created through a series of swift strokes that appear to swell from left to right, reflecting the motion of the water itself. The yellow-white foam that boils on the crest of the waves is practically tangible, while the boats bow into the frothing surf, battling through the waves with determination. He has again used a minimal palette, so that the entire picture appears drenched in a wet haze of moisture. It is all about the wind, water and raging elements, and positively pulsates with life. Saintes-Maries was a place that he was inspired by, and this quality of vigorous enthusiasm is very apparent in many of the paintings he made here.

CREATED

Saintes-Maries

MEDIUM

Oil on canvas

SERIES/PERIOD/MOVEMENT

Post-Impressionism, landscapes

SIMILAR WORK

St Briac by Paul Signac, 1885

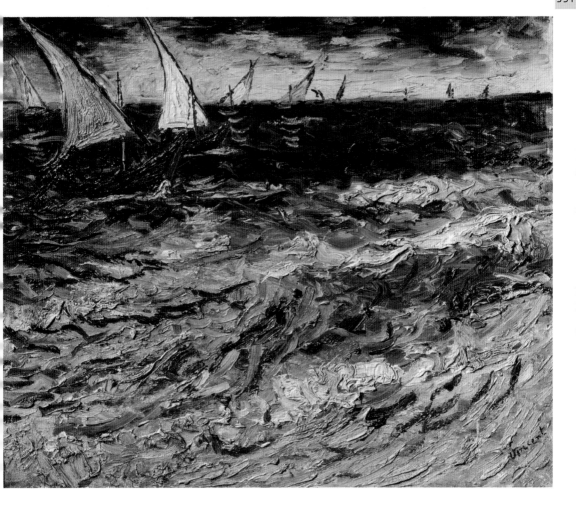

Green Corn Stalks, 1888

© akg-images

Van Gogh has used an interesting perspective in this painting, and it was one that he often employed, especially in his last works. He has chosen a low viewpoint that suggests the artist was sitting in the field looking up at the wheat, which throws the green wheat stalks into close focus, while the rest of the landscape shoots off into the distance. The top of the wheat is silhouetted with spiky brushstrokes against the sky and contrasts with both the flatness of the sky and the thick strokes that compose the rest of the landscape. The wheat and the carpet of poppies were painted with short strokes and daubs of paint, somewhat reminiscent of the works of Signac, with whom Van Gogh was friendly. His use of primarily red, green and yellow was also reflective of Signac's colour theories, which Van Gogh used, though in a less scientific manner. The landscape of dotted colour and short brushstrokes is contrasted with the sky that Van Gogh painted more broadly with a strong diagonal emphasis that suggests light shafting down through the clouds.

CREATED

Arles

MEDIUM

Oil on canvas

SERIES/PERIOD/MOVEMENT

Post-Impressionism, landscapes

SIMILAR WORKS

The Wheat Field with Red Houses by Maurice de Vlaminck, 1905

The Lighthouse at Gatteville by Paul Signac

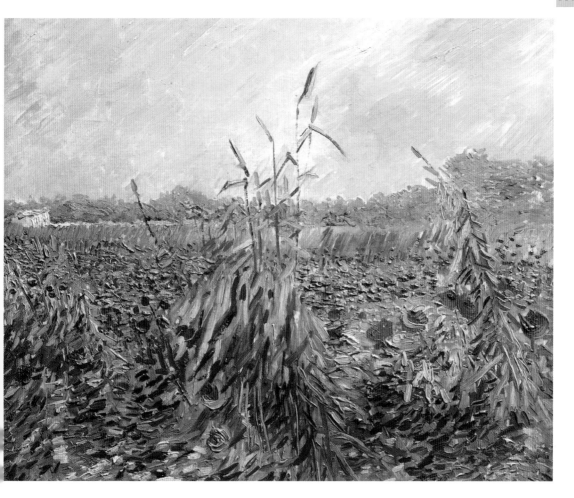

Sower at Sunset, 1888

Peasant imagery and especially that of the 'sower' was something that Van Gogh turned to numerous times throughout his career. His affiliation with this subject was partly as a response to the work of the romantic Realists such as Millet, and a reflection of his own socialist ideals. The sower in particular was a figure that Van Gogh saw in terms of representing the eternal cycle of agricultural life, of honourable endeavour and tradition, and symbolized these qualities to the artist. The sun was also a symbolic element for him, and in many of these paintings it shines with an unearthly luminescence. Here he has created a great orb of light, from which short precise brushstrokes radiate outwards so that the whole sky becomes bathed in golden rays. The rest of the canvas is made up of short, quick brushstrokes that lend the ground a textured and slightly surreal feel. Barely perceptible are two crows that emerge from the fractured background, while the figure appears to be part and parcel of the land on which he works.

CREATED

Arles

MEDIUM

Oil on canvas

SERIES/PERIOD/MOVEMENT

Post-Impressionism, peasants and labourers

SIMILAR WORK

The Sower by Jean-François Millet, 1850

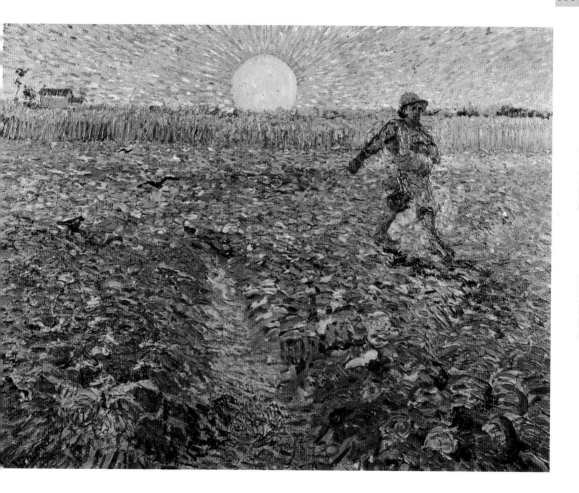

The Garden at Arles, 1888

This was one of two paintings that Van Gogh made of the garden at Arles within the same month, which was not unusual. He often made several paintings of one motif rapidly and within the same time frame, before moving on to a different subject, although he invariably returned to the old motif again at a later date. This system of painting was of huge importance to the Impressionists, who were concerned with conveying the changing light on the motif. It is interesting because it affords one the different views of the subject, and shows the artist working through an idea. In a sense it provided something of the creative process that drove him.

This painting has a very decorative feel, and shows Van Gogh experimenting with the Pointillist theories of his friend Signac and of Seurat. He has used small, short brushstrokes, loaded with pure and brilliant colour in a very controlled manner. Every stroke here is important to the overall design, and the painting does very much reflect a sense of 'design' rather than actual pictorial reality. Van Gogh drew with his paint, so that his pictures appear to evolve with a freedom not seen in works that are based on under drawings.

CREATED

Arles

MEDIUM

Oil on canvas

SERIES/PERIOD/MOVEMENT

Post-Impressionism, landscapes

SIMILAR WORKS

Alfalfa, St Denis by Georges Seurat, 1885

St Tropez, Pinewood by Paul Signac, 1896

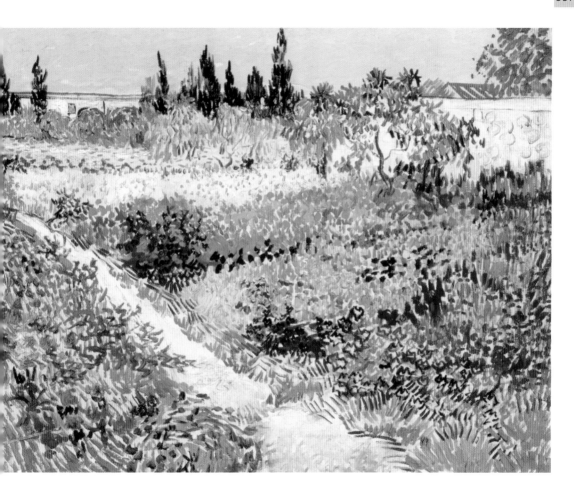

Sunflowers, 1888

Van Gogh painted a series of pictures depicting sunflowers, having first been inspired by the yellow flowers in Paris where he saw them growing in the gardens of Montmartre. They were a motif that he returned to often, and in the summer of 1888 he embarked on a large number of paintings of sunflowers to decorate his studio and house in preparation for Gauguin's arrival. Sunflowers were symbolic of life and hope to the artist, and could also be associated with his concept of the sun – round, glowing, yellow and hopeful. It is extraordinary that the artist, who was so plagued with mental illness and depression, was able to have interludes marked by such a positive outlook, which was reflected in his works. In this painting he has reduced the elements of the composition so that the image is one of great simplicity, while also reducing the colours to primarily his favourite yellow. This reflects him synthesizing realism with pattern and ornament, so they are both highly decorative and almost symbolist in feel, but also retain a fundamentally real quality.

CREATED

Arles

MEDIUM

Oil on canvas

SERIES/PERIOD/MOVEMENT

Sunflowers

SIMILAR WORK

Sunflowers in a Vase by Henri Matisse, 1898

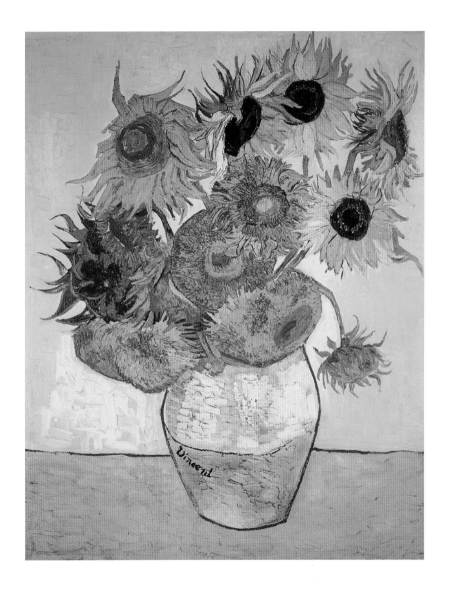

Willows at Sunset, 1888

© akg-images

This painting was done at great speed, and has the appearance of being unfinished or being a sketch for a later work. There is another painting that incorporates a pollarded willow in the foreground set against a vibrant sky with a figure of a sower, and it is possible that this picture was intended as a study for the later one. However, he used the image of pollarded willows in several paintings, and it seems to have been a form that he was attracted to. There is something stark and rather sinister about the truncated trees, particularly in this picture, as their spiky branches appear to form a grill across the picture surface and in front of the great, glowing sun. He has again treated the sun with some reverence, lending it a symbolic and almost iconic importance. Throughout the whole picture there is enormous north-south movement with his brushstrokes being strongly vertical virtually in their entirety, with the exception of the radiating strokes from the sun. There is a sense that he attacked the canvas with his paint in this picture. It has a surreal quality manifested in the strident, fierce strokes and intense colours.

CREATED

Arles

MEDIUM

Oil on cardboard

SERIES/PERIOD/MOVEMENT

Post-Impressionism, landscapes

SIMILAR WORK

The Old Tree by André Derain, 1905

Starry Sky Over the Rhône, 1888

This was one of three paintings made during the same month that incorporate the night sky and stars as fundamentally symbolic elements. He also painted *Café Terrace at Night*, and a portrait of his friend Eugène Boch (1855–1941), that was perhaps the most symbolic of the three. Here his stars glow with a luminescence, shining from the dark, blue and velvety night sky. Dotted along the banks of the Rhône houses also radiate a light that reflects in the water and adds to the mysterious atmosphere of the painting. The year after painting this Vincent wrote to Theo explaining his fascination with stars, 'For my part I know nothing with any certainty, but the sight of the stars makes me dream, in the same simple way as I dream about the black dots representing towns and villages on a map. Why I ask myself, should the shining dots in the sky be any less accessible to us than the black dots on the map of France? If we take the train to get to Tarascon or Rouen, then we take death to go to a star.'

CREATED

Arles

MEDIUM

Oil on canvas

SERIES/PERIOD/MOVEMENT

Post-Impressionism, landscapes

SIMILAR WORK

Nocturne in Black and Gold, the Falling Rocket by James Abbott McNeill Whistler, *c.* 1875

The Sower, with the Outskirts of Arles in the Background, 1888

During his time at Arles landscape motifs dominated his work, although towards the end of 1888 he also embarked on a large series of portraits. When depicting his landscape scenes there is often a hint of the town of Arles in the background, but the town is in general dwarfed by the surrounding scenery. Here again, the outskirts of Arles hover to the outside of the painting reduced to a puff of smoke and the odd geometric form of a building. This work was done at a time when Van Gogh was experimenting with his painting technique, and was using large areas of flat colour delineated by heavy outlines. This technique was one that Bernard and Gauguin were also using, and that came to be known as Cloisonnism. It produced the effect of 'compartmentalized' colour in the manner of stained-glass window design where pattern and colour were carefully delineated. The composition has been reduced to its most simple forms to suggest the landscape across which the sower walks, and is drenched in areas of fierce, supernatural colour such as the mustard yellow sky.

CREATED

Arles

MEDIUM

Oil on canvas

SERIES/PERIOD/MOVEMENT

Post-Impressionism, peasants and labourers

SIMILAR WORK

The Buckwheat Harvest by Émile Bernard, 1888

The Sower, 1888

© akg-images

Van Gogh painted this *Sower* in October 1888, shortly before the arrival of Gauguin and when he was in a state of high excitement. The town of Arles sits on the horizon, emerging unobtrusively from the landscape as if it formed a natural extension of the fields around. It is instead the sower who stands out here, painted darkly and contrasting against the pale field in which he works. The canvas is stippled with undulating strokes of paint that form a pattern across the surface with a finely drawn quality. Although there is some repetition in his brushstrokes, seen particularly in those of the furrow behind the sower, for the most part the application of paint here is more random, less regular and suggestive of a delicate organic pattern. There is still a sense of the surreal, with his colours intensified, something that he described with the words, 'I am using colour more arbitrarily to express myself forcefully.' This was something that he turned to increasingly so that his use of colour was the expression of his thoughts and emotions.

CREATED

Arles

MEDIUM

Oil on canvas

SERIES/PERIOD/MOVEMENT

Post-Impressionism, peasants and labourers

SIMILAR WORK

The Mower at Noon: Summer by Louis Anquetin, 1887

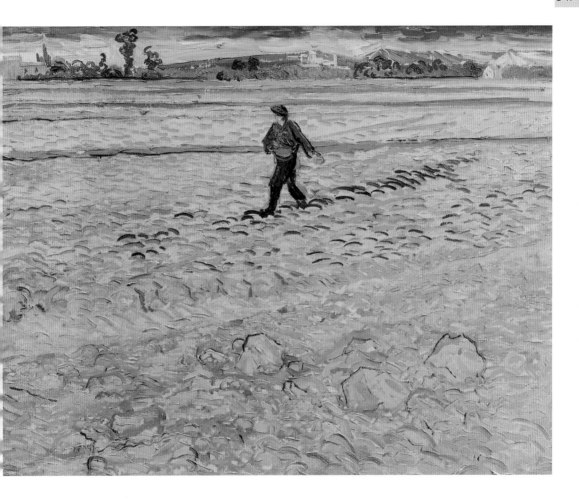

The Artist's Garden, 1888

Van Gogh referred to this small park that sat opposite his 'Yellow House' as the 'Poet's Garden' in acknowledgment of Petrarch and Boccaccio who had both lived in the south of France. This personalization of the public garden reflected the artist's own romantic vision of the place, and the two figures who appear below shaded branches would seem to be lovers. He painted this park several times, but here it is the magnificent fir tree that has become the primary focus of the picture. The pictorial space is divided sharply on the diagonal, one side being the blonde, sandy path, the other the enormous tree that appears to jut into the viewers' space. Building on the strong diagonal of the work is his treatment of the spiky fir branches, which themselves form a wonderful pattern of diverging diagonal lines. The whole painting is a study of blue-green, from the tree and the grass through the path and across the two figures whose skin retains the colour wash of the background. This technique of using variations of one colour was characteristic of much of his work.

CREATED

Arles

MEDIUM

Oil on canvas

SERIES/PERIOD/MOVEMENT

Post-Impressionism, landscapes

SIMILAR WORK

Fields in Summer by Georges Seurat

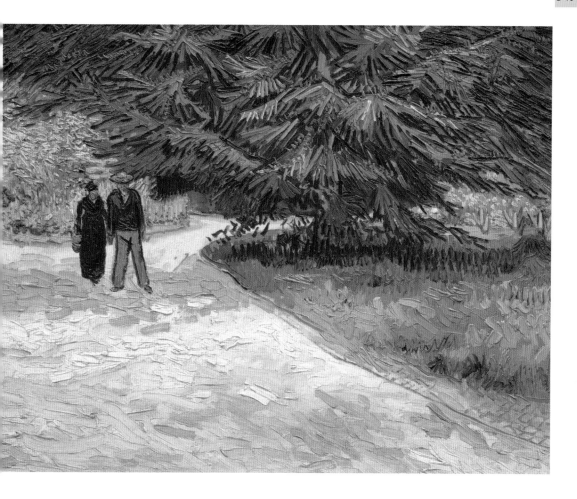

Trunk of an Old Yew Tree, 1888

Propelling a tree trunk, (not even the tree in its entirety), to the centre of the canvas and treating it as the primary subject was an unusual practice, but something that Van Gogh did several times. He was fascinated by the striations and pattern of tree bark and tree roots, and made several paintings focusing on just these elements, seeking out the decorative quality that the natural formations made. Here he has included a landscape, too, and in the distance behind the tree is the town of Arles, though it barely impinges on the scenery. The small clump of dark trees on one side of the yew and the tall poplar on the other dwarf the buildings in the background, and also echo the diminutive chimneys and steeple, while the diagonal path in the middle distance cuts the painting in two with the old yew in the foreground and the background scenery behind. By placing the yew directly in the middle of the canvas it blocks the view, and in so doing entices the viewer to study it further, seeking to look behind it.

CREATED

Arles

MEDIUM

Oil on canvas

SERIES/PERIOD/MOVEMENT

Post-Impressionism, trees

SIMILAR WORK

Large Pine and Red Fields by Paul Cézanne

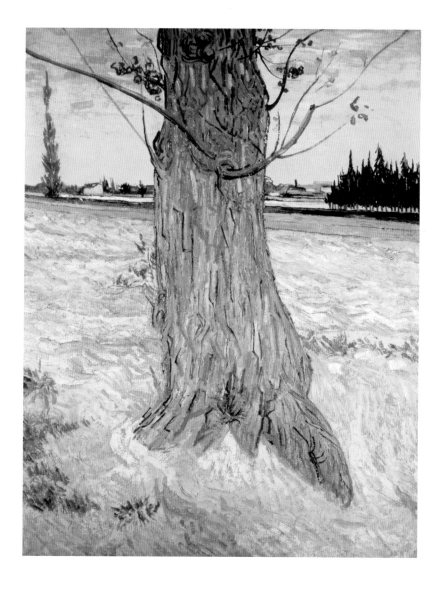

L'Arlesienne (Madame Ginoux), 1888

Van Gogh painted two versions of this picture, this one and one that hangs at the Musée d'Orsay in Paris. This is the more highly finished of the two and was painted using thick paint and very precise outlines. It is strongly reminiscent of Gauguin's work at this time, and it was during Gauguin's stay with Van Gogh that he produced this painting. Van Gogh was experimenting with flat areas of bold colour clearly defined by sharp outline, which was in contrast to his often more highly expressive brushwork. Here he has been less concerned with the depiction of texture, and more concerned with the effect of shape and colour. The intensity of the yellow background illuminates the figure, whose skin is of a similar though reduced tone, a technique that he used often. He has concentrated his colours to primarily yellow, blue, green and the vibrant red of the books, which are wonderfully dog-eared. The painting, which was of the proprietress of Van Gogh's local café, was executed quickly, and unfortunately this speed has led to the cracking and deterioration of the paint surface.

CREATED

Arles

MEDIUM

Oil on canvas

SERIES/PERIOD/MOVEMENT

Post-Impressionism, portraits

SIMILAR WORK

The Night Café by Paul Gauguin, 1888

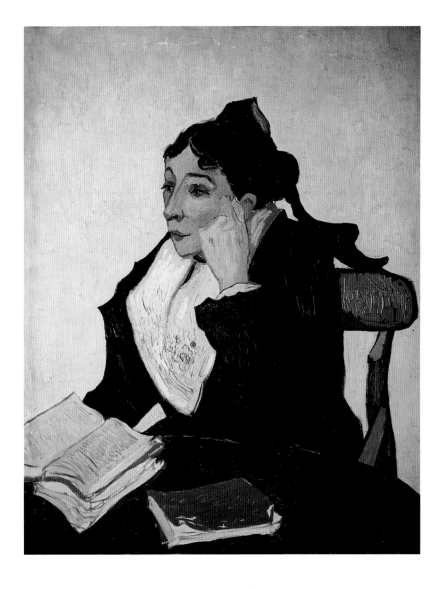

The Dancehall, 1888

When Gauguin stayed with Van Gogh he took with him a painting by their friend Bernard for Van Gogh to look at. The picture was Bernard's *Breton Women in the Meadow*, painted at Pont-Aven and it was to have something of an effect on a few of Van Gogh's subsequent works. Although the artist had already been working towards a form of Synthetism and Cloisonnism within his own style, Bernard's painting, and also that of Gauguin led Van Gogh to further his experiments with this technique, and this painting, *Dancehall*, reflects this. Here Van Gogh has again used the heavy outline and flat areas of colour, but he has also used the composition to create a vigorous pattern across the canvas. In a characteristic manner he has included great yellow spheres of light that hover between a physical reality and a symbolic element, and seem to echo the round, yellow bobbing heads over which they hang. These lights also add to the Japanese feel of the work, which is further felt through the dark and shiny-headed women in the foreground.

CREATED

Arles

MEDIUM

Oil on canvas

SERIES/PERIOD/MOVEMENT

Post-Impressionism

SIMILAR WORK

Breton Women in a Meadow by Émile Bernard, 1888

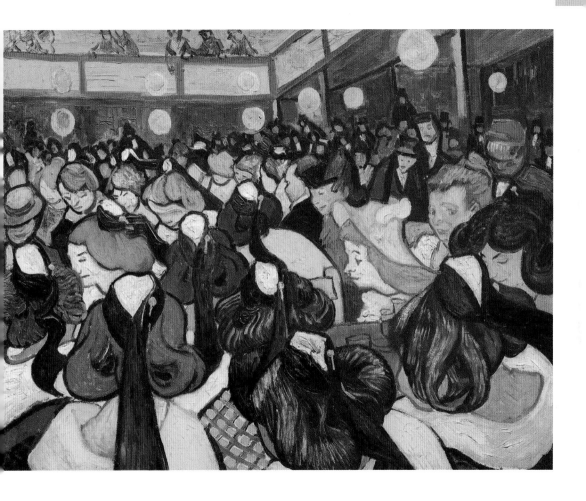

The Novel Reader, 1888

In contrast to the *Dancehall* painting that reverberates with a busy energy, this picture of a young woman absorbed in her book is monumentally still. It is a study of intense concentration and lends the viewer an almost voyeuristic feel, born of the woman's total unawareness of anything other than her book. Van Gogh has simplified his forms so that she is highly stylized, particularly seen in the exaggeration of her slender hands, and he has again relied on heavy outline as seen in other works of this time. The darkness of the woman sits rather uneasily against the yellow-green background, which results in her appearing unrelated to her surroundings, although he has used the same slightly feverish tone throughout. The background itself is unresolved and appears unfinished, in particular the white slash of paint behind the book and the muddied patch above this suggests he was still grappling with his composition. Also, normally his paintings done in this style were very precise, with clear areas of flat colour, unlike the brushwork here, which is sketchy and rapid in appearance.

CREATED

Arles

MEDIUM

Oil on canvas

SERIES/PERIOD/MOVEMENT

Post-Impressionism, portraits

SIMILAR WORK

Portrait of Madame Roulin by Paul Gauguin, 1888

Olive Grove with the Alpilles in the Background, 1889

© akg-images

This work was painted after Van Gogh had moved to the asylum at Saint-Rémy following his mental breakdown in Arles in the winter of 1888. Although the artist had had a long history of mental illness that had manifested itself in his erratic behaviour and difficult nature, it was from this point onwards that his condition worsened dramatically and he became increasingly ill.

He was drawn to the naturally curved and gnarled forms of these olive trees that he painted often during his stay at the asylum, and has treated the entire canvas with an undulating crescendo of sinuous line. In a similar manner to his late Arles works he has employed flat areas of colour, but has taken this as his starting point, and has enlivened the surface with strokes of paint that become almost decorative. There is great continuity through the canvas with the Alpilles mountains behind the trees echoing their rounded form, as do the clouds and the contours of the ground. The work is highly stylized and defined by his use of heavy line, which calls to mind the Japanese woodcuts that he was so fond of.

CREATED

Saint-Rémy

MEDIUM

Oil on canvas

SERIES/PERIOD/MOVEMENT

Post-Impressionism, landscapes

SIMILAR WORK

Bougival by Maurice de Vlaminck, 1905

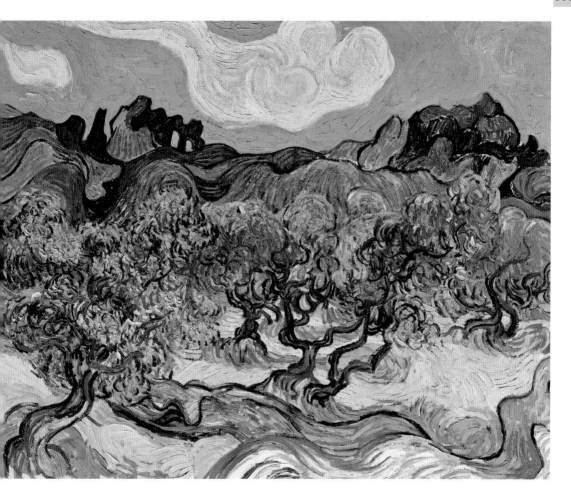

Cypresses, 1889

The asylum of Saint-Rémy was situated in beautiful countryside peppered with olive, almond and cypress trees and surrounded by Van Gogh's favourite wheat fields. The Alpilles mountains loomed in the distance, and several miles away was the small town of Saint-Rémy that boosted a primarily agricultural community. Initially Van Gogh was allowed to paint in the asylum garden, and he painted the view of a wheat field from his window, but later he could go out into the countryside when accompanied by an asylum staff member.

There is a lyrical quality to this painting that does not reflect the artist's troubled frame of mind. His palette is bright and though strong, is less intense and strident than many of his works done at around this time. His experiments with stylization are evident, and this quality of decorative pattern manifested through his brushstrokes was one that was very evident in these paintings done at the end of his life. There is a rhythm to the brushwork that is full of short swirling strokes that are repeated through the tree, foliage and sky, and the effect is one of great freedom.

CREATED

Saint-Rémy

MEDIUM

Oil on canvas

SERIES/PERIOD/MOVEMENT

Post-Impressionism, cypress trees

SIMILAR WORK

The Red Pine by Raoul Dufy

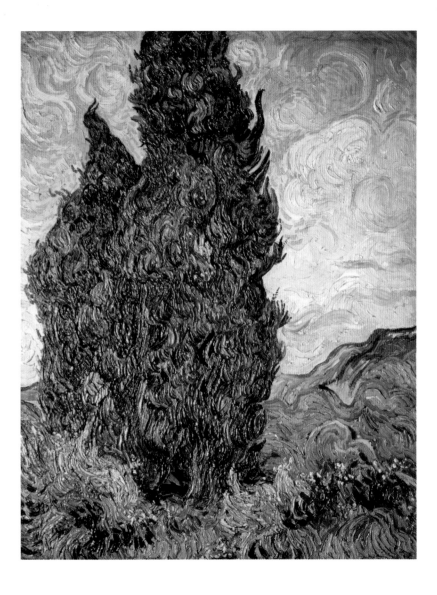

Field with Poppies, 1889

This painting was done in early June 1889, not long after Van Gogh had arrived at the asylum, and as such it can be assumed that it was made either from the window of the asylum or from very near to it. Although this was one of the most distressing years of Van Gogh's life, it was also a time during which he produced some of his most exciting works, and this innovativeness continued until his death. Here he has played with an unusual perspective, which was a technique that he often employed. The view shoots away down a steep hill to fields in the distance and has no horizon, which was an element that he used increasingly in his last paintings. He produced a number of drawings around the same time as this painting, and the style of this painting is similar to that of the drawings, although Theo was not enthusiastic about them. His brushwork here is very controlled, with short, sharp lines to delineate the foliage, and something of the Pointillist in his treatment of the dotted flowers.

CREATED

Saint-Rémy

MEDIUM

Oil on canvas

SERIES/PERIOD/MOVEMENT

Post-Impressionism, landscapes

SIMILAR WORK

St Tropez, Pinewood by Paul Signac, 1896

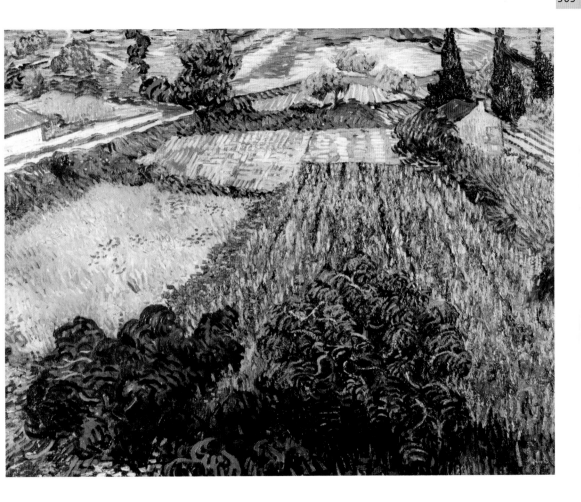

Evening Landscape with Rising Moon, 1889

© akg-images

The moon, the sun and the stars were important symbolic elements for Van Gogh who equated their radiating light to religious precepts surrounding resurrection, redemption and salvation. In this painting the moon in brilliant yellow rises from behind the smoky blue Alpilles mountains, and radiates a light that he has evoked through multiple short strokes of white paint. His use of these short, regular, white strokes was fairly unusual for him, but gives the effect of the dappled moonlight playing across the landscape. There is great rhythm in this painting that is created through these very precise brushstrokes – every stroke of paint here has a function and builds towards the greater surface pattern across the canvas. His forms are very rounded from the stacks of wheat to the mountains, and this sense of 'roundness' and curvature was something that was characteristic of many of his later works. This painting was done in July 1889, which was when he made his first trip back to Arles from the asylum, and subsequently had his first serious breakdown in Saint-Rémy.

CREATED

Saint-Rémy

MEDIUM

Oil on canvas

SERIES/PERIOD/MOVEMENT

Post-Impressionism, landscapes

SIMILAR WORK

Collioure, The Village and the Sea by André Derain, 1904–05

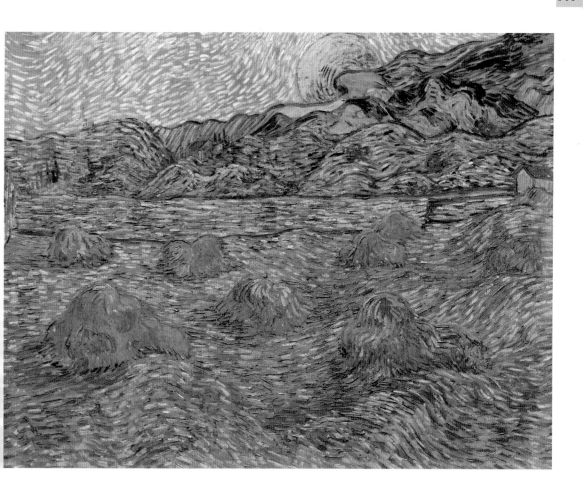

A Road in Saint-Rémy, 1889

The strident and controlled frenzy of brushstrokes in this work marks something of the artist's troubled soul at the time this was painted, but is also very deliberate. Although Van Gogh expressed his inner self through his paintings, he was not simply an 'emotional' artist but considered his works and his style with deliberation. His constant worry was his poor financial state and the burden on Theo, and he worked with a view to his paintings being commercial, despite this not being the case until after his death.

This painting was made in December 1889, though the colours and the light reflect a particularly ambient winter. There is a claustrophobic air to the work with the bushes impinging on the woman's path and particularly in the painting of the sky with its strong downward strokes. At this time Van Gogh was keen to leave the asylum and was struggling with episodes of mental instability. He was suffering from a lack of inspiration in his surroundings, having spent months painting the landscape, and had more recently taken to copying old prints of Millet, and even his own paintings.

CREATED

Saint-Rémy

MEDIUM

Oil on canvas

SERIES/PERIOD/MOVEMENT

Post-Impressionism, landscapes

SIMILAR WORK

The Orchard by Maurice de Vlaminck, 1905

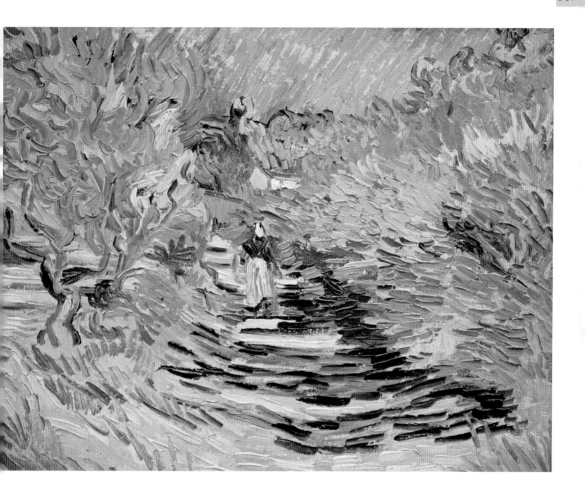

Country Road with Cypresses, 1890

© akg-images

The cypress tree was a motif that Van Gogh frequently used, although at first he struggled to depict them. Their dominant form and dark colour made them overpowering in a landscape, and dwarfed elements around them, which can be seen here in the relationship of the tree to the small figures. The broad path that winds up the canvas with a strangely distorted perspective also dominates the figures, appearing virtually to engulf them with its shining luminescence.

The painting was exhibited with the Indépendants in March 1890, where it earned rare praise from Gauguin, and was given by Van Gogh to the critic Albert Aurier. Aurier was friends with Bernard who had brought Van Gogh's work to his attention and suggested that he should publish an article on the painter. The piece appeared in January 1890 in the Symbolist magazine *Mercure de France*, and was full of praise for Van Gogh describing him as, 'almost always he is a symbolist ... feeling the constant urge to clothe his ideas in precise, ponderable, tangible forms, in intensely corporeal and material envelopes'.

CREATED

Saint-Rémy

MEDIUM

Oil on canvas

SERIES/PERIOD/MOVEMENT

Post-Impressionism, cypress trees

SIMILAR WORKS

Sunset by Odilon Redon

Cows at the Drinking Trough by Paul Gauguin

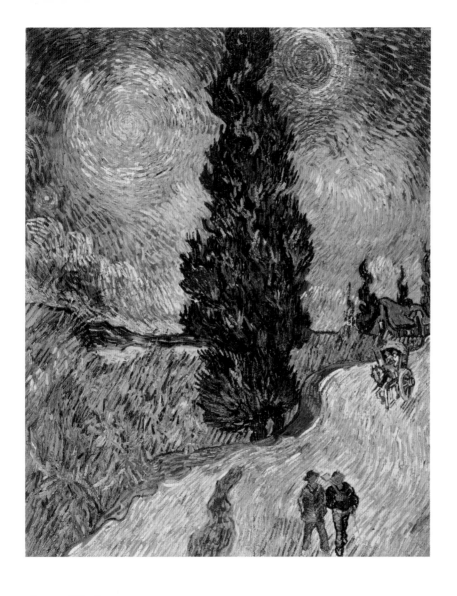

Village Street in Auvers, 1890

In May 1890 Van Gogh finally left the asylum at Saint-Rémy and travelled north to Paris to see Theo for a few days before moving on to the small community of Auvers-sur-Oise, which would be his home for the remaining few months of his life. It was a rural village full of traditional old farm cottages, many of which were thatched and sat on unpaved dirt roads that wended their way amongst the buildings. It was spring, Van Gogh's most positive time of year, and on his arrival he was initially taken with the small town describing it as being, 'of grave beauty, the real countryside, characteristic and picturesque'.

This was one of several views of the streets of Auvers that Van Gogh painted, and shows his use of outline to clarify and simplify the various forms. His palette though still bright was marked by a 'muddiness' of tone that resulted in an earthly quality in the colours. He has used areas of flat colour, then enlivened and added texture to the surface through controlled brushwork, particularly evident in the bricks of the wall and the pan-tiled roofs.

CREATED

Auvers-sur-Oise

MEDIUM

Oil on canvas

SERIES/PERIOD/MOVEMENT

Post-Impressionism, Auvers village streets

SIMILAR WORK

The Village Road by Paul Cézanne, c. 1872–73

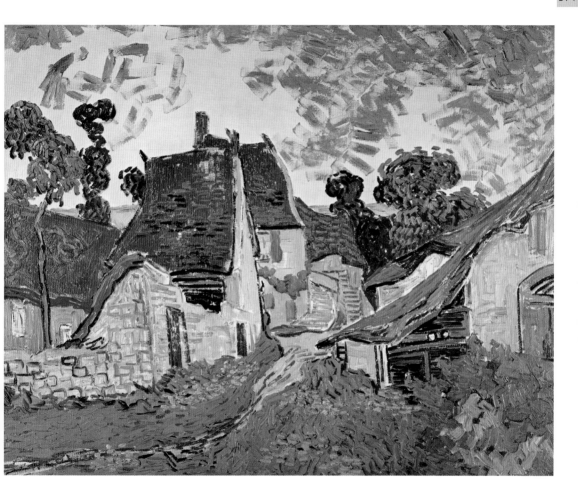

Straw-Roofed Houses, 1890

Although Van Gogh's move to the south of France had been the realization of a dream, the dream had shattered over time. However, his return to the north was a change that he embraced, and he described how his time in the south of France had allowed him to better appreciate the north. This was an extraordinarily positive and surprising view from the artist, who was dealing with such a debilitating mental illness.

On his arrival at Auvers he threw himself into his work with characteristic enthusiasm and began a number of drawings as well as working on his painting. The graphic quality is evident in this painting, seen in his use of a fine brush to virtually draw in details such as brickwork, chimneys and foliage over areas of colour wash. There is a crescendo of movement that travels up the canvas from the blank bottom corner through the house and garden to the expressive trees and culminating in the swirling, tumultuous sky. The curved organic shapes seen in the trees and sky were something that he had been using increasingly, stylizing the natural form and creating pattern from the landscape.

CREATED

Auvers-sur-Oise

MEDIUM

Oil on canvas

SERIES/PERIOD/MOVEMENT

Post-Impressionism, last works

SIMILAR WORKS

Caldas de Montbuys by Raoul Dufy, 1945–46

Houses by the Water by André Derain, c. 1910

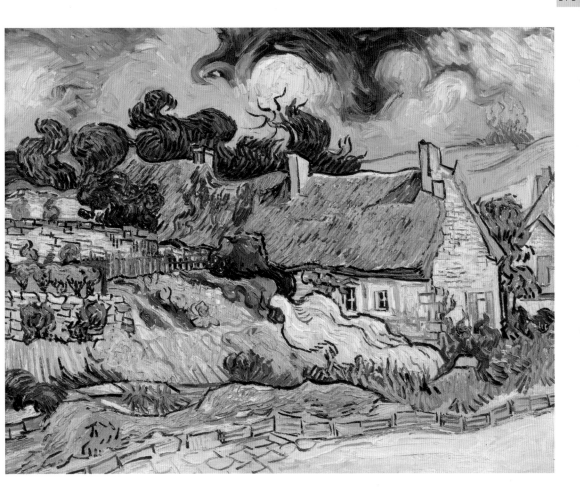

Young Peasant Girl with Straw Hat sitting in the Wheat, 1890

In early June 1890 Van Gogh was in good spirits describing himself as feeling, 'completely calm and in normal condition', when writing to Madame Ginoux in Arles, but just a few weeks later he was devastated by the news that his young nephew and his sister-in-law were both seriously ill. He painted this picture, and another of the same subject at around this time.

This painting has an echo of his early peasant works done at the beginning of his career, and shows the girl in close focus and sympathetically rendered. There is much of the Symbolist here, and even more so in the other painting that hangs at the Washington Gallery of Art. The poppies have been reduced to glowing red orbs, picking up on the girl's ruddy cheeks and the dotted pattern of her rich, blue dress, against which her vibrant yellow hat glows. He has applied the paint so thickly that the surface is highly textured and her face almost three-dimensional, while his use of heavy outline sets her apart from the background of wheat.

CREATED

Auvers-sur-Oise

MEDIUM

Oil on canvas

SERIES/PERIOD/MOVEMENT

Post-Impressionism, last works, portraits

SIMILAR WORKS

The Cowgirl by Maurice Denis, c. 1893

The Checked Blouse by Pierre Bonnard, 1892

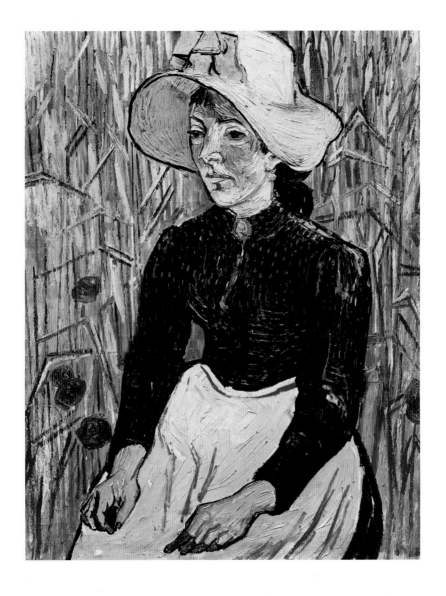

Still Life, Vase of Carnations, 1890

During June 1890 Van Gogh undertook a series of still-life paintings of different flowers in vases and glasses, returning to a subject that he had addressed throughout his career. He worked on these primarily at Dr Gachet's house, which seems to have been a place of inspiration for Van Gogh who delighted in his collection of art and antiques. He spent a considerable amount of time at the doctor's house, visiting two or three times a week, and painted several portraits of Gachet as well as one of his 19-year-old daughter seated at a piano.

As was typical of Van Gogh he has employed a disquieting perspective in this painting so that the vase appears to tip to the left, which is counterbalanced by the spiky leaf tendril. Situating the vase close to the edge of the table again creates a sense of displacement that is balanced through the luscious head of blue and white Impressionistic flowers. The picture was painted swiftly, he was producing almost one a day at this time, and evokes the clarity and pattern of his beloved Japanese prints.

CREATED

Auvers-sur-Oise

MEDIUM

Oil on canvas

SERIES/PERIOD/MOVEMENT

Post-Impressionism, last works, still lifes

SIMILAR WORK

A Bunch of Flowers by Henri Matisse, 1907

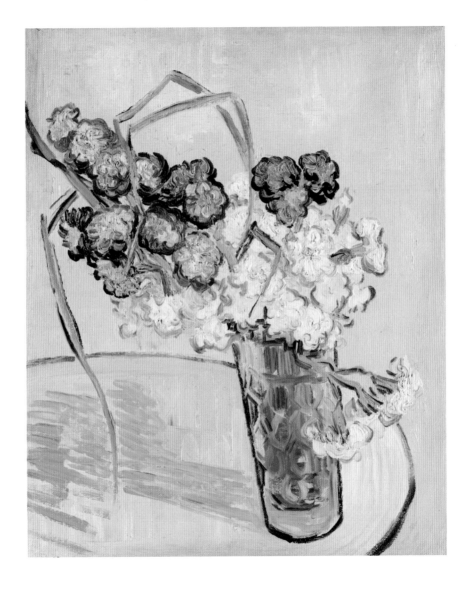

Author Biographies

Tamsin Pickeral (Author)

Tamsin Pickeral has studied art and history of art since she was a child, and lived for some time in Italy furthering her appreciation of the subject. She now specializes in books on art and horsemanship with recent publications including *The Horse*; *30,000 Years of the Horse in Art*; *The Horse Owner's Bible*; *1001 Paintings*; *The World's Greatest Art: Turner, Whistler, Monet*; *The World's Greatest Art: Charles Rennie Mackintosh*; and *The Encyclopaedia of Horses and Ponies*.

Michael Robinson (Foreword)

Michael Robinson is a freelance lecturer and writer on British art and design history. Originally an art dealer with his own provincial gallery in Sussex, he gained a first-class honours degree at Kingston University, Middlesex. He is currently working on his doctorate, a study of early modernist-period British dealers. He continues to lecture on British and French art of the Modern period.

Picture Credits: Prelims and Introductory Matter

Pages 1 & 3: *Van Gogh's Chair* (detail), © akg-images
Page 4: *Field With Poppies*, Kunsthalle, Bremen, Germany/The Bridgeman Art Library
Page 5 (l to r top): *Two Cut Sunflowers*, © akg-images; *Dr Paul Gachet*, © akg-images; *The Asylum Garden at Arles*, © Oskar Reinhart Collection, Winterthur, Switzerland/The Bridgeman Art Library
Page 5 (l to r bottom): *The Night Café, Arles*, © akg-images; *Landscape with Chariot*, © akg-images; *Old Man in Sorrow (On the Threshold of Eternity)*, © Rijksmuseum Kroller-Muller, Otterlo, The Netherlands/The Bridgeman Art Library
Page 6 (l to r top): *View of The Hague*, © akg-images; *Terrace of the Café*, © akg-images; *Olive Trees*, © National Gallery of Scotland, Edinburgh, Scotland/The Bridgeman Art Library
Page 6 (l to r bottom): *Noon: Rest from Work* (after Millet), © akg-images; *Flowering Plum Tree* (after Hiroshige), © akg-images; *The Angel* (after Rembrandt), © akg-images
Page 7 (l to r): *Vase with Gladioli*, © akg-images; *Sower at Sunset*, © akg-images; *Village Street in Auvers*, © akg-images
Page 10: *Sunflowers*, © Neue Pinakothek, Munich, Germany/The Bridgeman Art Library
Page 12: *Restaurant de la Sirène*, © akg-images
Page 15: *Portrait of Père Tanguy*, © akg-images
Page 16: *Self Portrait at the Easel*, © akg-images
Page 17: *Autumn Landscape*, © Fitzwilliam Museum, University of Cambridge, UK/The Bridgeman Art Library
Page 18–19: *Wheat Field with Crows*, © Van Gogh Museum, Amsterdam, The Netherlands/The Bridgeman Art Library

Further Reading

Arnold, W.N., *Vincent Van Gogh: Chemicals, Crises and Creativity*, Birkhauser Verlag AG, 1992

Blunden, M. and G., *Impressionists and Impressionism*, Skira, 1970

Bonafoux, P., *Van Gogh: The Passionate Eye*, Thames and Hudson, 1992

Brodskaya, N., *The Fauves*, Parkstone Aurora, 1995

Bumpus, J., *Van Gogh's Flowers*, Phaidon, 1989

Collins, B. and Ciuraru, C., *Van Gogh and Gauguin: Electric Arguments and Utopian Dreams*, Westview Press Inc, 2001

De Leeuw, R., *The Van Gogh Museum*, Waanders, 2005

Dunstan, B., *Painting Methods of the Impressionists*, Watson-Guptill Publications, 1976

Ed. Bernard, B., *Vincent by Himself*, Orbis Publishing, 1985

Ed. Lord, D., *Van Gogh on Art and Artists, Letters to Emile Bernard*, Dover Publications, Inc, 2003

Elgar, F., *Van Gogh*, Thames and Hudson, 1958

Exhibition Catalogue, *From Monet to Gauguin*, Royal Academy of Arts, 1995

Exhibition Catalogue, *Post-Impressionism*, Royal Academy of Arts, Weidenfeld and Nicolson, 1979

Freeman, J., *The Fauve Landscape*, Abbeville Press, 1990

Gruitrooy, G., *Van Gogh: An Appreciation of his Art*, Smithmark Publishers, 1995

McQuillan, M., *Van Gogh*, Thames and Hudson, 1989

Mancoff, D.N., *Van Gogh's Flowers*, Frances Lincoln Publishers, 2001

Parsons, T. and Gale, I., *Post-Impressionism*, Studio Editions, 1992

Pinkvance, R., *Van Gogh in Saint-Rémy and Auvers*, Harry Abrams Inc, 1986

Rathbone, E., *At Home with the Impressionists: Masterpieces of French Still-Life Painting*, Universe Publishing, 2001

Rewald, J., *Post-Impressionism, From Van Gogh to Gauguin*, Museum of Modern Art New York, 1978

Schapiro, M., *Van Gogh*, Thames and Hudson, 1985

Shoham, S.G., *Art, Crime and Madness: Gesualdo, Carravagio, Genet, Van Gogh, Artaud*, Sussex Academic Press, 2002

Thomas, D., *The Age of the Impressionists*, Hamlyn Publishing Group Ltd, 1987

Thomson, B. and Howard, M., *Impressionism*, Bison Group, 1988

Thomson, R., *Seurat*, Phaidon, 1985

Van Gogh, Vincent, translated, Pomerans, A.J., *The Letters*, Penguin Books Ltd, 1997

Walther, I.F., *Van Gogh*, Taschen, 2001

Wilkie, K., *The Van Gogh File: The Myth and the Man*, Souvenir Press Ltd, 2005

Zemel, C., *Van Gogh's Progress, Utopia, Modernity and Late-Nineteenth Century Art*, University of California Press, 1997

Zerries, A.J., *The Lost Van Gogh*, Forge, 2006

Index by Work

General Index